The Watercolor Painter's Problem Book

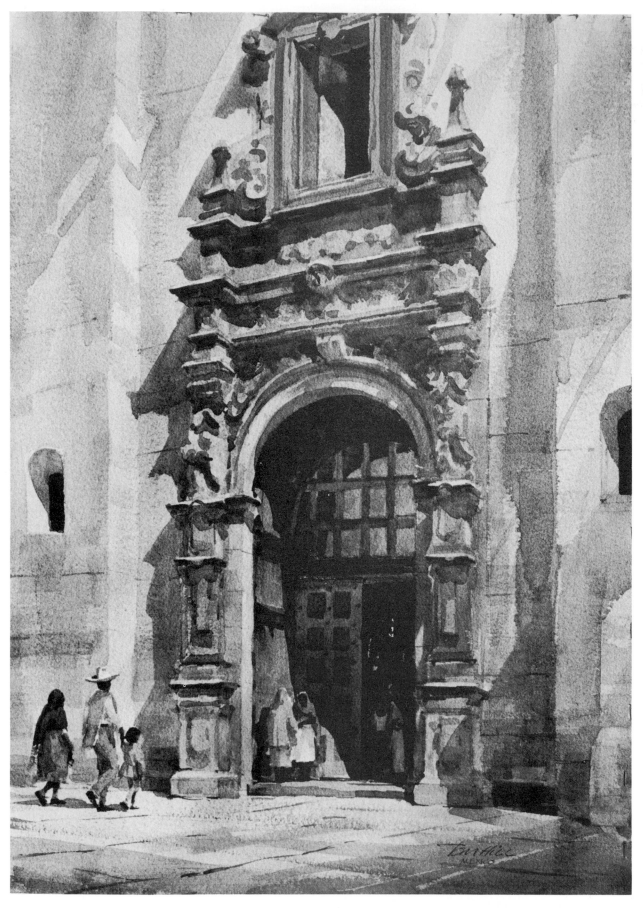

Church Façade, Mexico, 30" × 22" (76 × 56 cm), Collection of The Arizona Bank. Shortly after Cortez' conquest of the Aztecs in central Mexico, the Spanish set about building elaborate churches. This one is in that tradition and of that time period.

The Watercolor Painter's Problem Book

by Tom Hill, A.N.A., A.W.S.

WATSON-GUPTILL PUBLICATIONS/NEW YORK
PITMAN PUBLISHING/LONDON

Acknowledgments
To Don Holden, Marsha Melnick, and
Bonnie Silverstein for their support, enthusiasm,
and wonderful professional help.

First published 1979 in the United States and Canada by Watson-Guptill Publications,
a division of Billboard Publications, Inc.,
1515 Broadway, New York, N.Y. 10036

Library of Congress Cataloging in Publication Data
Hill, Tom, 1922–
 The watercolor painter's problem book.
 Bibliography: p.
 Includes index.
 1. Water-color painting—Technique. I. Title.
ND2430.H54 1979 751.4′22 79-630
ISBN 0-8230-5677-5

Published in Great Britain by Pitman Publishing Ltd.,
39 Parker Street, London WC2B 5PB
ISBN 0-273-01350-5

Manufactured in Japan

First Printing, 1979

To Barbara

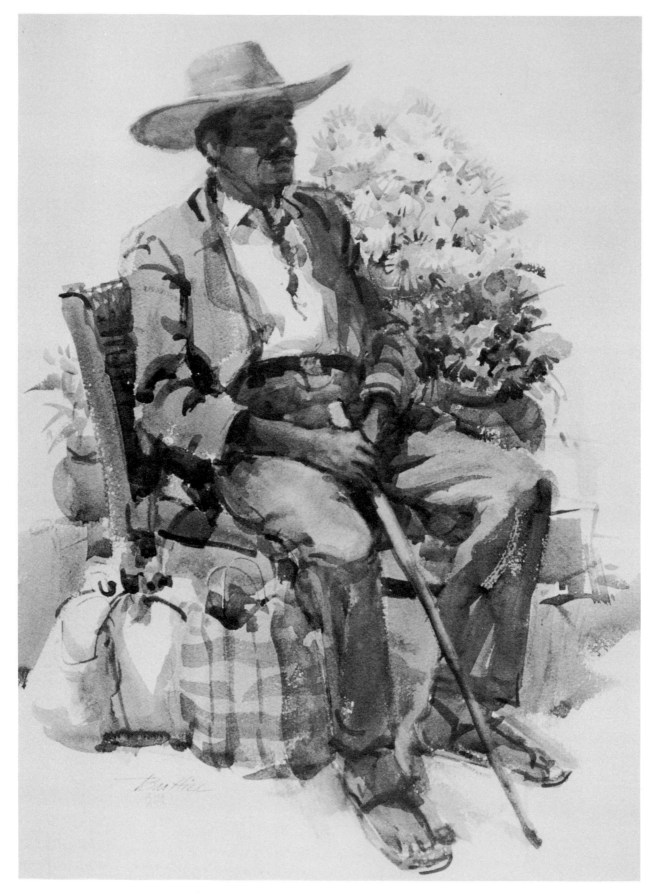

Juan Padilla de las Flores, 30″ × 22″ (76 × 56 cm), Collection of Mr. and Mrs. Dale Boatman. This gentleman posed for a class demonstration I did. The flowers were added later.

Contents

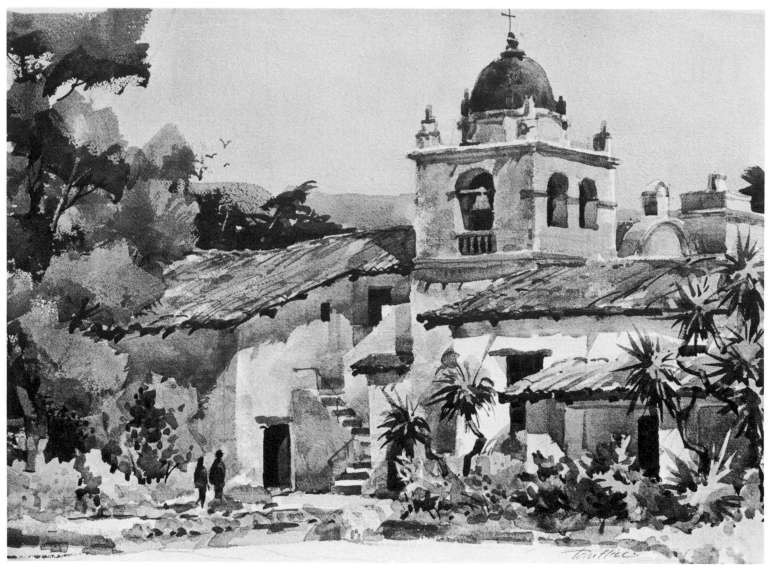

The Mission at Carmel, 22″ × 30″ (56 × 76 cm), Collection of Mr. and Mrs. Phil Rasmussen. This painting was done as a class demonstration of the beautifully preserved mission in California's historic city, Carmel.

Introduction

Every artist has painting problems, especially people like us who use watercolor, a medium that's a problem all by itself! So a book that deals directly with specific watercolor painting problems and then shows solutions, has got to be a good idea. Now I'm not saying that there's a readymade solution for each problem, because there isn't. And there's no one solution cither, for there's always more than one way to paint and more than one way to approach and solve the problem at hand. But in this book, I'll examine twenty typical painting problems and, through a series of step-by-step color photographs taken of the actual painting as I painted it, along with some captions that will further explain what I'm doing I'll show you one way I solved them. I hope you'll use the solutions that I present as starting points—ways of thinking about the problem—that might help you solve some of your own watercolor painting problems.

For example, Problem 15 deals with the problem of painting a stone wall—and the stone wall isn't the whole painting, but only a part of it. *My* stone wall example happens to be one wall of an old Pennsylvania barn, and in my painting of it, I show you one way the stone wall can be painted. There are other ways, of course, but here, at least, you can see *one* way completely defined for you as the painting process takes place.

Your painting of a stone wall, on the other hand, may not have a barn in it, or it might not have the same shape, color, or kind of stone wall that I'm painting. Your problem might be to paint a jumbled stone wall out in a farmer's field, or a very finished, trim stone wall bordering some elegant building, or perhaps a stone wall that is the breakwater for a harbor. Nevertheless, seeing how I solve a similar painting problem may give you clues to solving your own, and at least offer some ways to think about the problem. Then you can work out a solution, not necessarily copying what I've done here, but using my example to help you work it out your *own* way.

If you look over the list of problems, you'll notice that some concern specific problems, such as reflections in water, or how to paint the effect of weathered wood. Other problems, however, are less specific—like those that deal with a mood or a "feeling"—such as interpreting the quality of light at dusk or the atmospheric feeling of space that might be manifested during sunset. So, some of the problems will have more specific answers or solutions, with even some "rules" you can apply, whereas others will only be starting points in your search for your own solutions.

Nearly every painting shown will have, in addition to the specific problem discussed, *other* painting problems solved within it. Often, these will be a duplication of problems in other chapters, though they may be solved here in another way. I hope that you'll see additional solutions this way, and that it will widen your information and problem-solving abilities!

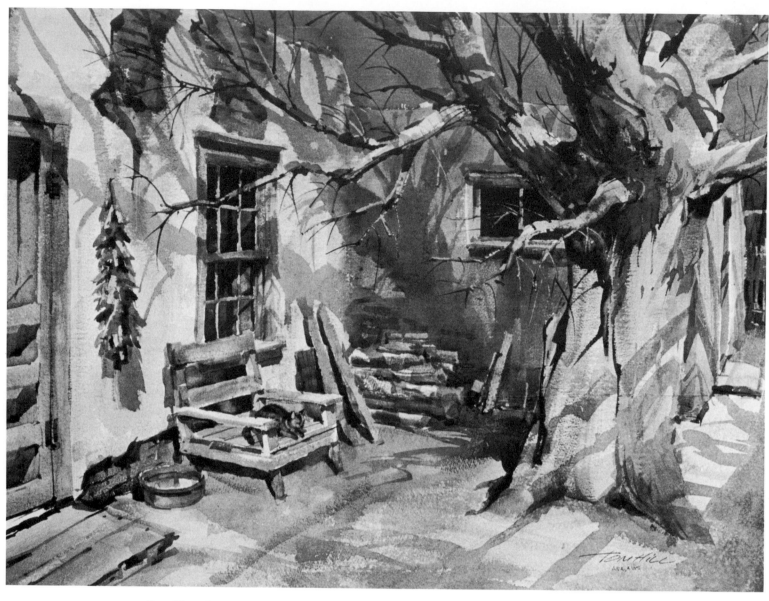

Cerrillos Cottonwood, 22″ × 30″ (56 × 76 cm), Collection of Dr. and Mrs. Ross Chapin. A winter sun warms a corner of this little old adobe building in northern New Mexico.

Materials and Equipment

Before we start discussing problems and doing the demonstrations themselves, I'd like to talk with you for just a moment about getting *ready* to paint. When I start out to paint a picture, I not only need to have my subject (or mood or feeling) firmly in mind, but I also want to be able to paint the painting with authority and ease!

In order for all this to happen, it follows that I must really know my subject sufficiently (understanding) and also possess the necessary painting skills, craftsmanship, and painting experience to do the finished painting. Throughout this book you'll hear me harping about "understanding." By this, I mean not only understanding your subject and your painting medium, but understanding yourself, as well. Craftsmanship is more than an ability. It's an attitude—a desire to be thoroughly familiar with your materials and equipment, and know the best way to use them. Skill and painting experience are really a matter of doing. You learn by doing—and you learn from your mistakes. So it follows that the more you do, the more your skill and experience will grow. This involves time, but artists, unlike athletes and movie starlets, have no age limit for retirement (isn't it wonderful?) and can continue the quest for understanding and painting excellence indefinitely!

I'll tell you about some of my materials, equipment, and painting procedures, and you can check this information out against what you're currently using and doing. You may find a way of planning, working, or discover a piece of equipment that could be helpful or useful. Of course, what I say may be redundant to some of you, but let's go through it anyway for those of you that are new to watercolor—even if you're more experienced, a little review won't hurt!

Transparent Watercolor. Transparent watercolor (or any other transparent medium such as inks and dyes) differs from *opaque* watercolor (or any other opaque medium such as oils, acrylics, and casein) in one very important way. In transparent painting, you're producing "veils" of color that must be painted over a white (or nearly white) surface. The light must then go through these veils, strike the white paper (or canvas or board) that's *underneath* and be reflected back through the color, for you to see it. Just try a transparent painting on black paper and you'll understand what I mean—there'll be practically nothing to see! Because no white paint is used in transparent watercolor, *all* whites—and light-value areas too, must be planned *in advance* and "saved" as the painting process proceeds.

In opaque painting, the paint forms an opaque film, and light reflects off the *top* of this—so it's even possible for you to start with black paper, canvas, etc., and paint up to your whites or lightest values, adding them *last*.

What we're talking about here are the two *extremes*, between transparent and opaque painting. In reality, some transparent colors are more "opaque" than others, and some opaque colors more "transparent" than others. So, whatever your medium or style of painting, it's important to understand and know what to expect from which color!

Colors. Transparent watercolor is available in tubes (moist) and in pans (firm to hard). But when using pans, you must first soften the color with water, each time you use it, and even again while actually painting, it seems! The pans are okay for small paintings and field sketches, but I don't use them for larger paintings when, for example, I want a lot of color for a big wash—in a hurry! I'm presently using tube colors almost exclusively. I only buy the best quality paint in the largest sized tubes possible. The larger tubes are a better bargain, and student-grade colors don't produce the results I want. There are nearly 100 different colors available, with many versions of each primary and secondary color. For example, Winsor & Newton offers some sixteen or seventeen reds (not counting some of the earth colors that are actually grayed reds), some fifteen or sixteen yellows, some eleven or twelve blues, and so on. So you're blessed with a wealth of choices in wonderful, permanent colors. But which should you choose, when only a few of each are actually needed?

11

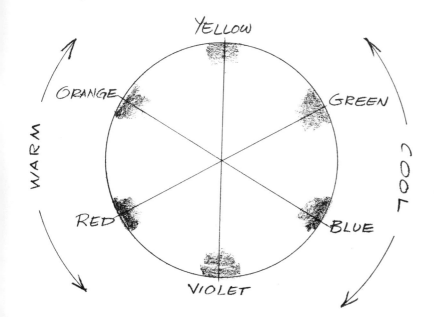

In my book *Color For The Watercolor Painter* (Watson-Guptill, 1975), I deal more extensively with most of the permanent colors, examining and listing the properties, advantages, and drawbacks of each. But here I'll just touch on the ones I use in painting the demonstrations. You can experiment with others on your own. But you should do that anyway—I've never known any two artists that liked exactly the same colors or set the same palette.

Over the years, I've tried out most of the colors available, and at one time had quite a few on my palette. However, I've gradually eliminated more and more of them, keeping only those that do the job best for me. This doesn't mean that I arbitrarily exclude a particular color *forever*, or that I don't try new ones. As a matter of fact, I'm always on the lookout for better ways and better results.

My Colors. Basically I always try to have a warm and a cool version of the three primaries—red, yellow, and blue, plus a few supplements, and that's all.

It's surprising to many people when they first consider it, but there are only a few colors that make up the visible spectrum—just six in all: red, orange, yellow, green, blue, and violet. These colors are wavelengths of direct light that combine to produce the white light of the sun. The colors on our palette, however, are not those of direct light (they have no light of their own), but are only reflecting color wavelengths—that is, each pigment reflects only that portion of the direct light spectrum that affects it, while absorbing all the rest of the colors in the spectrum. For example, red pigment reflects red light, while green pigment reflects green, and blue reflects blue light, and so forth.

In *direct* light, the more colors you combine, the more intense or brighter and whiter the result (think of combined spotlights on a stage). But in *reflective* light, the more pigments you combine, the *less* intense and blacker the result (think of your palette when it needs a good cleaning!).

Color Wheel. In Figure 1, the six colors are placed in a circle. It's called a color wheel, and it's just a simple and convenient way to quickly see the relationships between colors. You'll notice two things: First, that directly across from any color is its opposite, most often called its "complement," and second, that colors seem to possess temperatures, with warm and cool sides to the color wheel.

Dimensions of Color. If you think of color in terms of the following three "dimensions," it will help clear up some of the confusion about the properties of color. *Hue* refers to the specific color (red, blue, violet, etc.). *Value* means the range from light to dark. Think of how a black and white photograph

converts all different colors into values of light, dark, or somewhere in between and, you'll understand what is meant by "value." Thus, a red and a blue can have the same *value*, even though they're different *hues*. The word *intensity* refers to the amount of brightness or dullness of a color. There could be two reds, each with the same value, but one is brighter or more intense than the other. ("Intensity" is also called "chroma," "brilliance," or "saturation"). When you squeeze some watercolor from the tube, it will be as intense as it's ever going to get. Mixing it with other colors, especially its complement, won't intensify it, but will only dull or neutralize it. In fact, mixing a color with its complement is one of the best ways to *gray* or neutralize a color. Paradoxically, if you put any two complementary colors beside or near each other but *don't* mix them, they'll make each other look *more* intense!

Here are a few other color terms that should be kept in mind and understood. *Local color* means the actual hue of the object or whatever. For example, the local color of an apple is red and local color of a sky is blue. In watercolor, a *tint* means that you've added water to a hue and diluted it (in the case of opaque painting, it refers to the addition of white paint). *Shade* means that you've added some of the hue's complement, near complement or black. The word *tone* is ambiguous and is often confused with the term "value," but it really means a hue that has been made into a shade, then a "tint" made of that! No doubt, you'll hear all these terms used improperly, but at the least try to get the terms *hue, value,* and *intensity* straight in your mind!

Here are the colors that I use in the demonstrations in this book (this doesn't mean that these are the only colors I use), with a brief description of each one's characteristics. You'll note that all are on the transparent side, which seems appropriate since I'm talking about transparent painting! Incidentally, quite often one manufacturer will call a color by one name, while another company calls the same color a different name, and these *proprietary names* as they're called, can add to our confusion. I wish they'd all use the same name for the same color, but they don't, so all we can do is go back to the basics of hue, value, and intensity and note where the particular color falls on the color wheel.

Yellows. *Winsor or Hansa* yellow is on the cool side, leaning slightly toward green, and is a transparent and strong color. *New gamboge* is also transparent and strong, but leans a little more toward orange than green, so I call it a warm yellow.

Reds. *Scarlet lake* is not really a warm red, but the warmest of all the transparent reds. It's very transparent and strong. *Alizarin crimson* is closer to violet than to orange, so it's cool, transparent, and a strong favorite of many artists. *Permanent rose* is almost a violet, so it's cool, but I still group it with the reds. Transparent and fairly strong, it makes beautiful violets when mixed with its neighbor, ultramarine blue.

Blues. *Ultramarine blue*, also called French ultramarine, is the transparent workhorse blue, an all-round favorite of artists for many years. It's closer to violet than it is to green, so it's a warm blue. *Cobalt blue* is just about midway between green and violet, so I consider it neutral in temperature. It's fairly transparent, but not too strong. *Phthalo blue* (also called Thalo or Winsor blue) is definitely a cool blue, as it leans toward green, not violet. It's very transparent and potent, so a little goes a long way! *Manganese blue* is also cool since it leans toward green. It's transparent and makes granulated or sedimentary washes with ease! I like it, and currently use it in place of the older and more opaque cerulean blue.

Green. *Phthalo green* (also called Thalo and Winsor green), like its chemical partner, phthalo blue, is very transparent and also very potent—just a little too much added in a mixture and it will easily dominate the other color, so be careful!

Earth colors. *Raw sienna* could actually be placed with the yellows, since it's a grayed yellow. It's transparent and fairly strong. *Burnt sienna* is a raw sienna that's been roasted! This wonderful color has been on the palettes of artists for centuries. It's really a grayed orange-to-red color (depending on the brand you're using). Transparent and fairly potent, it does a great job in graying all the blues. *Yellow ochre* is lighter in value, yellower, and more intense than raw sienna, but not as transparent. Somewhat weak, it's easily dominated by many other colors in mixtures, but it's a sunny hue, and one that's often found in landscapes.

As for the myriad of other colors available today, if you're curious and haven't tried some of them, by all means do so. If they do the job better than what you've been using or what I'm currently using, then you may want to switch!

Paper. Paper has been around since the Egyptians. It has been made from a multitude of different fibers, mostly of vegetable origin. Very broadly speaking, through various methods, the fibers are broken down into a souplike consistancy in water, and then poured over a screen or sieve. As the water drains through, what's left is paper. Of course, there are many more steps involved, and many types of paper exist. The very best watercolor papers used to be made from linen rags, though I understand linen rags have become extremely scarce today for this

purpose, so cotton is the principal ingredient now. Commercially produced papers contain a lot of wood-pulp fiber, but first-class watercolor paper doesn't have any wood pulp, and is chemically neutral.

Good watercolor paper is expensive, and the cheaper, machine-made papers are tempting because of their lower prices. But the results just aren't the same! There are a few manufacturers making cotton rag papers that, though machine-made, are a lot closer to the handmade variety. But there's a lot of handwork involved in making the best paper, and I personally prefer the handmade papers that come from Europe.

The papers of various manufacturers differ from each other, so try several brands to see which you prefer. Watercolor paper is labeled by it's weight: 140-lb paper means that a ream of it (approximately 500 sheets) weighs 140 pounds, a ream of 300-lb paper weighs 300 lbs, and so forth. Most of the paper available in the United States in sheet form comes in a size called Imperial, also known as a "full sheet." It's about 22" × 30" (56 × 76 cm), and can be cut into half and quarter sheets. Surface textures range from smooth (hot-pressed) through medium (cold-pressed) to roughest (rough), although these textures vary from brand to brand. I enjoy painting on Arches (French); Fabriano (Italian); Saunders, Green, or Crisbrook (English); as well as some Japanese and even Indian papers. Watercolor paper also comes in pads called blocks, but I prefer to use individual sheets.

Stretching Paper. I like to stretch my watercolor paper before I paint. To do this, I wet the paper until it soaks up enough water to swell in size. Then, while it's expanded, I fasten it down to my watercolor board. When it dries, it tries to return to its original size and becomes as taut as a drumhead. It makes a wonderful surface to paint on, and because it's stretched, there's a minimum of wrinkling and buckling that's such a nuisance when painting on unstretched paper.

There are several ways to fasten the paper down to the board. You may use a Kraft paper tape that must first be moistened, to tape the edges of the watercolor paper to the board. This must be done with just the right amount of water, not too much or too little, or the tape won't stick. But I like to use a staple gun and staple the paper's edges about ½" (1.3 cm) in from the edge, every two to three inches (5 to 8 cm), all the way around the paper's edges. There are several good staple guns available, like the Swingline No. 101 Tacker, which will take 5/16th-inch (0.8-cm) staples. (Don't expect little desk or office staplers to do the job!)

Brushes. Not long ago I had the opportunity to visit the Smithsonian Institute in Washington, D.C., where I saw a marvelous display of all types of paintbrushes from the last century. I had no idea that there were so many types and that they were so well made in those days! Nearly all appeared to be handmade. Like so many things today, handmade brushes are getting hard to find, and they're expensive. Fortunately, you don't need a lot of brushes in order to paint successfully in watercolor. In fact, I think it's usually better to have only a few: a couple of well-made flat brushes and a couple of good round ones will handle just about every problem!

For years, the best brushes for watercolor were made of red sable hair. But good oxhair brushes are fine, too, and cost about half as much. In recent years, synthetic hair has been used in making watercolor brushes (the "white sables"). It's even less expensive—and is surprisingly good. Figure 2 shows the brushes I use the most and Figure 3, the ones that I use less frequently.

Palettes. Because you're painting transparently, it's imperative that the mixing surface of your palette be *white* to better judge the hue, value, and intensity of the paint you're mixing. There are many solutions to the palette problem: you could use a piece of glass, painted white on the underside, or a white china plate, or a butcher's white porcelain-enameled tray. My objection to all of these is that the gobs of pigment aren't separated enough and so often run together, graying and dirtying each other. Try looking at the plastic watercolor palettes available. Most of these have individual "wells" for each pigment and are better for this reason. My suggestion is to get one with big wells and a big mixing surface. If it comes with a lid, it will help keep your pigments moist between painting sessions, especially if you leave a little piece of wet sponge or rag inside on the mixing area!

I've yet to see the "perfect" palette, especially for carrying to location. You have to carry it more or less level if the colors are *moist*, or they'll overflow their wells and make an expensive mess!

Other Painting Tools. Of course there are ways to get the paint onto the paper other than by using brushes. Sponges, stamps, a toothbrush for spattering—all are useful, just as clean rags, tissue, blotters, masking tape, and mask-out fluids are useful in controlling, as well as removing, paint from the paper. Try them all. Just be sure that you don't become the slave of some tricky technique. I use a mat knife a lot in watercolor painting, not only for scratching or scraping, but as a "squeegee" to move wet color aside. An oil painter's palette knife does well for some of this, too. Razor blades (single edge) also have their place as a tool (see Figure 4).

Some artists I know start painting on blank water-

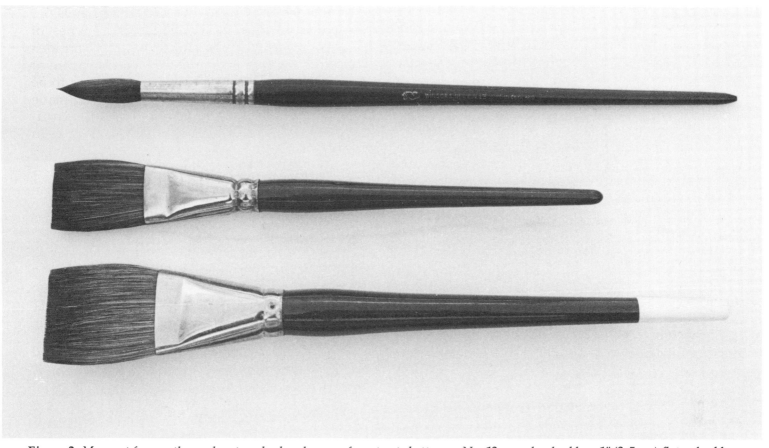

Figure 2. My most frequently used watercolor brushes are, from top to bottom, a No. 12 round red sable; a 1" (2.5 cm) flat red sable (you could also use oxhair); and a 1½" (4 cm) flat oxhair watercolor brush.

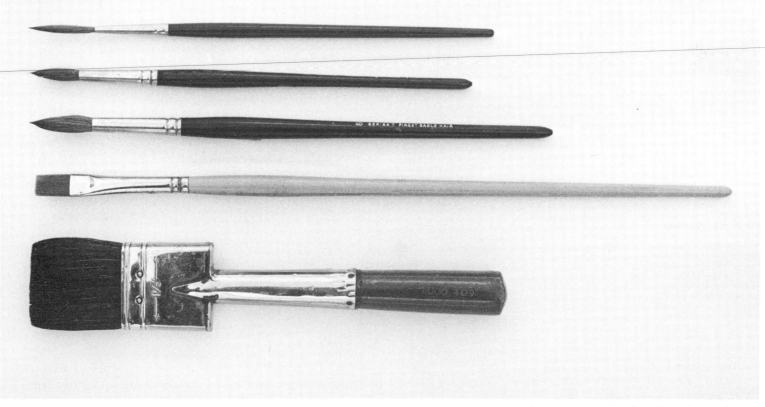

Figure 3. These are the brushes I use less frequently. From top to bottom, they are: a No. 6 sable "rigger," a No. 6 and No. 8 round red sable watercolor brushes, respectively, a No. 5 nylon bristle brush, and a 1½" (4 cm) flat muslin or varnish brush.

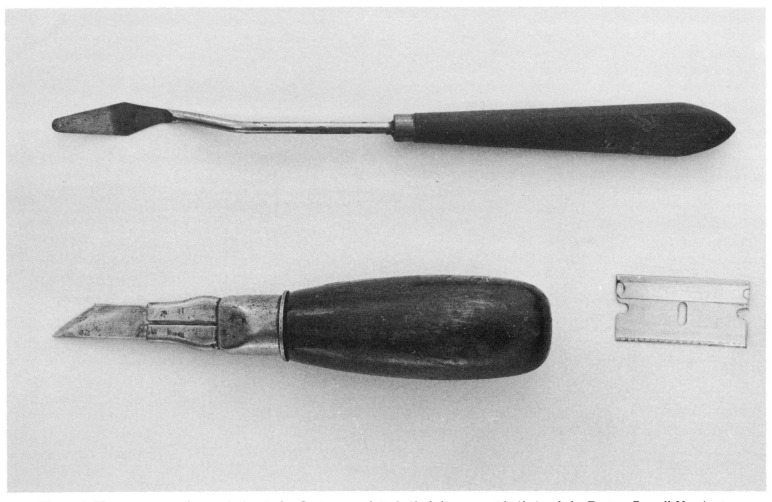

Figure 4. These are some of my painting tools. On top, a palette knife; below, a mat knife (made by Dexter, Russell Harrington Cutlery, Inc., Stonebridge, Mass. 01550), and to the right, a single-edge razor blade.

color paper right away, but most of us prefer some sort of beginning guidelines on the paper prior to using paint. I've used a lot of pencil drawing in the demonstrations that follow, mainly so that you can see in advance the plan and design for the painting. I usually draw lightly with a graphite pencil, and prefer the softer leads (2B through 6B). You might want to try charcoal or paint in your design very lightly with a light tint of color, say a very diluted cobalt blue or yellow ochre. Erasers are also important. You can erase pencil marks, even from a dry wash, if you didn't apply the pencil too vigorously! However, hard erasing can alter the paper's surface so that when you paint over it again, the paint will run into the damaged fibers and probably be darker in value. I use a soft eraser like ''Pink Pearl.'' Kneaded erasers are useful, too, especially for lightening pencil marks, while still leaving a trace of them visible.

Painting in the Studio. Several conditions are important in order to have a good studio: Adequate lighting; a good drawing table or easel; a comfortable chair or stool; a good sidetable (taboret) that has enough space for my palette and all my painting gear. I have a large window that faces north and lets in lots of light, but I also have artificial light for times when the daylight isn't too good, or for work at twilight or evening. Currently, I'm using three 48" (122 cm) four-tube fluorescent fixtures, which have color-corrected tubes and are hung from the ceiling. This makes twelve tubes in all, which is a lot of light—in fact, it lights my taboret as well as my drawing board, so I can see the color accurately both places! You might not want so much light—one four-tube 48" (122 cm) unit gives quite a bit of light. But make sure you use color-corrected tubes.

My drawing board is large—its top is nearly 3' × 4' (0.9 × 1.2 m)—and has a sturdy base. I can raise or lower the top as well as tilt the angle, simply by turning a knob (see Figure 5). *Taboret* is a French word meaning a small portable stand, but when it refers to this essential piece of artist's furniture, it means a sidetable where you can put your palette and tools while you're painting. There are commercially made taborets on the market, but I designed and made mine for my specific needs. Some of the drawers are shallow, so that brushes, pencils, pastels, and watercolor tubes stay more or less one layer deep and I don't have to dig around to find something, as is the case in deeper drawers. Also, I put it on easy-rolling, rubber, swivel casters, and after applying an off-white formica top, I covered that with a cut-to-fit piece of clear plate glass. This is easy to keep clean and serves as extra palette surface (see Figure 6).

My chair is a large and comfortable ''executive'' fiberglass-molded chair made by Knoll and As-

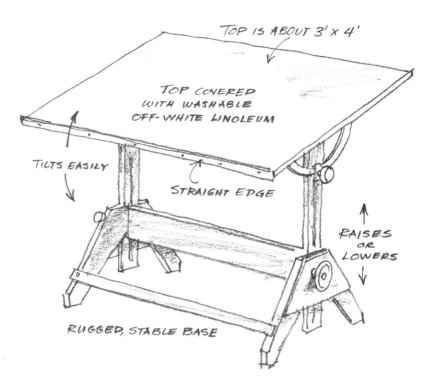

Figure 5. My drawing board.

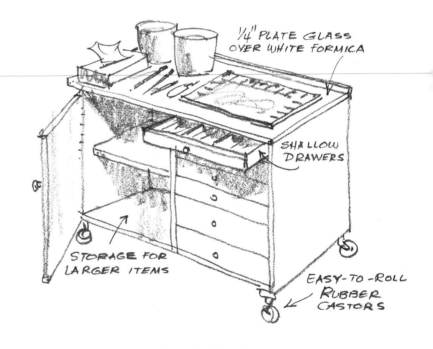

Figure 6. My taboret.

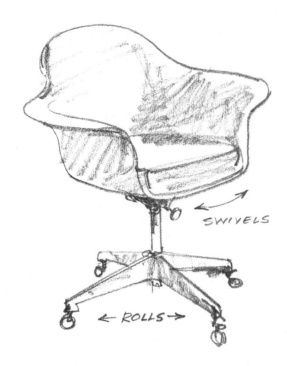

Figure 7. The swivel chair I use.

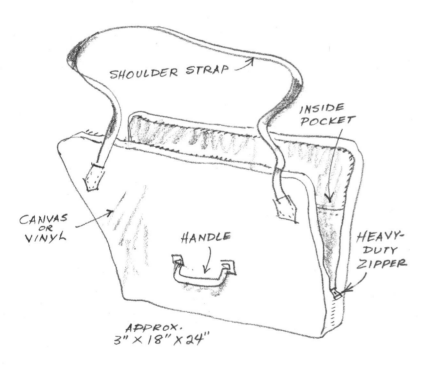

Figure 8. My painting bag, for carrying outdoor painting supplies.

sociates. It can swivel as well as roll back and forth, which is great if I want to turn toward my taboret or roll back for a longer look at what I've just painted (see Figure 7).

My studio also contains files, both *regular*, for storage of pictures and reference material, and *flat*, for storage of paper and paintings; and bookshelves for slides, sketch books, and the like.

Painting on Location. My painting time is divided somewhat evenly between indoor studio painting and painting outdoors on location. On-location painting has problems not found in the comfort of a studio: wind, sun, rain, heat, cold, insects, and nosy on-lookers. It can be distracting, even uncomfortable. But for me, the direct encounter with the scene or subject that captured my interest in the first place is worth it! Photographs, sketches, and notebooks worked from later aren't the same as first-hand experience, which gives me an extra edge in understanding my subject, even if the painting I produce on location is a washout and must be redone. I highly recommend painting on location, in spite of its trouble and extra effort, and hope that you do it, too.

My basic painting gear for on-location painting depends to some degree, on one factor: How far I have to carry this painting gear. If I'm near my vehicle, then I can pack more elaborately, even adding folding chairs and tables, and carry lots of water. However, if the painting site is "over that hill," I'll probably narrow things down to the bare essentials.

Those bare essentials could be as simple as a little bottle of water (water is *heavy!*), a small stretched paper, a few primary colors, and a couple of brushes, in a little watercolor paintbox. But most of the time I want more than that, and usually manage to get all I need into a painting bag that I designed and had an upholstery shop sew together for me. This bag will hold a half-sheet size of watercolor paper, my board and easel (see Figure 8), my paintbox with brushes, pencils, colors, and the like, a plastic jug of water, water containers for painting, tissue, and even a small folding stool, if I want to take it, though there's usually some way to improvise a seat on location, and I'll often leave the stool at home.

There are several types of easels available for painting outdoors, from the simple three-legged variety, to the French easel, which is in reality a paint box in the middle, folding easel on top of it, and folding adjustable legs below. Look the easels over if you don't have an easel or are unhappy with your old one, but remember weight and fragility if you're traveling or hiking to location. My easel is a simple affair: an ordinary lightweight photographer's tripod, to which I screw my watercolor board with the watercolor paper already stretched on the

top side of the board. By epoxy gluing a 3" or 4" (8 to 10 cm) thin metal plate (like an electrical junction box cover, which has a hole drilled in it and a nut welded on its back) to my watercolor board, and recessing the nut into the board's surface, I have a versatile easel that's lightweight, fully adjustable in all directions—including adjusting to irregular ground, and one that I can disassemble easily and pack in the painting bag (see Figure 9).

Paint Box. If I'm painting close to my vehicle and want lots of painting tools, I can get everything I need in a fishing tackle box, but if I'm walking and carrying the painting bag, the tackle box is too bulky to fit inside. Then I use a Smith-Victor metal color-slide storage box, taking out the plastic liner. I can get everything essential into it, and it's only 2" (5-cm) thick, 7" (18 cm) deep, and 14" (36 cm) long. You'll find them sold in photograph supply stores.

Water. In my vehicle I carry a 5-gallon plastic water jug, with a pour spout, which gives me plenty of water for a day's painting. If I'm on foot, I use one of those flat two-quart plastic bottles, like the ones that starch or liquid detergent come in. This fits down in the bag, and two shallow plastic refrigerator food-storage containers—one for clean paint water, and the other for dirty water.

Technique. Much has been written about the technique of watercolor and the many ways it can be applied. Although this book assumes that you have some mastery over watercolor techniques, a review of some of the basics is good for a refresher. There are three kinds of basic washes: (1) The "flat" wash, where the color is evenly applied; (2) the "graded" wash, where the color goes from light to dark or vice versa in the same wash; and (3) the floated or "wet-in-wet" wash, where color is applied to already wet paper or paint. These, plus the various brushstrokes possible with flat and round brushes, make up the backbone of watercolor technique. Familiarize yourself with all of them, if you aren't already, but remember it's what you have to *say* in your painting, and not fancy techniques, that really makes you an artist!

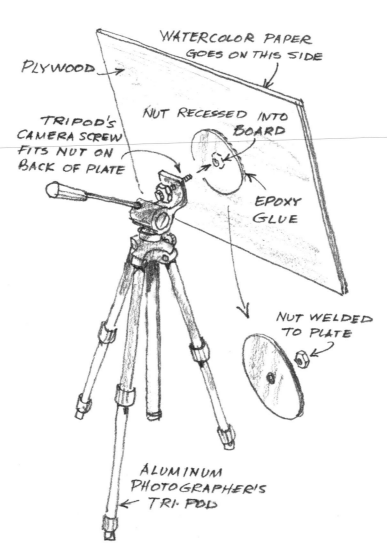

Figure 9. My outdoor painting easel.

PROBLEM ONE

Sunset

Considering that they occur every twenty-four hours, it's always amazing how sunsets (and sunrises) have the great variety that they do. With a thick, cloudy, and overcast sky, the event can be very low key, almost passing unnoticed, and with a very low intensity of color. Yet, the very *next* sunset can be an extravaganza of brilliant light and color, if sky conditions have changed.

Everyone seems affected by such a sunset, some with awe and feelings of reverence for the wonder of our world, and others merely reveling in the passing visual glory. So, you'd think that sunsets would be a natural and favorite subject for artists to want to paint. Yet, I know artists who "wouldn't dream of painting such a trite and 'corny' subject!"

However, artists have been interpreting sunsets for centuries, some with great success, but many with only garish "postcard" results. It seems to me that the more spectacular the actual sunset is in light and color brilliance, the more difficult it is to paint it and still avoid that postcard result.

In painting a sunset (or sunrise) you must decide what it is that you want your painting to say (I've said *that* before!), analyze what makes or contributes to that effect, *then* paint it. As an example, let's say you want to paint a sunset, with low light and a thick overcast sky. Just remembering the effect isn't enough. You must look at the real sunset, study it, and understand what's happening. Like everything else, if you're armed with understanding, the rest will be easier! If a clear, cloudless sky is your subject, then you really should study one! It will certainly be different from a cloudy, overcast sky. There are even variables in clear skies: one might be in a rural setting with really clear air; another might be in a setting where manmade smoke and smog cause the sun's rays to pass through this thicker layer, creating differences in light refraction.

For this demonstration, I decided to take a chance and paint a rather brilliant sunset that could lapse into a "corny" scene if I wasn't careful. As for observing my subject firsthand, that was no problem. Where I live—in southern Arizona—brilliant, spectacular sunsets are more common than anywhere else I've been.

Summer is the rainy season and brings *chubascos* (the Mexican word for "thunderstorms") to this part of the country, usually in late afternoon. Their awesome, towering clouds are loaded with moisture, which drops in sheets of rain as they travel along, and they offer material for endless arrangements of light, color, and shapes in the evening sky. In my painting, I depict that time when the sun actually drops below the distant mountain range, but its rays can still be seen striking the clouds above. They, in turn, reflect the little light there is on the landscape below.

Here are some points to consider: (1) No matter how "busy" or elaborate the actual sky is, you still have to make a workable and sound composition, and so must plan and edit your subject to that end. (2) Even if the sunset is unbelievably brilliant, the chances are that you'll do better if you reserve your brilliant passages for the smaller parts of the painting, and not spread intense colors wildly and indiscriminately all over your painting. (3) Since a sunset (or sunrise) changes at every moment, you might want to record it with sketches, color notes, and color photographs to help you paint it later.

Brushes. As usual, the painting was "established" with my 1½" (4 cm) and 1" (2.5 cm) flats, and finished with No. 8 round sable and a No. 6 rigger.

Paper. I used a stretched, 300-lb rough Arches paper.

Colors. If there's ever a time for transparency, it's in interpreting the effect of light in a sunset! I used a transparent palette of yellows (new gamboge and raw sienna); reds (scarlet lake, alizarin crimson, and permanent rose); and blues (ultramarine, cobalt, and manganese blues); plus phthalo green and burnt sienna.

Painting Tip. Since many of the sunset effects will have to be painted at just the right moment, make sure you have every color wet and in ample supply on your palette before you begin so you don't have to stop midway to squeeze out more paint!

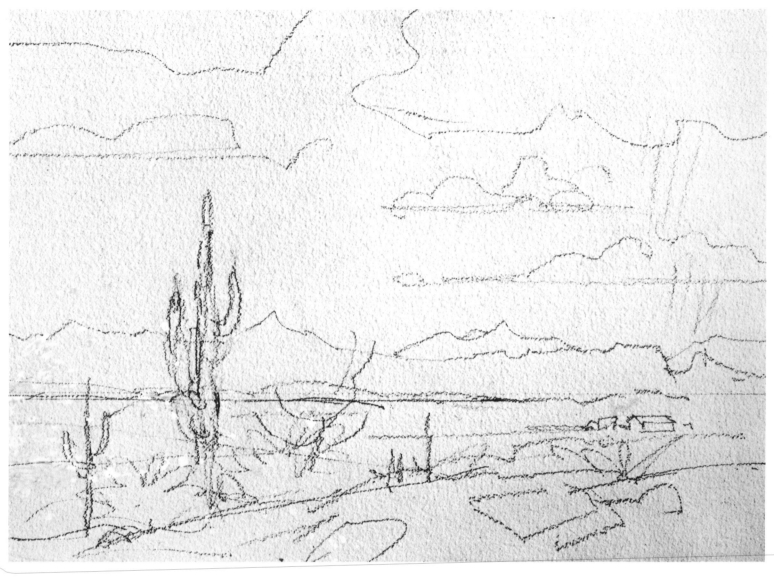

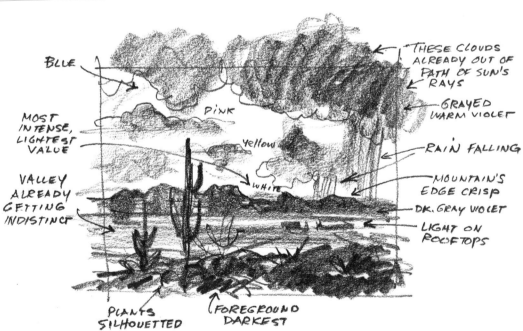

BLUE

MOST
INTENSE,
LIGHTEST
VALUE

VALLEY
ALREADY
GETTING
INDISTINCT

PINK

Yellow

WHITE

THESE CLOUDS
ALREADY OUT OF
PATH OF SUN'S
RAYS

GRAYED
WARM VIOLET

RAIN FALLING

MOUNTAIN'S
EDGE CRISP

DK. GRAY VIOLET

LIGHT ON
ROOFTOPS

PLANTS
SILHOUETTED

FOREGROUND
DARKEST

Step 1. My subject is right outside my studio door, so there's no problem in looking at it and getting my reference material firsthand (see study sketch below). Because the sunset scene is very busy, in planning my composition, I eliminate some of this potential confusion for a better painting. When I'm satisfied with the composition, I sketch it simply and directly onto my watercolor paper.

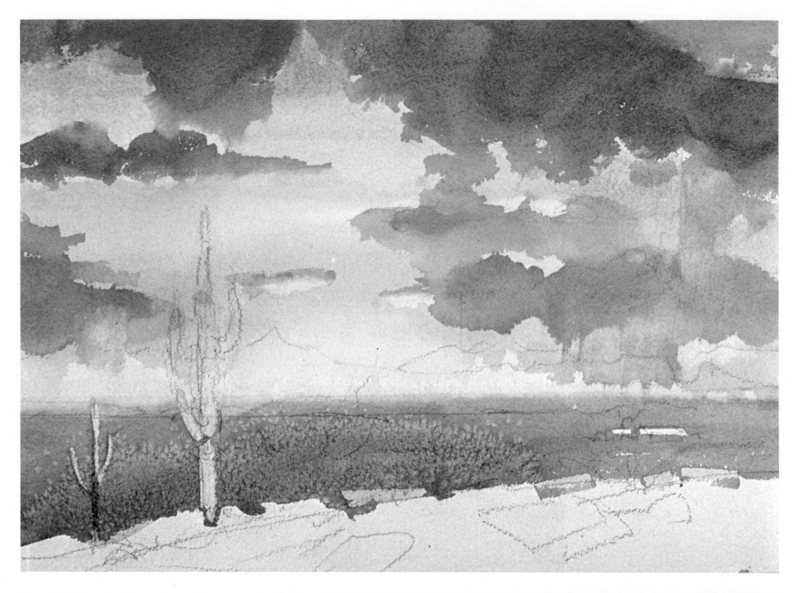

Step 2 (Above). I have everything ready—both my materials and the "plan of attack" in my mind—because much of the success, especially in the sky area, depends on sureness and timing. First, I wet the sky with my 1½" (4 cm) brush, and start painting across the top with manganese blue, mingled with cobalt blue. As I paint down, I gradually change to permanent rose, then (cleaning out my brush as I go along) to scarlet lake, then new gamboge, and finally to plain water on the nearly white paper just above the mountains at the center. Now I paint the middleground a mixture of phthalo green and manganese blue, grayed with permanent rose, knifing out the rooftops and cacti and sprinkling some salt on parts. Then I go back into the partially dried sky area, painting the upper clouds a grayed violet mixed with alizarin crimson, manganese blue, and a bit of burnt sienna; painting the middle clouds by adding scarlet lake and new gamboge to the mixture in varying proportions; and finally, painting the most intense hues in the little area just above the setting sun.

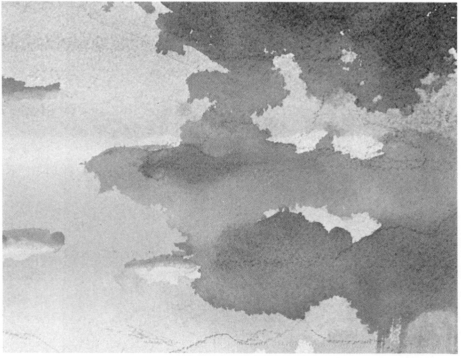

Step 2 (Detail). This shows how I lifted the whites out of a few clouds in the center to indicate the sun's rays shining directly on them.

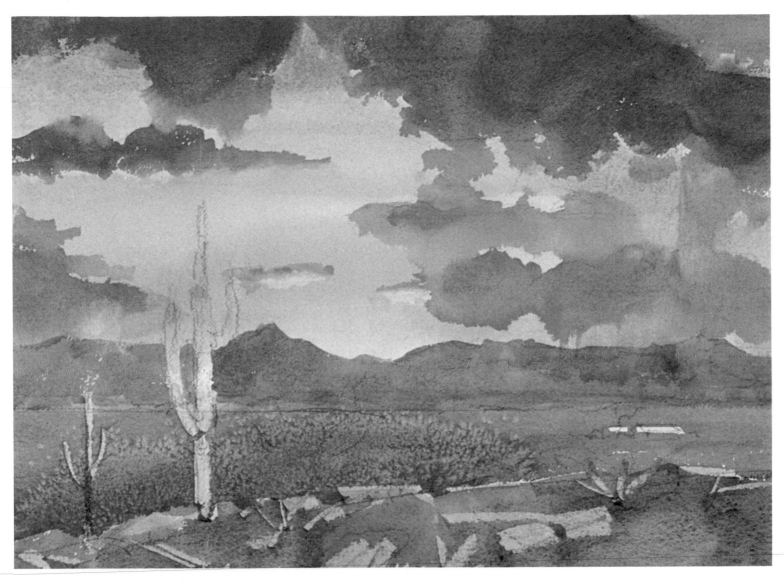

Step 3 (Above). I paint the distant mountains, using a slightly grayed wash of manganese blue and alizarin crimson, letting them meet and blend with the middleground. I paint around the large saguaro cactus, but knife out light areas from the wet wash to represent the smaller one. I also paint the underpainting in the foreground with burnt sienna, raw sienna, and some manganese blue in random patterns, knifing out some lighter areas there.

Step 3 (Detail). Here you can see the distant mountains. Note how they read as a middle value and as crisp edges against the sky.

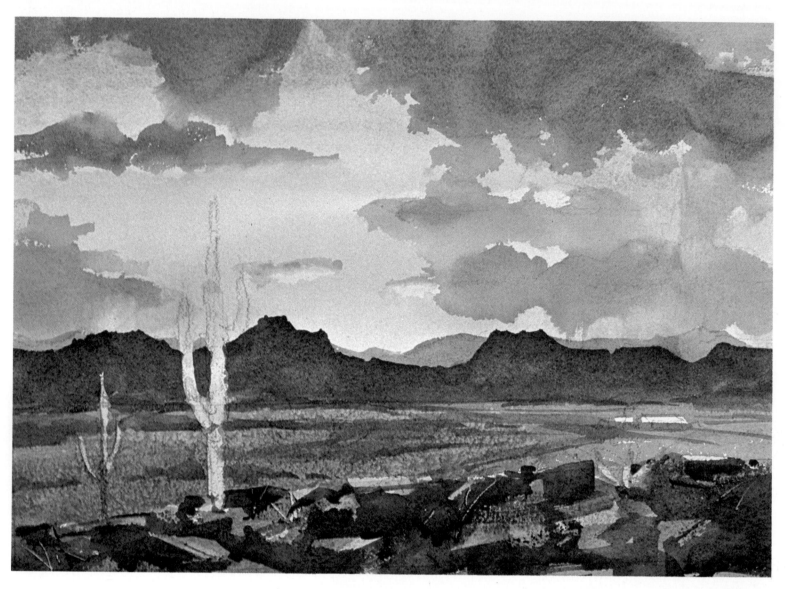

Step 4 (Above). When the distant mountains are dry, I paint the closer range a darker and warmer version of the distant ones, this time with alizarin crimson, manganese blue, ultramarine blue, and a bit of burnt sienna here and there. Where necessary, I paint right across the top edges of the distant mountains—the darker color covers them. Now I add more detail to the foreground, using dark values of rich mixtures of burnt sienna grayed with manganese blue and charged here and there with alizarin crimson and bits of phthalo green. After this, I add a feeling of the distant "lay of the land," creating perspective by dragging my almost-dry 1" (2.5 cm) brush appropriately across parts of the middleground.

Step 4 (Detail). This closeup gives you a good look at the difference in both value and color between the middle and distant mountains.

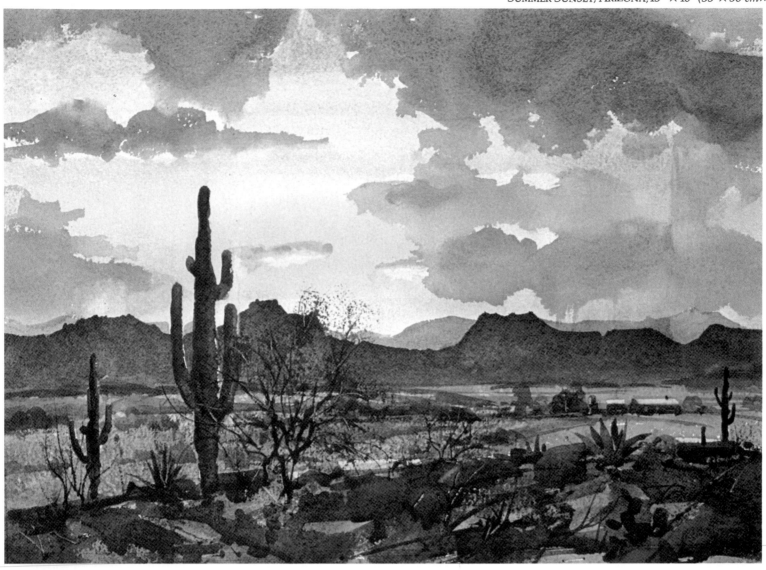

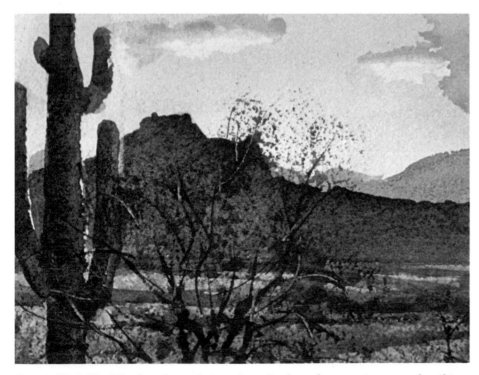

Step 5 (Above). The painting is already done insofar as its design and shape, value, and color relationships are concerned. All I need to add now are the final darks and details, and to "tune-up" a small relationship or two. I use my No. 8 round sable to paint in the giant cactus using a dark valued mix of ultramarine blue, and burnt and raw sienna, to make a grayed green. I let it read against the sky as a silhouette, thereby increasing the feeling of brilliance in the sky. The palo verde tree near the cactus is suggested by a very dry brushstroke done with my 1" (2.5 cm) brush by almost "patting" the brush's side on the paper. The small branches and twigs are rendered with a No. 6 rigger.

Step 5 (Detail). The brushwork just described can be seen in more detail in this closeup.

25

Dusk

To paint a watercolor that gives the "feeling" of dusk requires an examination and understanding of light and visibility at this rather magical time, right after sunset. Dusk is a visually deceptive and subtle time of day, since there's *some* light then, but not enough to see well.

After the sun goes over the horizon, all direct light and cast shadows are gone. For a brief time there's some light, but it's only the reflected light from the evening sky. As the light fades, shapes and forms become more blurred and vague, and details seem to disappear more and more. The atmosphere can acquire a mysterious quality. Try going outside some evening soon and observing for yourself this ever-increasing vagueness, graying of hue, and darkening of values as the night comes on.

The following observations of dusk might be useful to you when you're painting it: (1) Shapes and forms lose definition and become more blurred and indistinct. (2) Colors (hues) lose intensity (brilliance)—the lower the light, the less the intensity. (3) Values (lightness-to-darkness) become increasingly darker, and what were distinct value differences in stronger light now appear more nearly the same. (4) Adding something that is more defined, greater in intensity, and lighter in value to your painting (for example, a campfire, a lighted window, or a rising moon) can help make blurred, low-keyed passages in the painting even more effective through contrast!

I strive to use all these elements in this demonstration painting. The scene (in northern New Mexico) shows that the sun has just set and there's a glow in the western sky. The old adobe building is still fairly visible because of its lighter value, but the wagon, trees, fences, and both foreground and middleground are getting a little more difficult to see. The lantern-shine from the windows (well-defined, high-key color, light value) creates a good foil or contrast to all the other elements and enhances the feeling of dusk.

Brushes and Other Tools. I used a 1½" (4 cm) flat oxhair and a 1" flat sable to paint 90% of this watercolor. I also employed a No. 8 round red sable and used a No. 6 "rigger" (just a little bit!). You'll find more information on my brushes in the Materials and Equipment chapter. I also used a mat knife for scraping and a little salt for texture.

Paper. I used 140-lb Arches cold-pressed watercolor paper. It has enough "tooth" to help control really wet washes, but it's also smooth, to let the paint go on effortlessly. I'm not wed to any one paper, surface, weight—or brand, for that matter—but prefer to switch around, using different papers for different paintings.

Colors. Although I change the colors on my palette from time to time, I am always open to trying something new if it helps me, and I don't make a practice of setting different palettes for different paintings. Rather, I might use *more* of certain colors in one painting than others. For this demonstration I used mostly yellows (new gamboge and raw sienna); reds (alizarin crimson and permanent rose); and blues (ultramarine, cobalt, manganese, and phthalo). Burnt sienna and a little phthalo green completed my selection.

Painting Tip. Of course I worked on stretched paper (see Materials and Equipment chapter) and recommend that you do, too. To avoid the "mud" that can easily develop when you paint a painting with too many dark values, try to hit the hue and value the first time. Also, use simple mixtures—two colors will often do it—and stick with the more transparent colors.

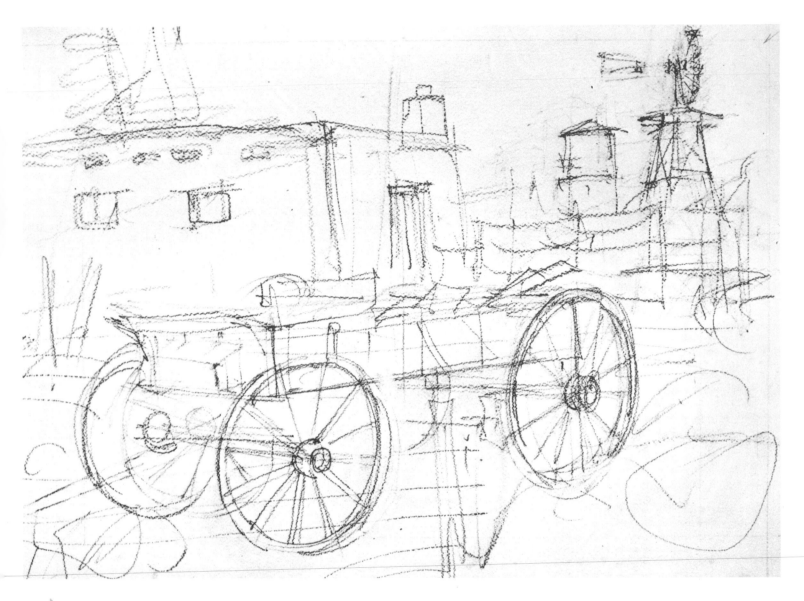

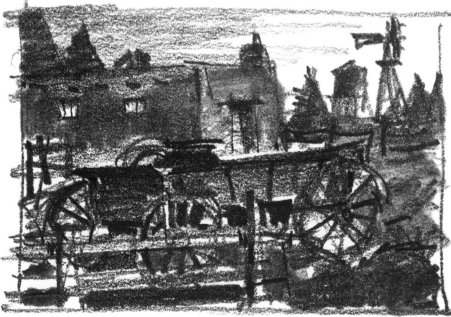

Step 1. With the composition and values pretty well established by doing the little scaled "thumbnail" study (left), I begin by making a pencil drawing on my stretched paper. I refer to my small thumbnail design and try for a close approximation of the same compositional elements on the larger watercolor paper. I pay attention to perspective, too, especially on the wagon's wheels (which are actually ellipses in perspective). I try to have the spokes correct, but not too well detailed or they could create a "target" or "bullseye" for the viewer. Normally, I use less pencil on the paper, so there'll be less graphite to contend with while painting and erase later, but here I apply the pencil dark enough to photograph and print in this book so you can see my drawing.

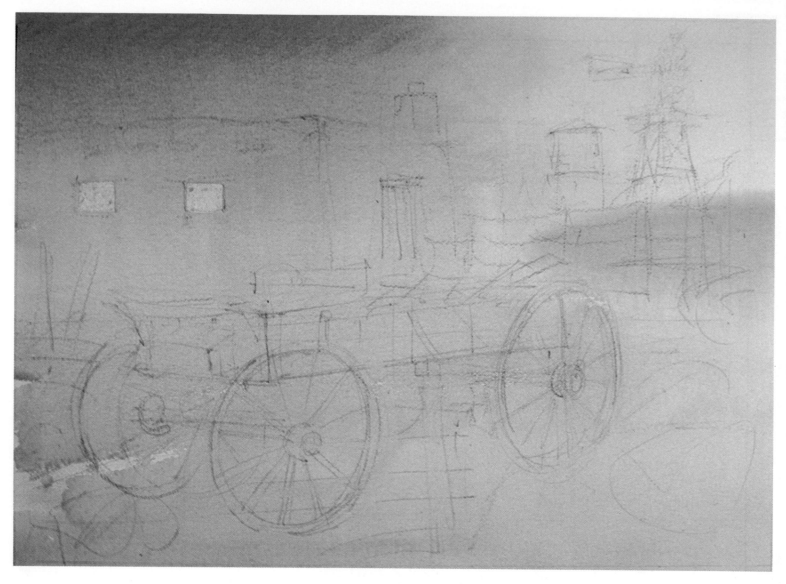

Step 2 (Above). First, I cover the windows with masking tape to save the white paper. Then, with my paper at a 45° angle, I quickly flood the entire sheet with clear water using my 1½″ (4 cm) flat brush. With this brush I paint new gamboge wet-in-wet onto the right-hand sky, then wash a violet mixture (ultramarine blue and permanent rose) onto the left-hand sky, allowing it to wash down over and across the building. With another brushload of a similar violet, I paint wet-in-wet across windmill and watertank bases. With the lower half of the paper still wet, I quickly wash in a diluted mixture of phthalo blue and phthalo green, using these pigments sparingly because of their staining potency.

Step 2 (Detail). Note the wet-in-wet blending of the warm and cool washes, and how areas can be painted across without spoiling future effects. In general, the less pigments are mixed together, the more they retain their individual identity and reflect purer color.

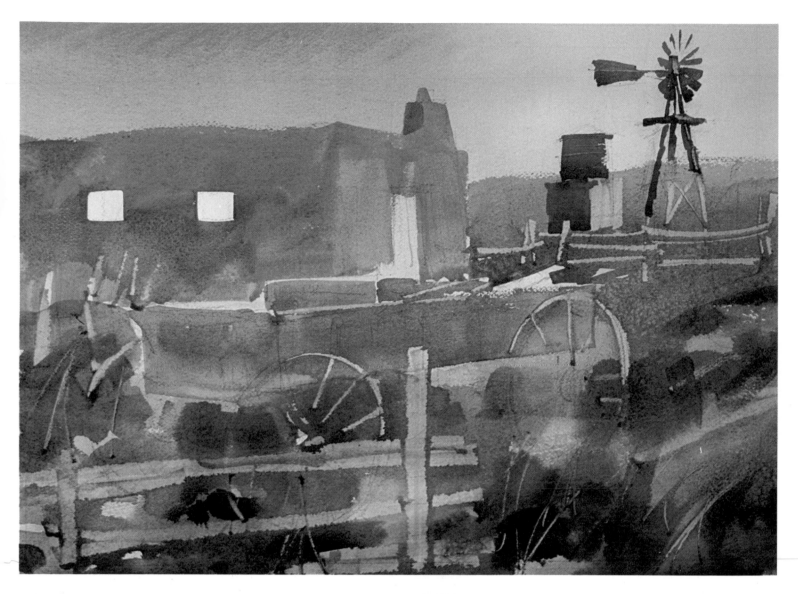

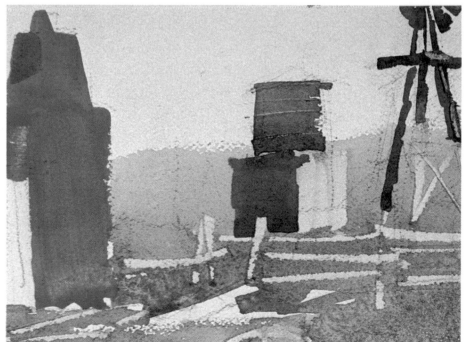

Step 3 (Detail). This shows the knifed out areas. To knife out color, I turn the knife's blade edge *away* from the direction of the stroke, squeegeeing out some of the pigment, but not gouging out the paper's surface. You can also see the salt textures quite clearly in this detail.

Step 3 (Above). On the dry paper I paint the building's shape, using raw sienna. I add a bit of its complement, a violet made of ultramarine blue and permanent rose, to its left-hand side, and while it's still wet, sprinkle in a dash of table salt. Salt has a way of "gathering" wet pigment and, when dry and brushed off, of leaving interesting textures. Next, after the painting is dry and the salt brushed off, I spray the foreground with an atomizer and immediately apply premixed washes of grayed phthalo green (with alizarin crimson added) and browns (burnt sienna and bits of ultramarine and cobalt blues), again adding salt to parts of it. The shapes blur appropriately. I work fast—if I wait too long after wetting the paper, I'd pick up the washes below it and get "mud." I start to define the wagon bed and, while it's still fairly wet, I paint the distant hills with ultramarine blue and permanent rose, allowing this to run down across the more distant fence as far as the wagon's rear wheel. A minute later, I knife out lights in the fences, wheels, water tank and windmill. After all this is dry, I paint in the windmill, watertank, and tower, then peel the tape off, exposing clean white paper.

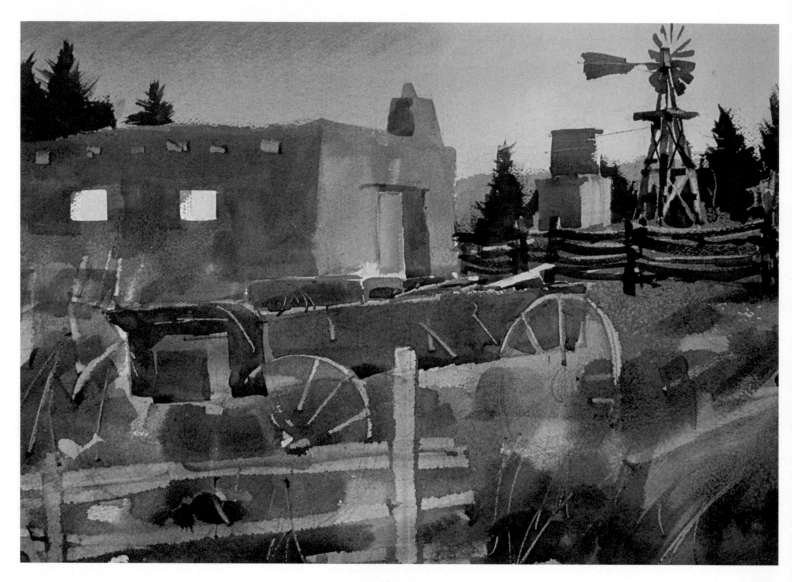

Step 4 (Above). With my 1½″ (4 cm) brush I further darken the left-hand side of the adobe building with a mixture of raw sienna and a bit of ultramarine blue, and then knife out the protruding rafters. The window openings get a wash of new gamboge and the door, manganese blue with a little burnt sienna. The juniper trees are next. To paint them, I use a dark grayed-green mixture of ultramarine blue, raw sienna, and a touch of burnt sienna, concerning myself mainly with their shapes and relationship to the rest of the painting. After this, I paint the mesquite fence in the background, and more of the structure of the windmill, using mixtures of burnt sienna, ultramarine blue, and alizarin crimson. The wagon gets another glaze of darkened cobalt blue, and the struts are scraped out while the wash is wet.

Step 4 (Detail). Here you can see my handling of the fence and juniper trees in more detail. Although darks are added, I still retain some of the lights I knifed out in Step 3. Also, note the rather "blocky" handling of the various elements, all painted with the 1½″ and 1″ (4 and 2.5 cm) flat brushes.

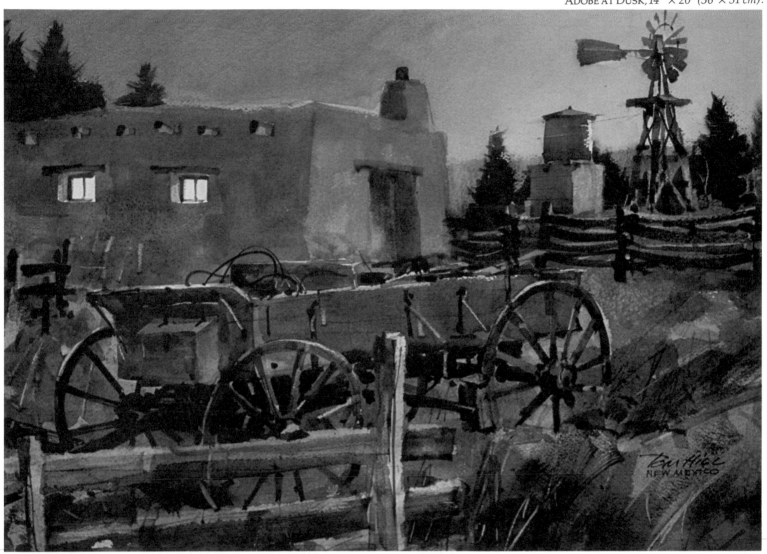

Step 5 (Detail). You can see the blurring of edges that seems to occur at dusk in this detail of the finished painting.

Step 5 (Above). Looking over the painting, I feel that it's now ready for final details and adjustments. With a mixture of burnt sienna, ultramarine blue, and a little alizarin crimson, I paint in the wooden windowframes and lintels, as well as the dark ends of the rafters above them. Next, with combinations of the same three colors, I paint the wheels and indicate the underside of the wagon. These darks help the previously painted areas under and around the wagon appear more transparent and luminous, and help establish the mysterious "glow" that occurs at twilight or dusk. Using a No. 6 rigger brush, I add calligraphic strokes to indicate details, like the coiled wire in the wagon, the hoop that holds the windmill's vanes in position, and the linear effect of some of the darker stems and stalks of the foliage in the foreground. Now I paint the detail in the foreground fence and add the finishing touches to the water tank and the wagon.

PROBLEM THREE
Night

Students often ask, "How do you paint *this*?" or "What's the secret for painting *that*?" Aside from being able to do basic drawing, composing, and watercolor technique, I'd say that if there's any "secret," it's in the artist's *understanding* of the subject or "feeling" prior to painting it! There's always different ways to interpret any subject, and the following demonstration shows just one way of interpreting "night."

What makes a night scene different from a day scene? It's the quality and quantity of light. If, as in some night-time situations, there's no light *at all*, then there's nothing to portray but blackness (absence of light). So, if you want your picture to say "night," there must be *some* light in it, though the amount of light can vary greatly—all the way from a few little stars to an extravaganza of light—and *still* say "night!"

For this demonstration, I decided to depict the brightly lit town square of the Mexican city of Oaxaca at night. The band is giving a concert, and the people are strolling or sitting and enjoying the scene and the music. It's a happy situation, and I try for that feeling, even by using fairly high-intensity color. The inside of the bandstand roof is well-lit and this light is cascading down on the musicians and the bandstand's base, and spilling out onto the sidewalks beyond. The surrounding buildings—the restaurants and shops still open for business—with their lighted arcades, are additional light sources. Street and park lamps add more light sources, all of which directly and indirectly light the walks, the tropical plants and foliage, and even the flowering jacaranda trees above.

In contrast to a daytime scene, with the sun as the only light source, here we have many light sources, each lighting its own area, and casting its own light and shadow pattern. In a scene such as this, the light(s) may often even cast shadows *upward*—a situation that doesn't occur in sunlight—helping to give the feeling of night.

So, in painting a night scene, you might want to consider these points: (1) Some light, however minimal, will help show that it's night. (2) Unlike the sun, which casts its light evenly over everything, the light(s) in a night scene usually lights only its immediate surroundings, and the resulting light-and-shadow patterns can be going in any direction, even up. (3) Night scenes can have more than one light source, while day scenes usually have just one—the sun. (4) In addition to light sources and their cast shadows, I think one of the most important things that can help a painting say "night" is the dark sky.

Brushes. Most of this painting was done with two brushes; a 1½" (4 cm) oxhair flat, and a 1" (2.5 cm) red sable flat. I did use a No. 8 round red sable, but very little and only as the painting was really just about completed. This No. 8 was useful "cutting in" the negative shapes of the sky, which helped reveal the foliage and branches of the trees. I also used it for little details such as those found in the bandstand and figures.

Paper. I used Arches 300-lb rough watercolor paper. It's about twice as thick as 140-lb paper and holds the water longer, which was useful for my initial wet-in-wet treatment.

Colors. I mainly used transparent colors, which gave me more clarity when glazing or when painting on top of a previously painted passage. I used yellows (new gamboge and raw sienna); reds (scarlet lake and permanent rose); and blues (manganese, cobalt, and ultramarine). The only other colors I employed were burnt sienna, phthalo green, and alizarin crimson.

Painting Tip. Even if I'm using 300-lb paper, I still stretch it. It's much easier to have everything under control then, especially during the wet-in-wet periods!

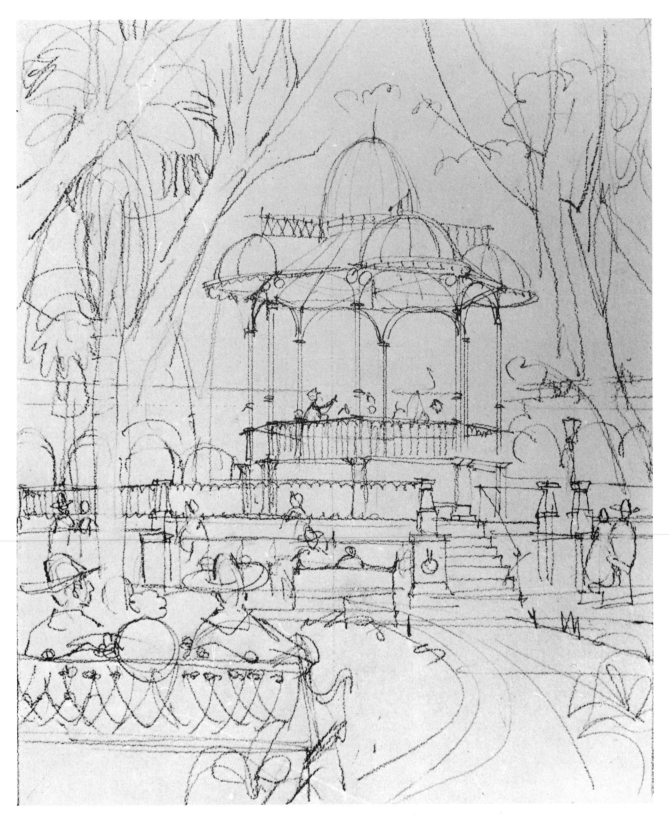

Step 1. Having sketched and painted on location in Oaxaca, Mexico, and possessing good reference material in sketches and slides, I feel rather confident that I can paint a demonstration of the subject, even with the added complication of portraying a night scene.

The bandstand (*quiosco de música*) in the center of Oaxaca's lovely town square (*zócalo*) is one of the most elaborate I've seen! A complicated, eight-sided, Victorian affair, it has multiple domes on its tin roof, ornate columns and filigree railings—and it stands two levels high. A true perspective problem for any artist! After my composition is determined, I solve the drawing and perspective problems on tracing paper, then transfer this sketch to my stretched watercolor paper.

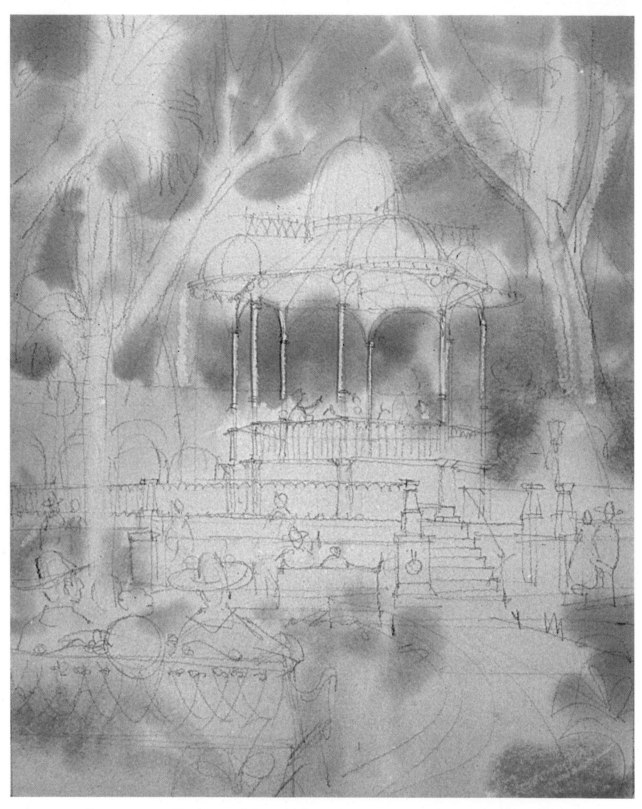

Step 2. I want the lost-and-found effects that occur at night, so I decide to start with the softness of a wet-in-wet technique. I soak the paper with clear water, checking to be sure that it's evenly wet. Holding my board horizontally, I quickly paint in the shapes of the sky, foliage, background, and foreground. The colors—phthalo green, new gamboge, manganese blue, cobalt blue, and permanent rose—are either tints or slightly grayed with their complements. The paper is wet and flat enough for the shapes to have soft, fuzzy edges, but not so wet or slanted as to have the paint run in any one direction or spread too far. Next, I knife out the columns and tree trunks.

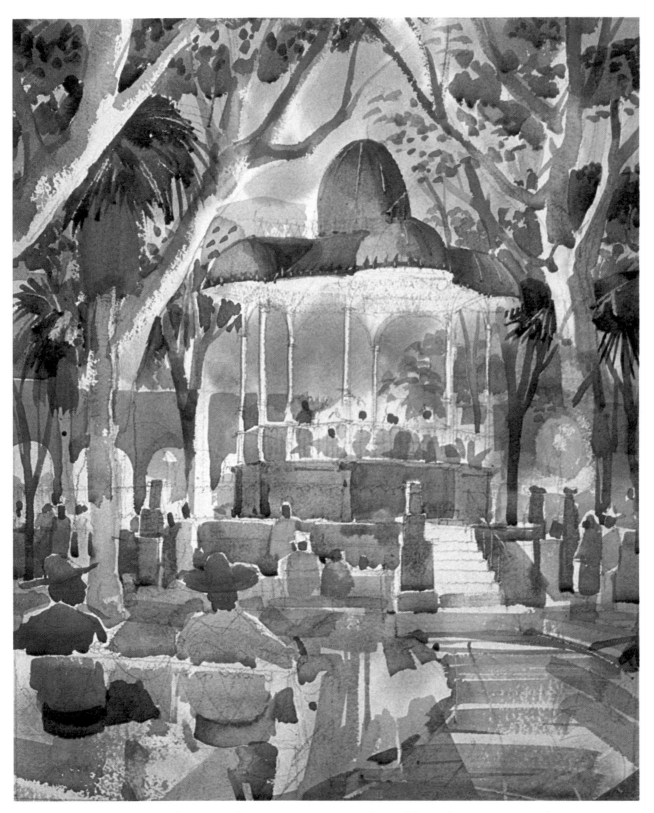

Step 3. With the paper dry, I paint in tree trunks and branches using my 1″ (2.5 cm) brush and mixtures of blue violet (manganese blue and permanent rose) and grayed yellow/orange (burnt and raw sienna with new gamboge). I add foliage using greens and yellow greens of varying intensities and values (new gamboge, phthalo green, burnt sienna, and manganese blue). I add more intense violet and orange dots to the previously painted violet of the blooming jacaranda trees. Now I paint in the basic shapes of figures in the middleground and foreground using a grayed blue violet, and add more figures in yellows, greens, and pinks, and paint the walkway at the lower right. The bases of the building and bandstand are painted as simple shapes in grayed yellow green (manganese blue, new gamboge, and raw sienna). The bandstand's roof is painted in two values of raw sienna, with shadows cast upward from the lights below.

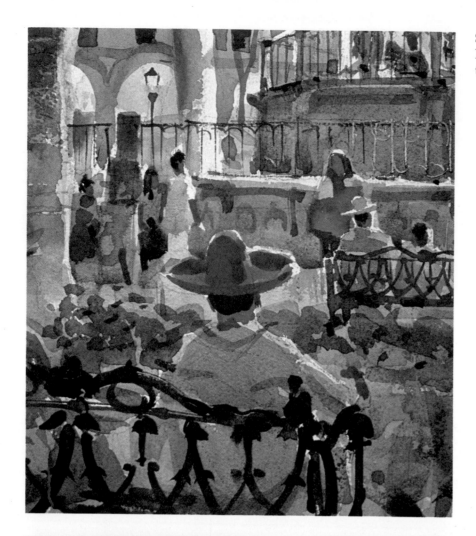

Step 4 (Detail). You can see in this closeup that I'm more concerned with "feeling" and design than I am with exact detail in my painting.

Step 4 (Detail). Here you can clearly see how I cut in the dark sky color around the trees and bandstand, helping increase the effect of night. I didn't use any mechanical means (such as tape or liquid frisket), but relied on my brush alone to get these effects.

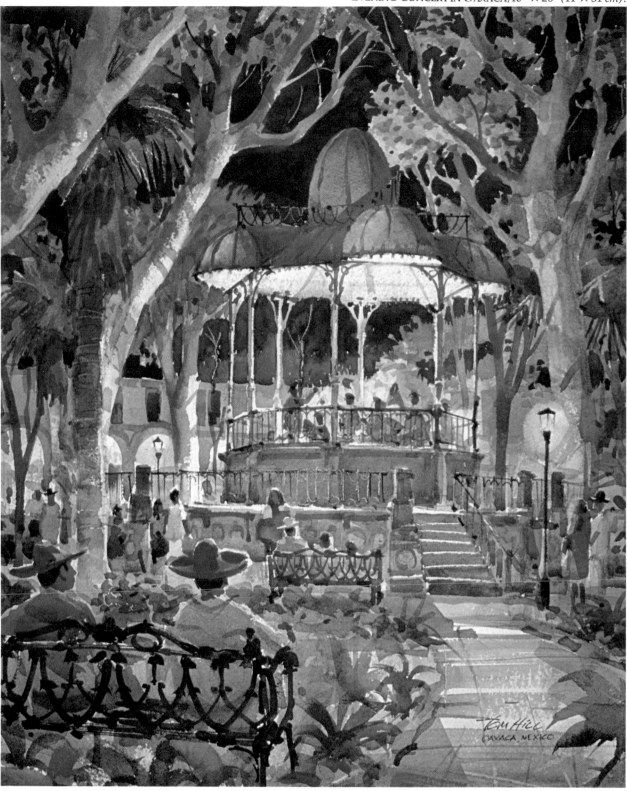

Step 4 (Right). Up to this point I haven't used many darks (necessary elements in painting "night"), but now I add them. Starting with the sky, and a very dark value of ultramarine blue, alizarin crimson, and burnt sienna, I paint around the trees and bandstand using my 1" (2.5 cm) flat and No. 8 round brushes. Next I paint the foreground plants and add the details and upward shadows in the trees above. The details and finishing touches are now added to the building and to the bandstand roof, base, columns, rails, steps, and so forth, as well as to the figures and benches. Most of this is done with my No. 8 round and No. 6 rigger brushes or is knifed out. What could be more romantic and paintable than Oaxaca's zócalo on a balmy spring evening?

Storm Clouds

A stormy sky with a feeling of light breaking through can be terribly exciting when experienced in real life and thus exciting to paint. But, like sunsets, this subject is shunned by some artists as "corny" or hackneyed.

Of course, the painting *can* be corny, but when properly designed and executed with good taste, the subject of storm clouds with light breaking through can be very exciting and capable of producing great "feeling" or mood.

Just as in painting sunsets, storms and everything associated with them can have an endless variety of possibilities. And as with nearly every subject you paint, seeing and experiencing the real thing will equip you far better to paint it with authority and mood. Years ago, I spent some time in Hawaii and experienced first hand some of the tropical squalls that pass through the islands. I have since experienced similar storms in the Caribbean, tropical Mexico, and Costa Rica, and this could be any of those or other places, too, but it happens that this demonstration painting is based on those early days in Hawaii.

When a squall (a rapidly moving storm) happens, its fast-moving clouds seem to change shape every minute; the wind comes in gusts and presses hard against everything in its path. Along the ocean's edge, spume and salt spray spatter in your face as you're pushed first this way, then that, by the wind. How exciting! As the weather front moves on through, the holes in the churning clouds become more frequent and you get an occasional glimpse of blue sky. One in a while, a shaft of sunlight will drive down through the ragged cloud holes, like some overwhelming celestial spotlight! Is this a "corny" painting subject? I guess that depends on who's painting it! All I know is that the actual event can be inspiring!

Here are a few points to consider when painting storm clouds: (1) As in painting sunsets, the chances are you're going to be faced with some editing. In other words, you'll have to take the wealth of material in front of you (as well as the jumble and chaos) and put it together in your painting in a way that will do the job! Don't be afraid to leave out material that won't help, even if it's right there in your view! At the same time, feel free to add or shift things around in favor of your painting! (2) Try to paint what you know personally, not what you saw in a film, on television, or in a magazine. If you get the (safe) opportunity, try going out in a storm and experiencing at least a little of it for yourself. The sketchbook, notebook, and camera are useful accessories here, too.

Brushes. By and large, my 1½" and 1" (4 and 2.5 cm) flats did it again. The Nos. 8 and 6 round sables and No. 6 rigger were used to finish up detail, but they didn't solve the big shapes or relationships.

Paper. This demonstration was done on Arches 140-lb, rough watercolor paper, which was first stretched.

Colors. I used yellows (new gamboge and raw sienna); reds (alizarin crimson and permanent rose); and blues (cobalt, ultramarine, and manganese); plus burnt sienna.

Painting Tip. As in painting sunsets, you'll have to move fast on some passages, so have plenty of moist paint ready, as well as your brushes, plenty of clean water, and anything else you'll need. That way you can spend all your time thinking about the painting process, without any distractions.

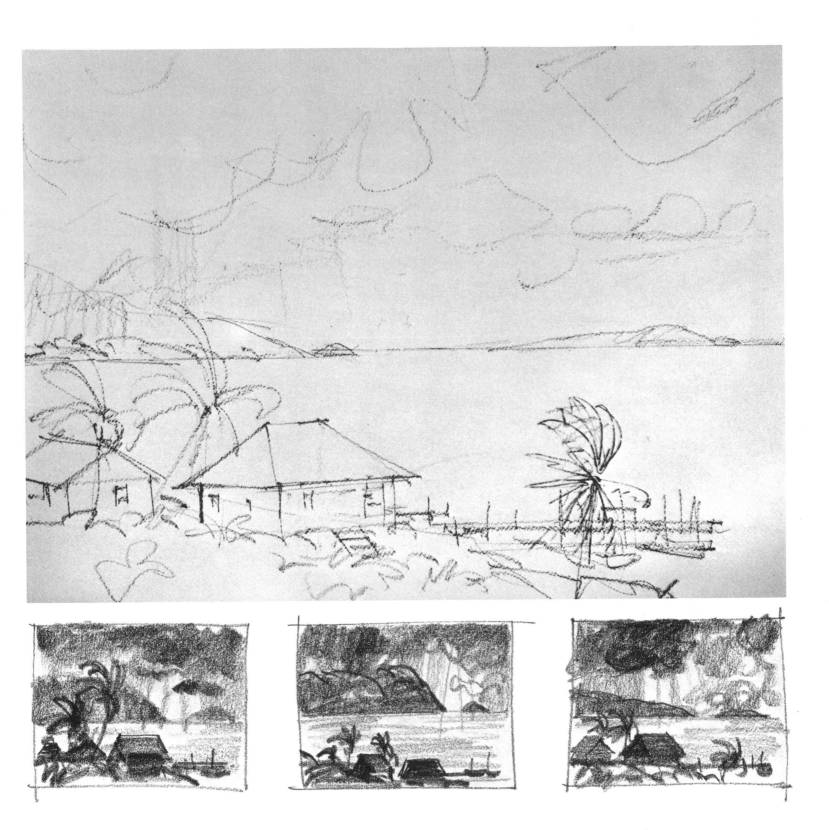

Step 1. As you can see from the little thumbnails below, I tried out several compositional arrangements before settling on the one I penciled in on my watercolor paper. I sketch the cloud shapes rather tentatively because I may be changing them as I paint if the compositional need becomes evident.

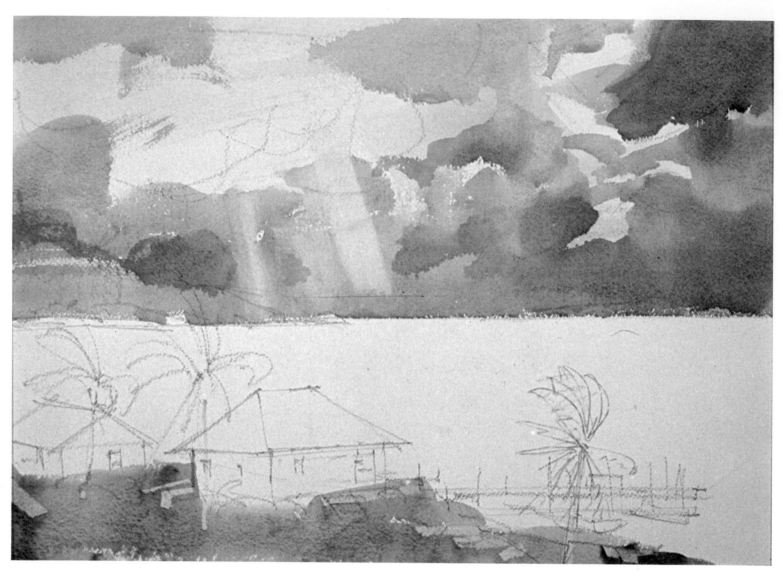

Step 2 (Above). Wetting the sky in the area just above the horizon, I use my 1″ (2.5 cm) brush to wash in a grayed violet mixture of alizarin crimson, cobalt blue, and a touch of raw sienna. This is allowed to bleed upward into the wet paper, but stays hard-edged above the horizon. Next, I paint distant blue sky in patches with a mixture of manganese and cobalt blues, letting parts of this run down and blend with the grayed violet below. As this dries, I paint in the middle and background cloud shapes, varying their grays from warm to cool and light to dark. After cleaning my brush and squeezing it out, I pick up—or "mop out"—the light shafts while the area is still wet. All of this takes careful timing! The foreground is painted with manganese blue and a little raw sienna charged into certain areas, and some light areas are knifed out.

Step 2 (Detail). This closeup shows the "mop out" of the shafts of light in detail.

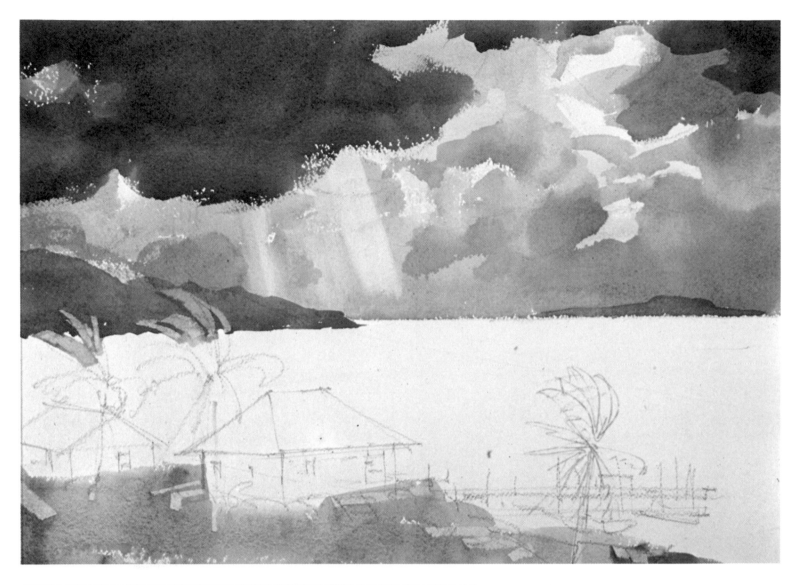

Step 3 (Above). I now mix a dark-valued wash of alizarin crimson, ultramarine blue, and a bit of burnt sienna and paint the closer, darkest clouds by applying the paint directly and quickly with my 1" (2.5 cm) brush. I pay close attention to how these cloud shapes relate to the other shapes around them, and modify them as I go in favor of the movement and composition of my painting. I let my brush drag along the bottom of the biggest cloud, producing "skippers" of white specks in the paper, and I pull my brushstrokes up and to the left to indicate cloud movement and wind direction. After this, I paint the distant land masses using a mixture of cobalt blue and raw sienna with a hint of permanent rose, knifing out the future palm fronds where necessary.

Step 3 (Detail). You can clearly see here the painting technique I used on the dark cloud, including the dragged bottom edge, the brush movements to the left, and the knifed-out palm fronds.

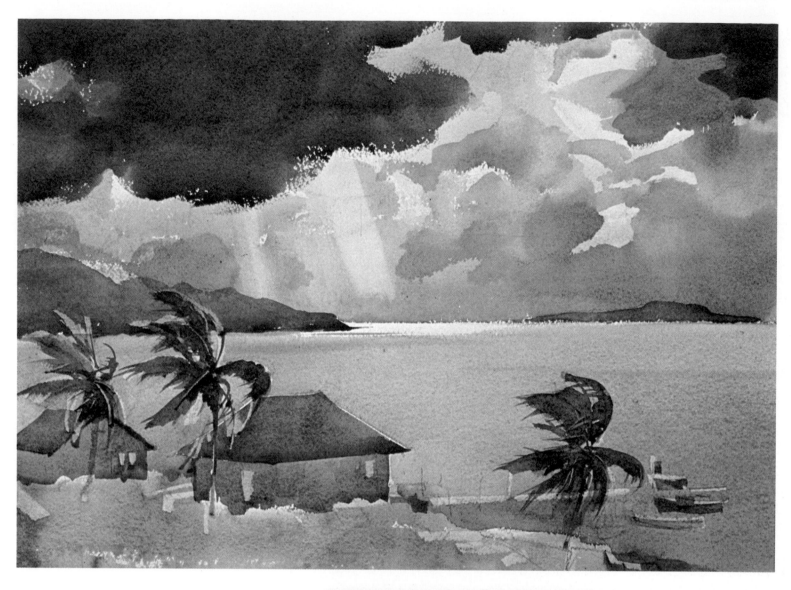

Step 4 (Above). Using my 1½″ (4 cm) flat brush and a mixture of manganese and cobalt blue, with some raw sienna in areas, I paint in the ocean, cutting around the houses and leaving white paper for the light on the water. While this is wet, I knife out the dock and boat shapes. As soon as the ocean area is dry, I paint the houses, making them dark enough to read as near silhouettes against the ocean. The roofs are a grayed violet, and the walls, a grayed blue. The palm fronds are painted with Nos. 6 and 8 round sables, noting the wind direction and the character of the fronds. Since I've painted many palms, I have a good idea of their structure. But if you've never painted them, you might want to make studies of them before you tackle a subject like this.

Step 4 (Detail). The light on the water, indicated by the pure white paper, is evident here, as are the details of the palm fronds.

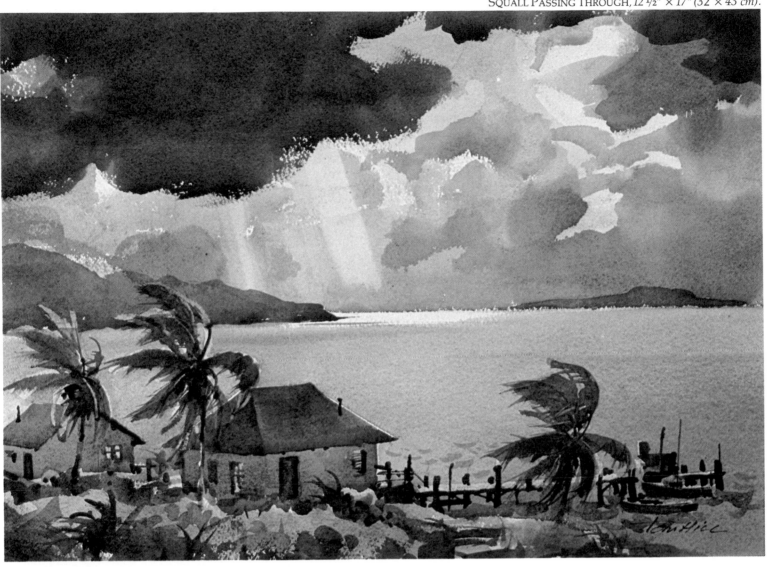

Step 5 (Above). Now I darken the roof of the center house, and indicate windows and doors. More palm details and foreground shrubbery and textures are added, most of this with the 1" (2.5 cm) flat and No. 8 round brushes. After this, I add the darks on the dock and boats with the No. 6 round and a touch of the rigger.

Step 5 (Detail). Note how only two light shafts are needed to express the feeling of light—three or more would have been too much!

PROBLEM FIVE

Fog

There's magic and mystery in fog. Horizons disappear, as do details. Colors are flattened and reduced in intensity. Familiar objects become strange and unfamiliar, reduced to shapes. Even sounds seem somewhat muffled and directionless. Fog is a favorite subject for watercolor painters, and watercolor is a favorite medium with which to paint its effect!

What do we need to know about fog situations so we can be "in charge" when we paint them? First of all, let's find out what fog *is*, so we'll know what to look for when we paint it. My dictionary defines "fog" as "vapor condensed to fine particles of water suspended in the lower atmosphere that differs from clouds only in being near the ground." Well, any particles hanging in the air, whether they're water droplets, smoke, bits of dust, or combinations like smog, have one thing in common: They cut down the visibility—our ability to see both distance and detail clearly. You can almost think of these particles as veils hanging between you and what you're looking at. The greater the distance, the more veils, and the less you can see!

My painting for this problem is a scene along the coast of northern California. Like parts of Oregon's coast, this area consists of cliffs that have been eroded by the constant action of the ocean. In the process of erosion, great monolithic chunks of harder rock that doesn't wear as rapidly stand alone on the beaches and in the shallow water, creating dramatic shapes that contrast with the smooth sand beaches in between. In the summer, the land gets warm; but the ocean current is cold. So nearly every summer morning, the clashing temperatures meet and create a lovely fog—just the thing for our watercolor problem! And fog isn't necessarily cold, gray,

and menacing, like the fogs so often described in some old English mysteries. It can often be pleasant, and even warm-hued, with the inherent promise that soon the sun will burn through and blaze away on the rocks and sand in brilliant splendor!

I think that it's probably easier to paint fog than many of the other problems we've been discussing, for there seem to be more constants and fewer variables. Here are some "rules" to keep in mind: (1) There's probably *no* horizon line visible. (2) Except in the foreground, detail is largely eliminated. (3) In daytime fog, values get lighter and colors become flatter and less intense. (4) In daytime fog, the sky is lighter and brighter overhead than near the (invisible) horizon. This is the opposite of a normal daytime sky. (5) Though detail is at a minimum, *outlines* of objects seem to stay crisp and defined even when they're a very light value.

Brushes. I used my 1½" and 1" (4 and 2.5 cm) flats for nearly all this painting. The rounds and riggers helped define details in the last stages.

Paper. I painted this demonstration on stretched, 140-lb, cold-pressed Arches watercolor paper.

Colors. My yellow was new gamboge; my red, permanent rose; and my blues, cobalt, manganese, and ultramarine. I also used raw and burnt sienna.

Painting Tip. Try painting with only three, at most four, principal values, working from the lightest to the darkest. You will be doing a lot of glazing, that is, letting a wash dry and then painting the next (darker) one on top of it.

Step 1. Although I painted this in my studio so that it could be photographed in progress, I recommend that you try painting fog on location. It's exciting and you'll see first hand all the things we're discussing here. When I first made the study for this painting, I was on the cliffs, perhaps 100 feet above the beach and ocean, so, looking down and out seemed to call for a vertical composition. The fog that morning wasn't as thick as some that I've seen, and I was able to make out cliffs and rocks at the other end of the beach, perhaps a city block or two away. In this first step, I pencil the main elements and shapes as simply as possible onto my paper.

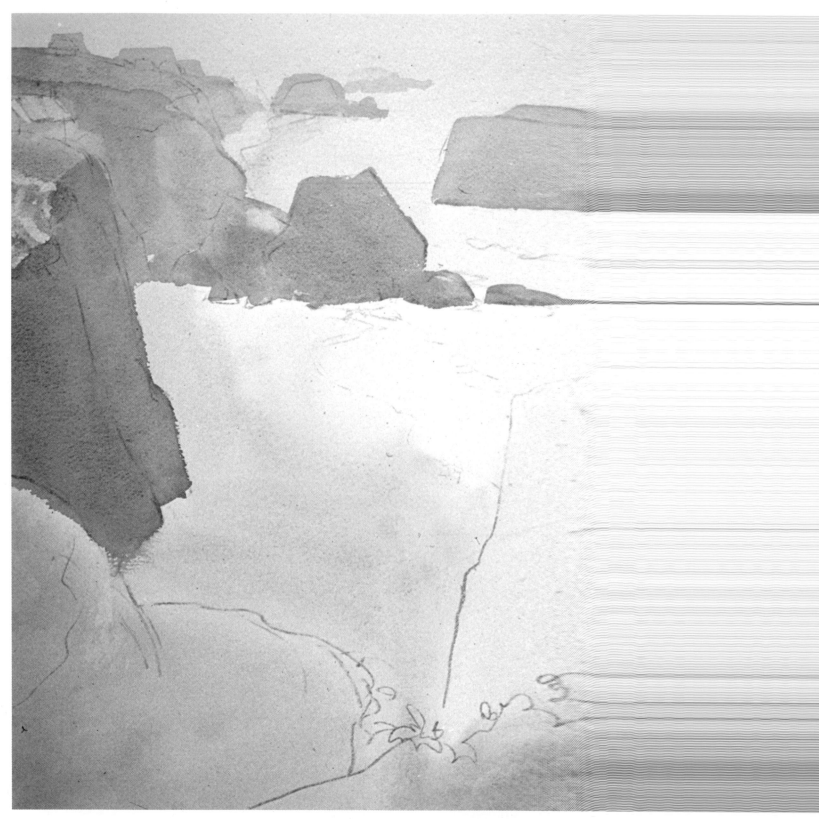

Step 2. I wet the entire paper with clear water. After it's soaked in and is no longer *running* wet, I use my 1½" (4 cm) flat brush to paint in a light-value mixture of phthalo and manganese blues, clear across the top of the paper and down the right-hand side. I immediately paint in another light-value wash of permanent rose and burnt sienna, using a clean brush, to represent the beach area. The lower part of the paper gets a wet-in-wet raw sienna wash for the foreground cliffs. After the paper is dry, I paint the distant and middleground rocks and cliffs, using varying mixtures of manganese blue and permanent rose grayed slightly with bits of burnt sienna. Note that the more distant elements are lighter in value and cooler in hue; the closer ones are a bit darker in value and warmer in hue. I knife out a light value or two on the top of the middleground cliff and also the little beach house that's sitting on it.

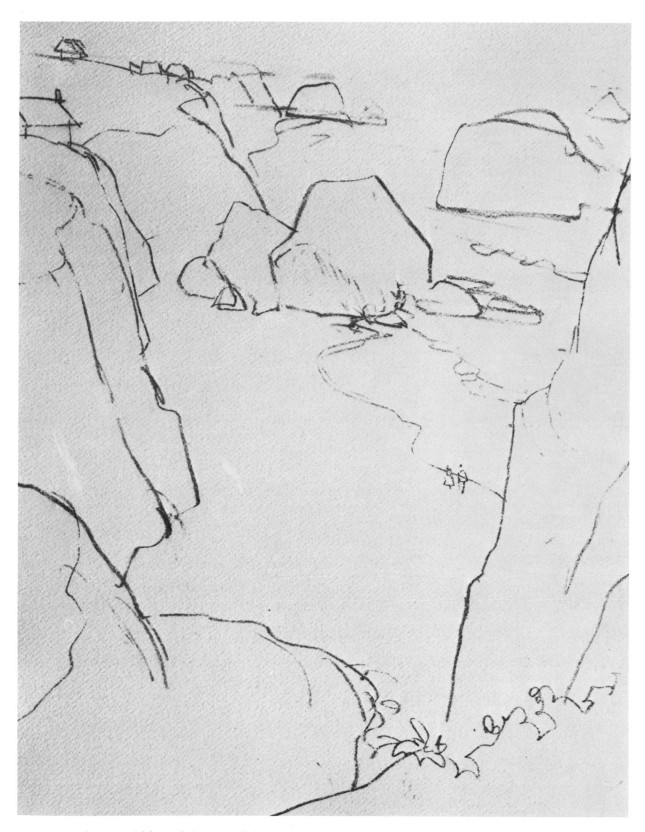

Step 1. Although I painted this in my studio so that it could be photographed in progress, I recommend that you try painting fog on location. It's exciting and you'll see first hand all the things we're discussing here. When I first made the study for this painting, I was on the cliffs, perhaps 100 feet above the beach and ocean, so, looking down and out seemed to call for a vertical composition. The fog that morning wasn't as thick as some that I've seen, and I was able to make out cliffs and rocks at the other end of the beach, perhaps a city block or two away. In this first step, I pencil the main elements and shapes as simply as possible onto my paper.

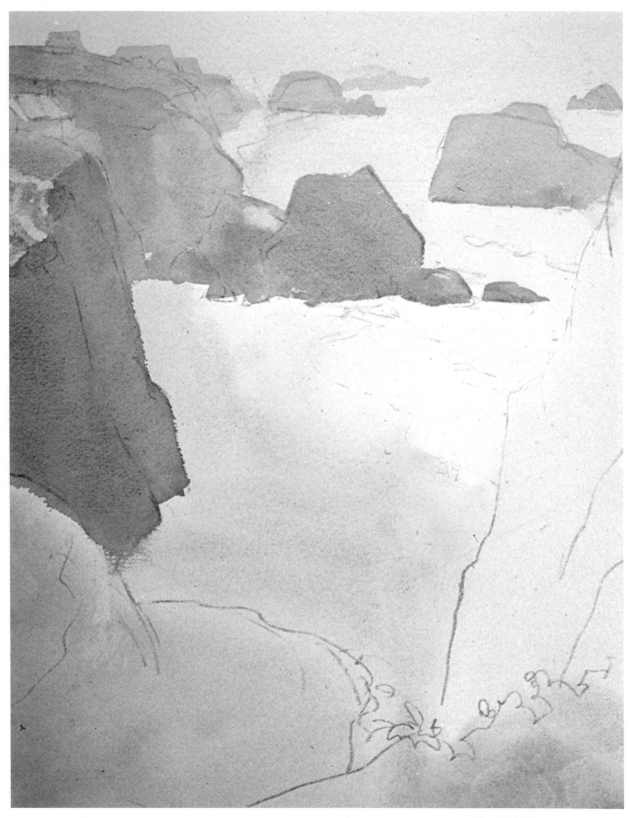

Step 2. I wet the entire paper with clear water. After it's soaked in and is no longer *running* wet, I use my 1½" (4 cm) flat brush to paint in a light-value mixture of phthalo and manganese blues, clear across the top of the paper and down the right-hand side. I immediately paint in another light-value wash of permanent rose and burnt sienna, using a clean brush, to represent the beach area. The lower part of the paper gets a wet-in-wet raw sienna wash for the foreground cliffs. After the paper is dry, I paint the distant and middleground rocks and cliffs, using varying mixtures of manganese blue and permanent rose, grayed slightly with bits of burnt sienna. Note that the more distant elements are lighter in value and cooler in hue; the closer ones are a bit darker in value and warmer in hue. I knife out a light value or two on the top of the middleground cliff and also the little beach house that's sitting on it.

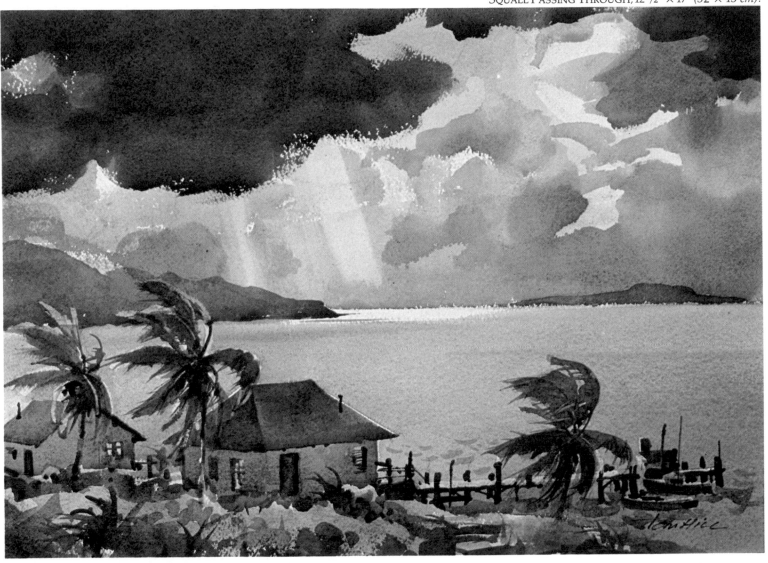

Step 5 (Above). Now I darken the roof of the center house, and indicate windows a d doors. More palm details and foreground shrubbery and textures are added, most of this with the 1″ (2.5 cm) flat and No. 8 round brushes. After this, I add the darks on the dock and boats with the No. 6 round and a touch of the rigger.

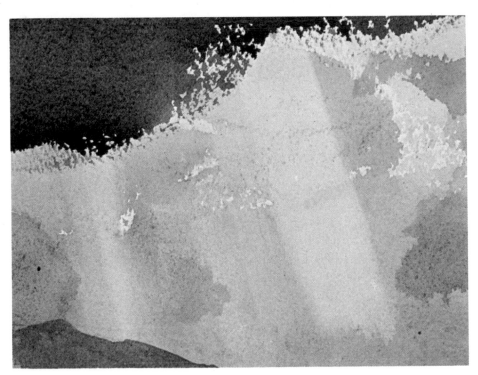

Step 5 (Detail). Note how only two light shafts are needed to express the feeling of light—three or more would have been too much!

PROBLEM FIVE

Fog

There's magic and mystery in fog. Horizons disappear, as do details. Colors are flattened and reduced in intensity. Familiar objects become strange and unfamiliar, reduced to shapes. Even sounds seem somewhat muffled and directionless. Fog is a favorite subject for watercolor painters, and watercolor is a favorite medium with which to paint its effect!

What do we need to know about fog situations so we can be "in charge" when we paint them? First of all, let's find out what fog *is*, so we'll know what to look for when we paint it. My dictionary defines "fog" as "vapor condensed to fine particles of water suspended in the lower atmosphere that differs from clouds only in being near the ground." Well, any particles hanging in the air, whether they're water droplets, smoke, bits of dust, or combinations like smog, have one thing in common: They cut down the visibility—our ability to see both distance and detail clearly. You can almost think of these particles as veils hanging between you and what you're looking at. The greater the distance, the more veils, and the less you can see!

My painting for this problem is a scene along the coast of northern California. Like parts of Oregon's coast, this area consists of cliffs that have been eroded by the constant action of the ocean. In the process of erosion, great monolithic chunks of harder rock that doesn't wear as rapidly stand alone on the beaches and in the shallow water, creating dramatic shapes that contrast with the smooth sand beaches in between. In the summer, the land gets warm; but the ocean current is cold. So nearly every summer morning, the clashing temperatures meet and create a lovely fog—just the thing for our watercolor problem! And fog isn't necessarily cold, gray,

and menacing, like the fogs so often described in some old English mysteries. It can often be pleasant, and even warm-hued, with the inherent promise that soon the sun will burn through and blaze away on the rocks and sand in brilliant splendor!

I think that it's probably easier to paint fog than many of the other problems we've been discussing, for there seem to be more constants and fewer variables. Here are some "rules" to keep in mind: (1) There's probably *no* horizon line visible. (2) Except in the foreground, detail is largely eliminated. (3) In daytime fog, values get lighter and colors become flatter and less intense. (4) In daytime fog, the sky is lighter and brighter overhead than near the (invisible) horizon. This is the opposite of a normal daytime sky. (5) Though detail is at a minimum, *outlines* of objects seem to stay crisp and defined even when they're a very light value.

Brushes. I used my 1½" and 1" (4 and 2.5 cm) flats for nearly all this painting. The rounds and riggers helped define details in the last stages.

Paper. I painted this demonstration on stretched, 140-lb, cold-pressed Arches watercolor paper.

Colors. My yellow was new gamboge; my red, permanent rose; and my blues, cobalt, manganese, and ultramarine. I also used raw and burnt sienna.

Painting Tip. Try painting with only three, at most four, principal values, working from the lightest to the darkest. You will be doing a lot of glazing, that is, letting a wash dry and then painting the next (darker) one on top of it.

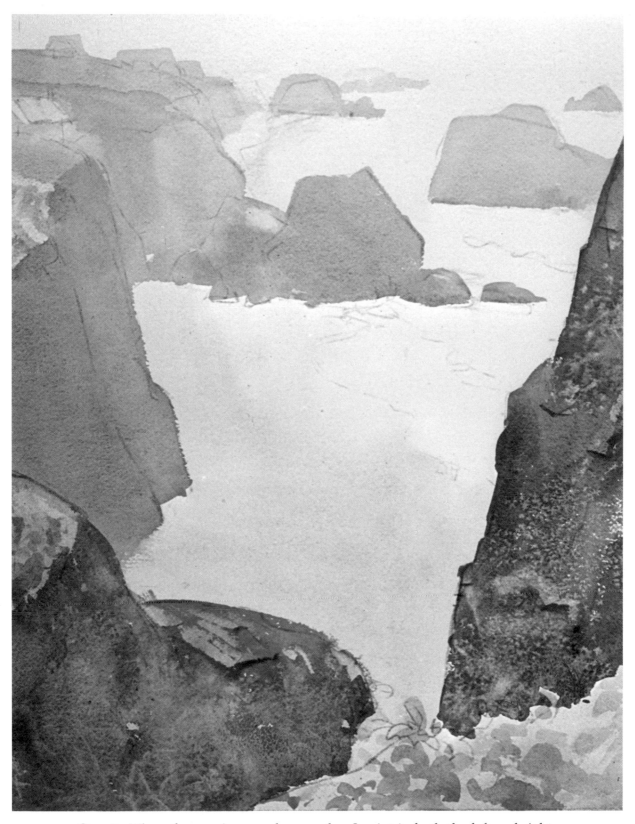

Step 3. When the previous washes are dry, I paint in both the left and right-hand foreground cliffs, making one warm and the other cool. I use my 1" (2.5 cm) brush and mixtures of raw sienna, burnt sienna, permanent rose, manganese blue, and even touches of ultramarine blue. These colors aren't all mixed *together*, so much as added independently into various areas and allowed to blend and mingle while often keeping a lot of their individual, original hues. While wet, I knife out some areas to add texture, to indicate light direction, and to play lighter values against darker ones. I also sprinkle salt in some areas for added texture on the sandy cliff. I underpaint the succulent plants growing in the closest foreground, using a mixture of manganese blue and raw sienna.

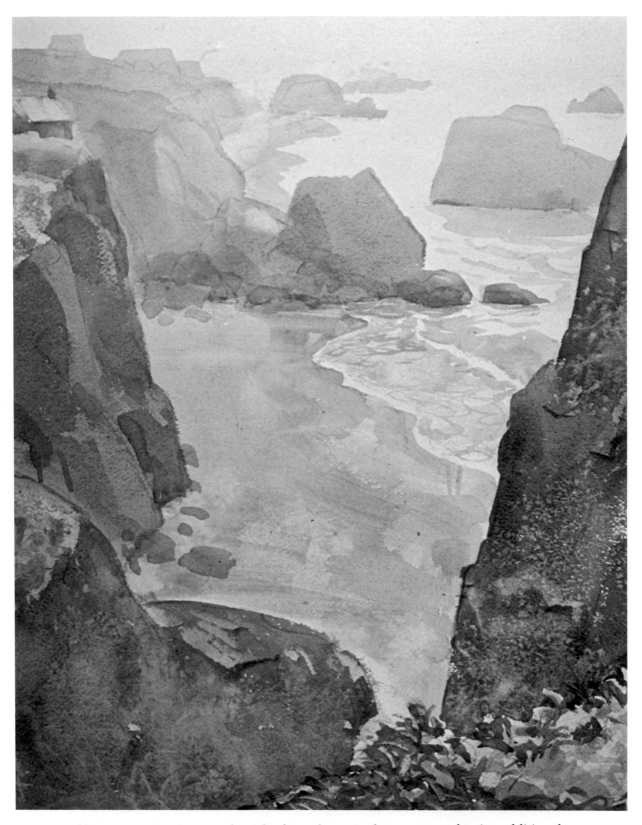

Step 4. I erase the pencil marks from the now-dry paper, and paint additional faces or shapes on the cliffs and rocks, using slightly darker versions of their original color, and making sure that my values continue to get lighter as they go back in distance. More values are also painted on the little beach houses. After this, I paint the wet sand with my 1″ (2.5 cm) flat brush and a mixture of permanent rose and cobalt blue. Next I paint the ocean waves and the reflections of the rocks in them, using my No. 8 round sable and a light-value wash of slightly grayed cobalt blue, then elaborating the swirling surf area with some raw sienna, using a No. 6 rigger. I now add more darks and some detail to the plants in the foreground.

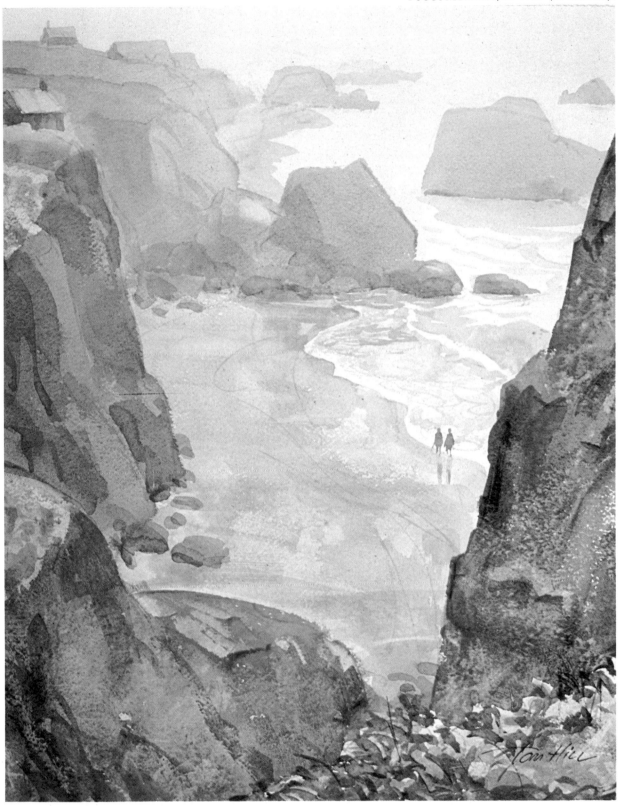

Step 5. About all that's left is to add the little figures on the beach and their reflections. They give both life and scale to my watercolor. A few more darks and a small detail or two, and the painting is done!

PROBLEM SIX
Foliage

I know I've said it before, but it bears repeating here—there's always more than one way to paint anything, and this demonstration, like the others in this book, shows only one way.

In thinking about how I might compose a painting that would show you several types of foliage, I recalled a trip I took recently into Colorado and Wyoming. There were interesting mixtures of both large and small deciduous trees and shrubs there, as well as several species of evergreens. So this painting shows an area of the Wind River section of Wyoming, though it could easily be taken for a number of other areas in the country. A small river, not much wider than a stream, winds through the valley. There, grasses and shrubs are plentiful, and typical deciduous trees, as well as some spruce, line the stream's path. A rancher inspects his property on a late summer morning. The mountains in the distance form a perfect color complement to the foliage and stream.

The most important part in painting anything is to begin with knowledge and understanding of your subject. Since I, for one, can't paint something that I haven't seen, let's begin with seeing. There are books on trees and shrubs, together with photographs and drawings—and these are helpful (there are even books on how to paint trees in watercolor!). But to really know what you're doing, I can't think of a better way than to get right out and have a drawing and painting "encounter" with the real thing! If possible, draw and paint the actual foliage you plan to use until you feel well acquainted with it, before painting it in your finished painting.

The following points might be helpful: (1) Begin by looking at and analyzing what you see. One of the best ways for me, regardless of the kind of foliage I'm painting, is to look for the subject's silhouette and its character or "gesture." As an example, an oak tree's silhouette will probably be rounded, its heavy trunk and gnarled limbs showing through clumps of leaves adding gesture. An alpine spruce, on the other hand, offers an entirely different silhouette and gesture. Its vertical, thin triangle points skyward, and its limbs, when they show through the thick masses of dark green needles, are often rather thin and angular, sticking straight away from the single, rigid trunk. (2) Approach the actual painting process by asking yourself, "What's the simplest, most basic way I can paint this subject?" Then paint it in the broadest and most direct manner you can, first by establishing its silhouette and gesture, then by worrying about the number of leaves to be delineated, bark texture, and so forth—these details are really of minor importance!

Brushes. I used my 1½" and 1" (4 and 2.5 cm) flats, a No. 8 round red sable, and my No. 6 rigger.

Paper. I worked on a stretched, rough surface of 140-lb Arches watercolor paper.

Colors. For my yellows I used Winsor yellow and new gamboge; for reds, permanent rose and scarlet lake; and my blues were manganese, cobalt, and ultramarine. Burnt sienna and raw sienna were my earth colors.

Painting Tip. Foliage is a rather broad term, and rendering any or all of it in watercolor offers you *many* technical possibilities. Wet-in-wet, drybrush, spatter and salt, stamping and sponging, even jabbing away like a Pointilist—all these methods can be useful. Just be sure you have your basics right and that *you*, and not some technique, are in charge of the painting!

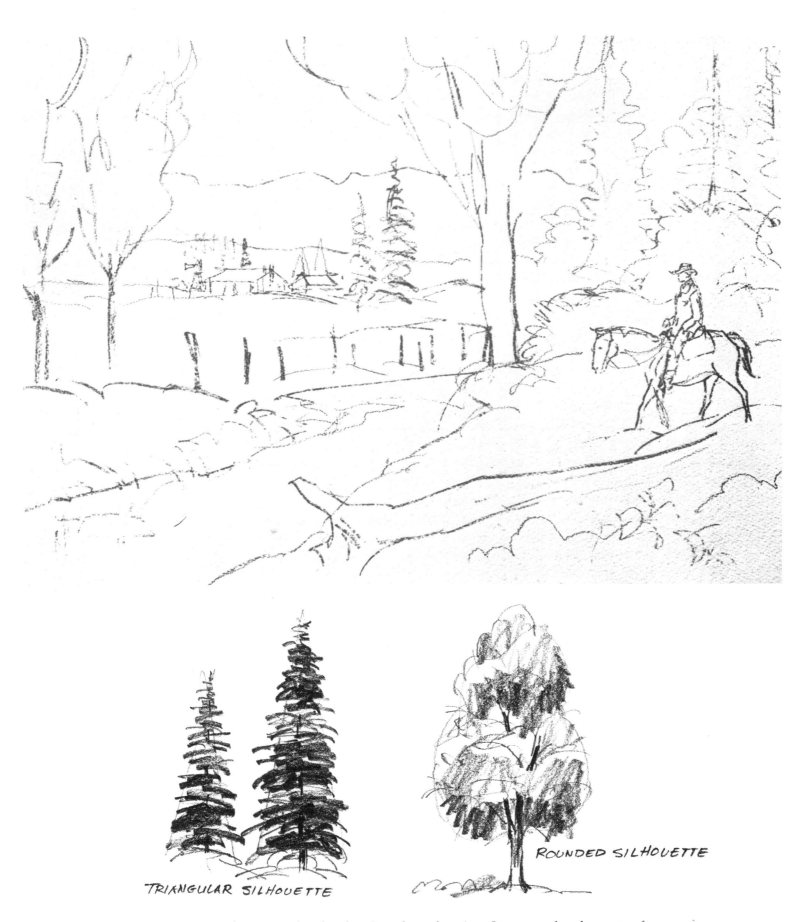

TRIANGULAR SILHOUETTE

ROUNDED SILHOUETTE

Step 1. Referring to the sketches I made on location, I arrange the elements of the painting to the best of my ability to show the subject of foliage. The scene I depict isn't exact, but is a combination of several scenes. When the thumbnail seems solved to my liking in terms of values and composition, I enlarge it by eye to this pencil sketch on my stretched watercolor paper.

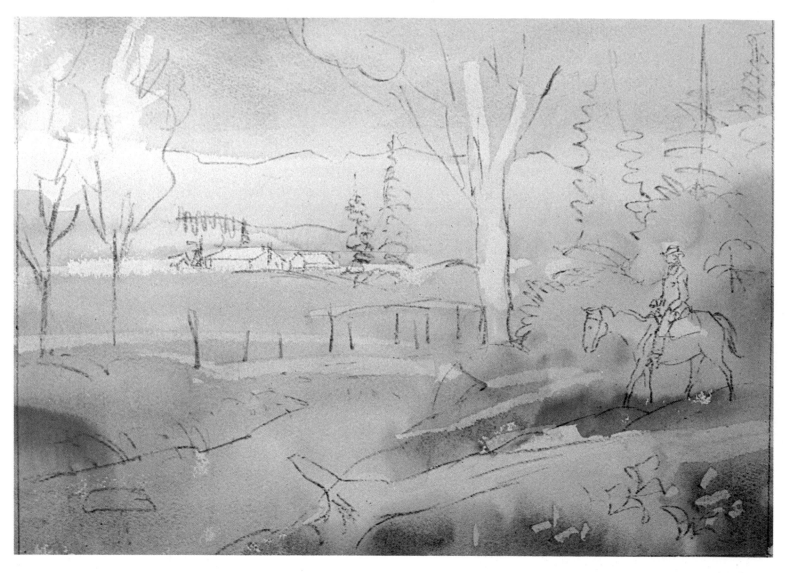

Step 2 (Above). First, I paint the sky area using my 1″ (2.5 cm) flat brush and a mixture of manganese and cobalt blues, with only a hint of permanent rose. After it sets a moment, I knife out the tree trunk and some potential foliage areas. Using a pale tint of permanent rose, I paint a light-value graded wash of permanent rose light at the top, grading it darker at the bottom, covering the mountains, and cutting around the buildings and tree trunk. At this point, I wet the lower half of the painting with clear water, using the 1½″ (4 cm) brush. After the glisten is gone from the paper's surface, I paint Winsor yellow and new gamboge wet-in-wet into the future pasture area, and new gamboge—with either manganese or burnt sienna—into the stream, its banks, and the foreground shrubbery.

Step 2 (Detail). Here you can see how I let the new gamboge mixture flow right across parts of the base for the horse and rider. This doesn't create a problem, because animal and rider are darker in value and mostly on the warm side.

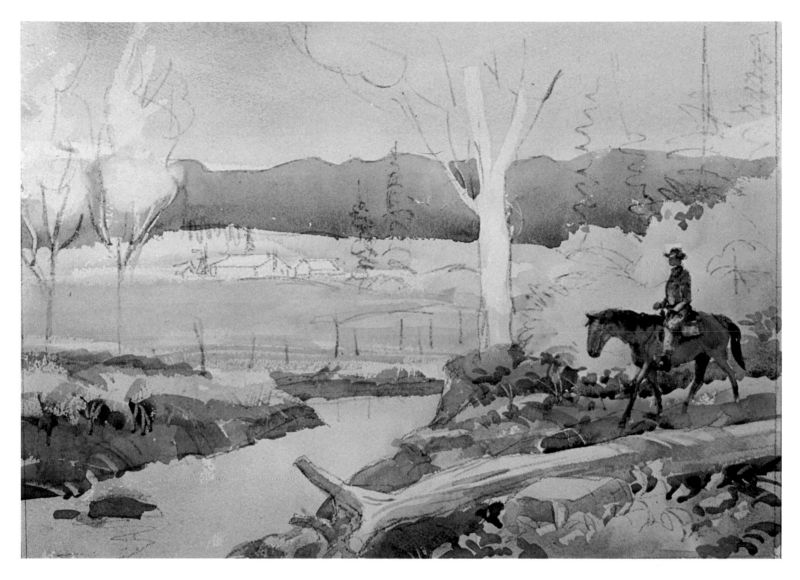

Step 3 (Above). Next I paint the banks of the stream with a varying mixture of burnt sienna, cobalt blue, and permanent rose, paying careful attention to the drawing so that the banks stay in perspective and don't appear to tip up or down! A mixture of ultramarine blue and a touch of scarlet lake gives the mountain color, and I paint it in as a shape with no detail, cutting around the tree shapes as necessary. Now, I indicate more of the shrubbery and growth around and in back of the horse, in front of the fallen tree log, and along both sides of the stream with my No. 8 round red sable. After everything is dry, I block in the horse and rider, striving for silhouette and action (gesture), not detail.

Step 3 (Detail). The simplicity of the mountain treatment, as well as that of the horse and rider show up in this detail.

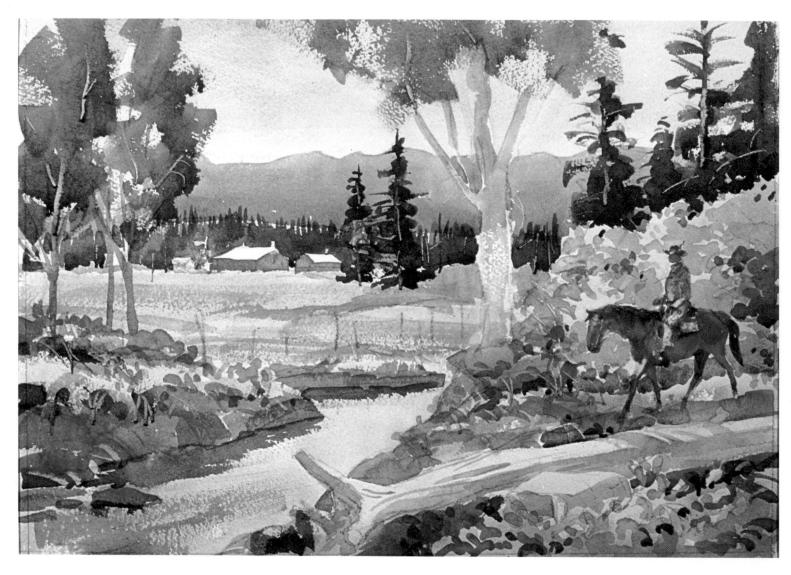

Step 4 (Above). The decidious tree foliage is next. Again, I handle this as a shape, concerning myself with the basic silhouette and painting it with my 1″ (2.5 cm) flat brush, using dragged edges to indicate the tracery of the leaves where the tree reads against the sky. These greens are mixed from combinations of new gamboge, raw sienna, and manganese and cobalt blues—plus a little burnt sienna, especially on the underside where they might get some warm-hued reflections from the ground below. Some knifing out of the lighter branches is done while the greens are still damp. Using similar, but darker value hues, I paint the evergreens, trying to give them their characteristic silhouette and gesture that's so different from the other trees just painted! More shrubbery and grass textures are now painted, often with little dabs and swipes from my No. 8 round sable, almost in a pointilist style in places. I paint the bank's reflection in the stream a simple, grayed warm blue, and then paint the walls of the buildings with a grayed burnt sienna.

Step 4 (Detail). This closeup shows my concern for essence of the subject rather than the detail, as evidenced in the painting of the horse and rider, and the shrubs and evergreens.

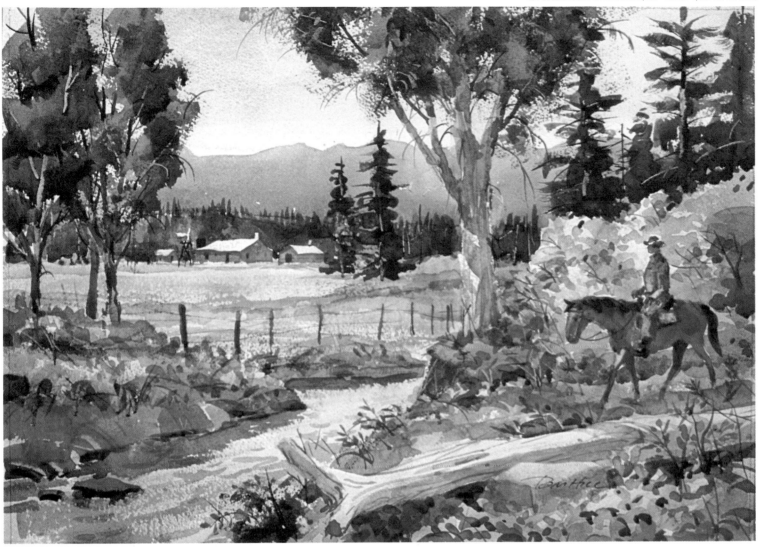

Step 5 (Above). So far, everything appears to be working out all right, and I feel that just a few touches and details will now complete the painting. Using either my No. 8 round sable or No. 6 rigger, I add branches, finish the tree trunks, and paint in the twigs, weed stems, and fence posts. A bit more detail is added to horse and rider—but no more than elsewhere, so they'll fit in harmoniously with the style of the rest of the painting.

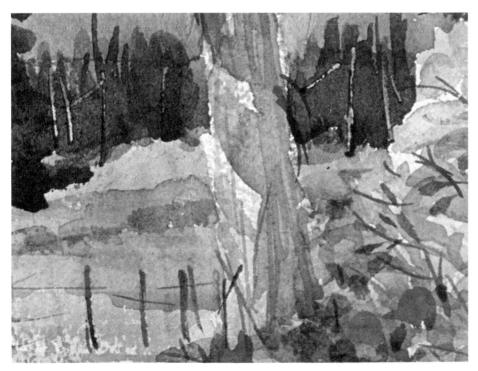

Step 5 (Detail). A few shadows, rendered in a light value of grayed blue-violet on the central tree trunk adds to the feeling of sunshine.

Sand and Pebbles

There are many ways to paint the effect of sand and pebbles in a watercolor. I once knew an artist who actually glued real sand and even small pebbles to the surface of his painting to express the character of sand and pebbles. Another artist I know carefully and meticulously renders nearly every tiny pebble—and even grains of sand—with small brushes, delineating tiny lights and shadows on each grain and pebble! Still another artist I know works at the opposite end of the possibilities, handling the sand and pebbles in a broad, dashing way by throwing the paint at the paper, spattering, and stamping. Each of these approaches is fine, as far as I'm concerned. There's lots of stretch in this painting business—and isn't that great!

Many beach or desert paintings I've seen are composed with the artist's viewpoint back far enough so that the detail and texture of sand and pebbles can be handled rather simply, and maybe only hinted at. For this demonstration, however, I decided to move in close enough to my subject so that I must confront some detail and texture and solve it satisfactorily. I want the painting to "say" sand and pebbles to my viewers, but even more important, I want the painting to have its own feeling—to express my personal view of the scene, over and above merely rendering details and textures. What I have in mind is a calm, sunny, little cove, protected from the open sea, where wavelets gently lap back and forth on a very small beach, and two little sanderlings run back and forth, endlessly searching for food. Just a little moment in time.

Here's a few thoughts I have in regard to using sand and pebbles in a painting: (1) Try to consider scale, almost before you decide anything else. In other words, ask yourself, "Are you very near your subject, moderately near, or rather far away?" If you're far away, possibly only a *shape* of the right value and hue will be sufficient for your sandy area.

If you paint sand from the middle distance it might require a little texture, but situating yourself much closer could involve rendering some of the details more completely. (2) There's a saying that I often try to remind myself of as I'm painting, and it applies to this problem as well as many others: "Less is more." Even though you're a wizard at painting detail, filling up your painting with it won't necessarily make the painting better. Often a little less of it will do the job better! (3) Composition, as always, is critical. Before you start to paint, think about how you'll arrange groups of rocks or pebbles or patches of sand. Avoid stringing these things out in rows or spotting them about like a case of measles. On the other hand, don't arrange awkward clumps of pebbles that look as though some strange ostrich went on an egg-laying binge. Doing a well planned and carefully considered value thumbnail sketch in advance is one form of insurance against these typical errors.

Brushes. I used my usual brushes for this demonstration: 1½" and 1" (4 and 2.5 cm) flats, Nos. 12 and 6 round red sables, and my No. 6 rigger.

Paper. I worked on 140-lb Arches rough watercolor paper—stretched, of course.

Colors. My yellow was new gamboge; my reds, scarlet lake and permanent rose; and my blues, cobalt, ultramarine, phthalo, and manganese. I added the earth colors of raw and burnt sienna.

Painting Tip. Keeping in mind the three points I made above, you can successfully employ a wide range of watercolor techniques to paint sand and pebbles. In addition to the standard washes and brushstrokes, spatter, salt, stamping, and sponging are all good possibilities, as long as they help your painting.

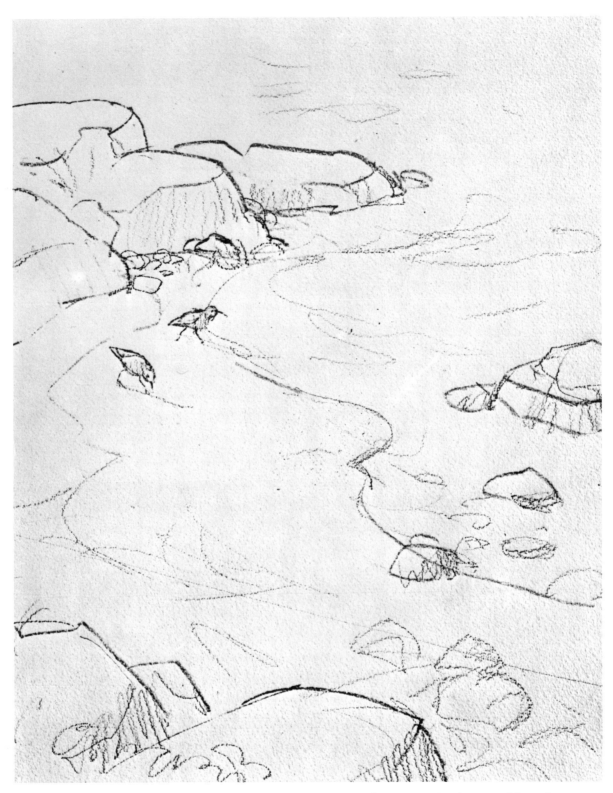

Step 1. As I mentioned in the preceding text, this demonstration is something of a closeup—the whole view only encompasses a few square yards or meters. This way, the sand and pebbles will have to be considered in some detail and solved successfully in the painting process. I have good reference for this studio painting: sketches and paintings done at the very same spot—or near it, some notes and color slides, including clear shots of the little sea birds (sanderlings) in action, plus a book on birds that further elaborates the detail on the birds. I pencil my painting plan onto the vertical composition, using a value sketch as my guide.

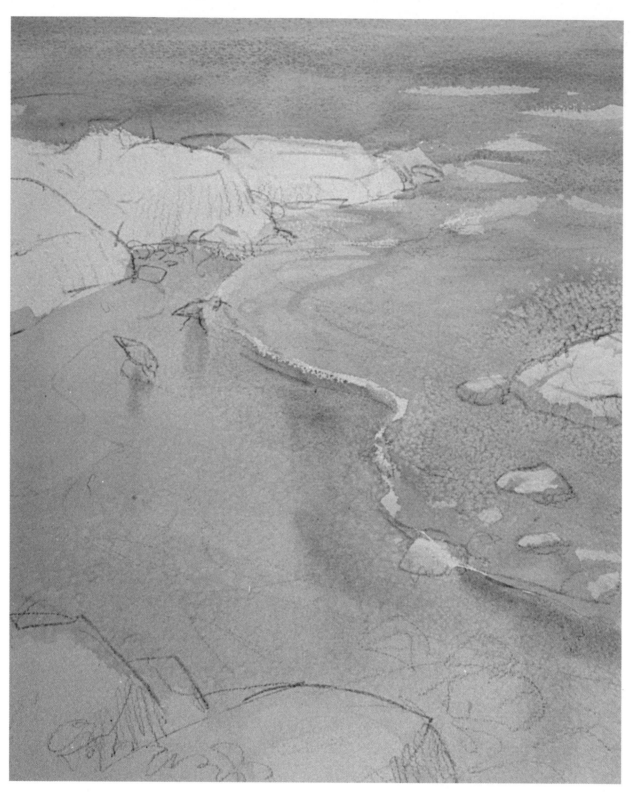

Step 2. Because I want this to be a fairly high-key painting, I plan to keep my hues basically clear and my values light. I start by wetting almost all of the paper with clear water, with my 1½" (4 cm) flat brush, but leave the rock grouping at the upper left dry. When the glisten of water has left the paper, I quickly brush in a light-value mixture of manganese and phthalo blue in the water, starting at the top and pulling the flowing wash down the paper, adding touches of permanent rose to the upper and middle areas, adding raw sienna as I paint down to the edge where the water meets the sand. The paper is steadily drying out, so I quickly charge in a light wash of new gamboge and raw sienna with bits of burnt sienna, into the sand area, managing to come right up to the water's edge, yet leave a little rim of white paper to indicate the foam. While this is wet, I indicate damp sand reflections of the birds and water with a grayed manganese blue and burnt sienna. I knife out some rocks in the water and sprinkle a little salt in places for additional textural effects.

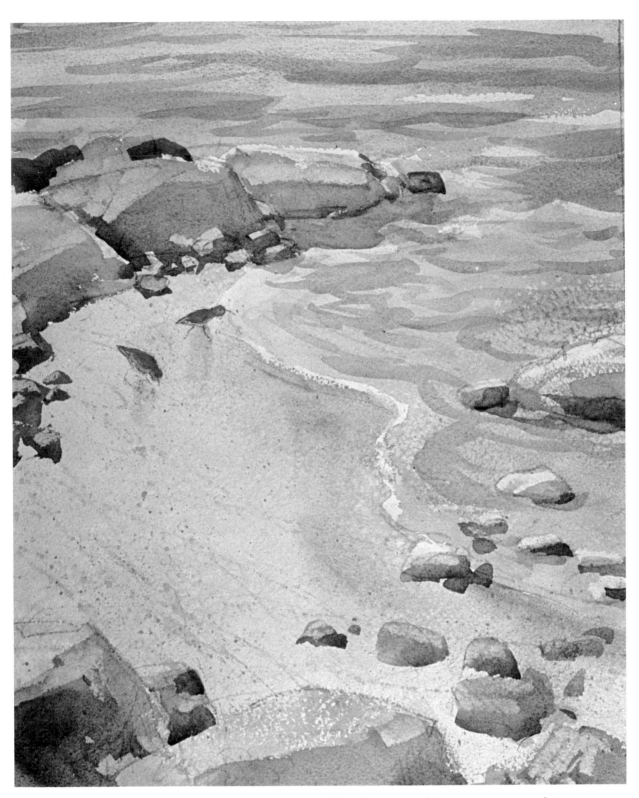

Step 3. When everything is dry, I use my No. 12 round sable to paint in wavelet shapes with a mixture of dark manganese blue to which I add bits of permanent rose for some of the upper wavelets where the water is deeper, and bits of raw sienna in the foreground wavelets where it's shallower and some of the sandy bottom shows through. The rocks and some pebbles are painted next, in several stages. First, light values of manganese and cobalt blues are grayed and charged variously with permanent rose, burnt sienna, and a bit of raw sienna; then darker values of this mixture follow, as well as some knifing out of lighter values. Using an old toothbrush, lightly loaded with some grayed burnt sienna, I spatter some texture onto the sand by holding the toothbrush face down and drawing my thumb across its bristles. I also "flip" a little spatter of paint onto the paper with my brush. In both cases, with the clean dry tissue that I hold in my other hand, I quickly blot up anything that's too dark, too much, or goes onto the wrong area. I add grayed burnt sienna on the upper part of the birds' bodies.

Step 4 (Detail). I'm not really a specialist at painting wildlife, but I feel that the detail on these birds is accurate enough, and more important, they fit in with the rest of the feeling in the painting, adding scale and giving it life.

Step 4 (Detail). In these enlargements, you can see the drybrush and spatter effects, as well as how the manganese blue pigment has settled in the paper's depressions, while the scarlet lake that was in the same mixture is so transparent that it leaves only a stain.

Step 4. Next, I add more darks and some drybrush texture to the sand, rocks, and pebbles. When this is dry, I mix up a large batch of manganese blue with a little bit of scarlet lake and burnt sienna. With this wash, using my 1" (2.5 cm) flat brush, I quickly and decisively paint a large shadow across the sand, while at the same time adding the cast shadows of the smaller rocks and pebbles and the birds' bodies. I cut around the large rocks in the foreground, leaving them in sunshine. You don't have to explain where a large shadow, such as the one I use here, came from, and it can add a great deal of feeling and perspective to your painting. Using my No. 6 round and No. 6 rigger brushes, I add final details to the birds, rocks, and pebbles.

Ocean Waves

The whole subject of water, and its many faces and moods, has always been fascinating to artists—and I'm no exception. Subjects dealing with water figure prominently in landscape painting, so we should understand as much as we can about it in order to be able to successfully paint it.

Painting ocean waves breaking on a shore is a tough subject, for if you paint at all realistically, you need to know what happens and how it happens. (Actually, I think having that knowledge would be helpful, no matter *how* you paint waves!)

Visiting the scene of the action, a beach or shoreline, is the best way to get the feeling. But even when you're right there looking at the action of waves as they meet the land, it can be very confusing when trying to analyze, then incorporate it into a successful painting! Although the scene can seem chaotic and inconsistent, there are some things in wave action that always happen. Knowing them helps in what to look for and then paint.

Depending on the situation, waves can range all the way from gentle little ankle-high babies, lapping at a tranquil shoreline in some protected bay, to giant crashing monsters, such as those that can occur where the open sea meets rugged land head-on! Ocean swells—part of tides, winds, and currents—travel along in open water, often even without whitecaps. But, as the water approaches land, its lower part begins to be slowed by the rising land underneath, while its top part continues on, with the result that the top piles up higher and higher, finally falling over on itself in a curling, al-most "waterfall" effect, the topmost water breaking into foam by aeration. Dashing into rocks, or up a beach, the water is finally stopped by gravity, and then reverses its direction, running or falling back, often meeting the next incoming waves, and the two conflicting movements creating a swirling mass of confusion at once both exhilerating to witness and

difficult to paint! But to paint it, we must make some order out of the confusion.

As usual, my inclination is to "vote in favor of my painting" by not painting what's literally there if it doesn't help it. I might observe five or six waves, plus lots of returning "spent" water, foam, and even the spray and mist of waves dashing against rocks. But the chances are that my picture will be better served if I leave some of this material out of it— maybe *fewer* waves breaking (one or two), *less* foam and swirl, and maybe only *one* wave dashing on the rocks.

When observing this kind of wave action, you must look for: (1) The rising swell or "crest" as the wave approaches land. (2) The valley or "trough" in back of it. (3) The crest falling over on itself, creating foam and a concave effect under its top. (4) The water from spent waves running back into the on-coming waves. Plan on accounting for these logi-cally in your painting and it will make more sense.

Brushes. My 1" and 1½" (2.5 and 4 cm) flats did all the beginning work. I also used a No. 12 and No. 8 round red sable and added a few details with a No. 6 rigger.

Paper. I use 300-lb, cold-pressed Arches water-color paper, stretched.

Colors. For my yellow I used new gamboge; for red, alizarin crimson; and for blues, manganese, cobalt and ultramarine—plus a little burnt and raw siennas, and that's all!

Painting Tip. Try to arrive at the color (hue) and value you want with as few applications of paint as possible. Remember, the more you paint over an area, the more "mud" and the less clarity you'll get.

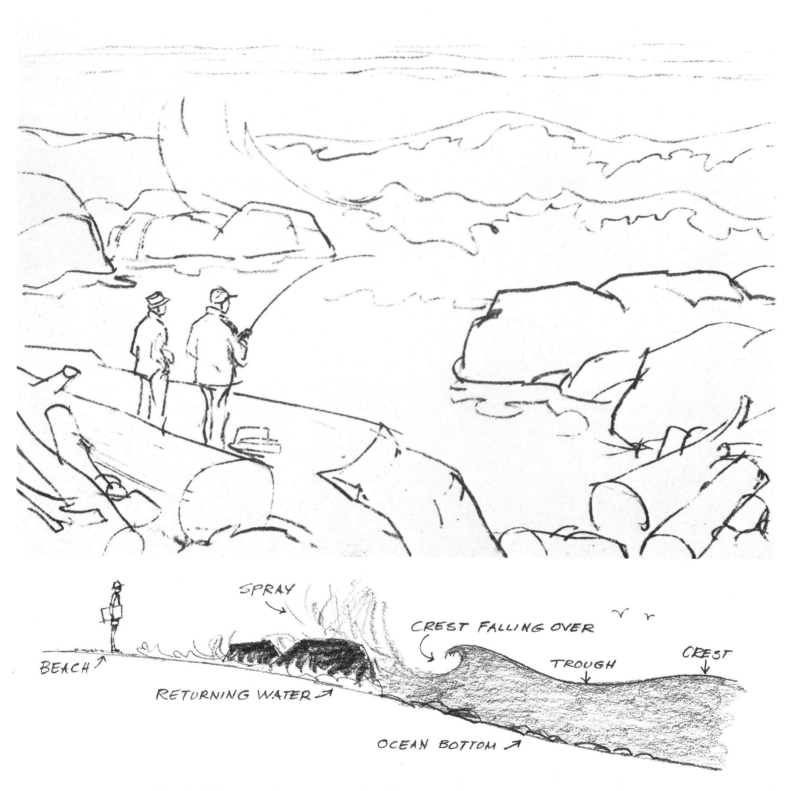

SPRAY

CREST FALLING OVER

CREST

TROUGH

BEACH

RETURNING WATER

OCEAN BOTTOM

Step 1. After several compositional studies, I settle for the arrangement above. It shows a very high horizon line, almost off the top of the picture, and one principal wave with a smaller one in front of it, plus several swells in the distance. The rocky reef outcroppings are arranged so that each is a different size, the largest in the foreground, the others smaller as our eye goes back into the distance. The two fishermen add scale to the picture, as do the large driftwood logs that tell us that this is probably northern country, which it is—the coast of Oregon. (Note the diagramatic illustration of wave action above.)

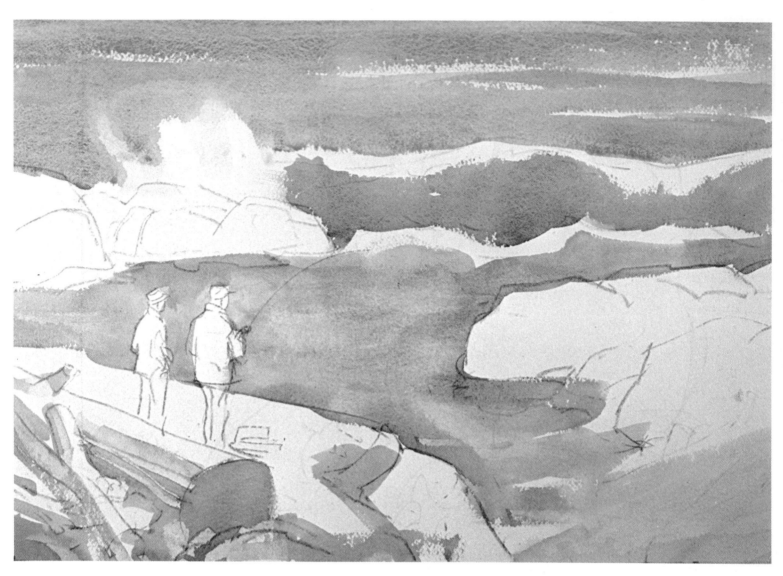

Step 2 (Above). I erase the pencil drawing of the smaller logs at the lower right, feeling that they add more detail than I now need. After this, I paint in the area above the principal wave with my 1" (2.5 cm) brush and a mixture of manganese blue and a bit of alizarin crimson. I purposely move my brush quickly and lightly, so as to leave some little white paper flecks or "skippers," then I charge in a bit of raw sienna into parts of this wash. Next, I paint the area under the big wave, this time with raw sienna and manganese blue, again letting my 1" (2.5 cm) brush skip a bit and leave ragged edges to show broken water and foam on the wave's lip. I paint the smaller wave and water in the foreground the same way, only I add more water and raw sienna as I come down to the bottom. I cut around the rocks and figures as I paint, then I add a light grayed violet to the logs and knife out some texture.

Step 2 (Detail). This shows in detail how I cut around my "saved" whites.

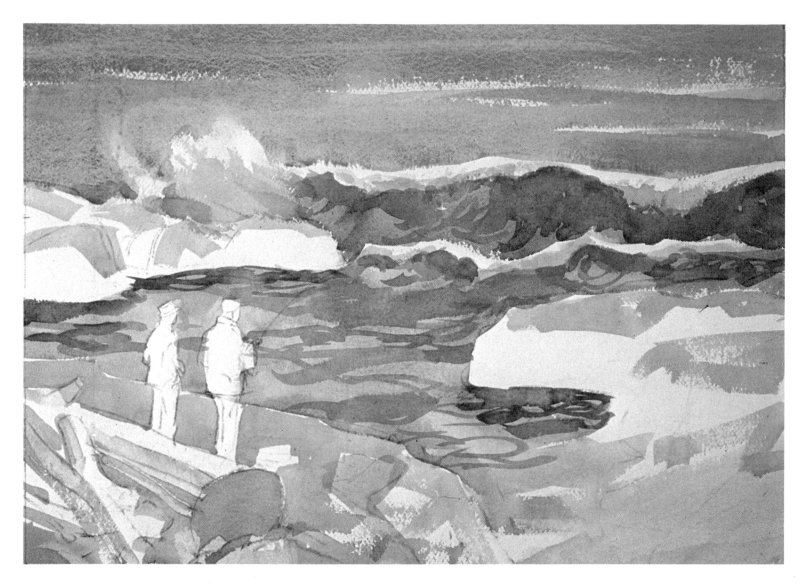

Step 3 (Above). I erase even more pencil after the paper is dry, then paint the shadow side of the foam and spray with a grayed cobalt blue. Next, the inside, concave part of the big wave is painted with a middle-value mixture of manganese blue and raw sienna, using my No. 12 round red sable. I also do the same on the smaller wave and in the foreground water, lightening and modifying the color as I come down the paper. I hold the No. 12 round quite lightly and as close to the end of the handle (away from the brush hairs) as I can in order to get a loose and wiggly line, trying for a feeling of liquid movement! Now, I add some middle-value grayed alizarin to the upper facets of the rock ledges.

Step 3 (Detail). This closeup allows you to examine the brushstrokes on the inside of the big wave and in the foreground water.

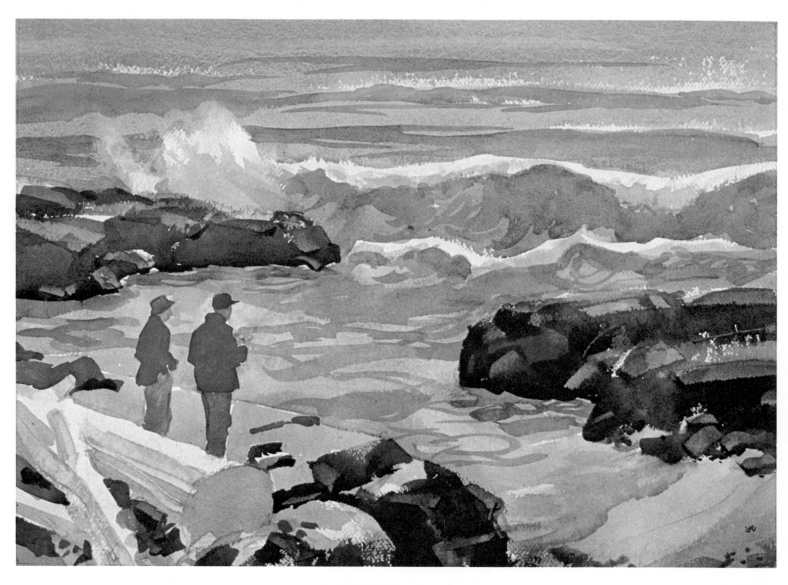

Step 4 (Above). Next, I block in the two figures, using simple, grayed primaries, and making sure that they're dark enough to read well against the water. After this, I paint in the more distant swells that will be the next breakers, using my No. 12 round sable and a middle-to-dark value of manganese blue and raw sienna. Again, I hold the brush loosely and far back on the handle to maintain freedom of movement and get casual, loose strokes. Now the rocks are painted with a 1″ (2.5 cm) flat brush and a dark-value mixture of ultramarine blue, alizarin crimson, and burnt sienna. I vary the proportions of the mixture as I go along, and knife out some lighter planes or facets on the sides and tops of the rocks to help indicate their form.

Step 4 (Detail). Here we can examine the shapes of the figures. Their bulky jackets and crisp caps, as well as their poses, are important to understand and then paint simply and with authority so that they won't fall into the category that so many watercolor figures in a landscape do, and look out of character with the rest of the painting, or appear somewhat "wooden" or added on!

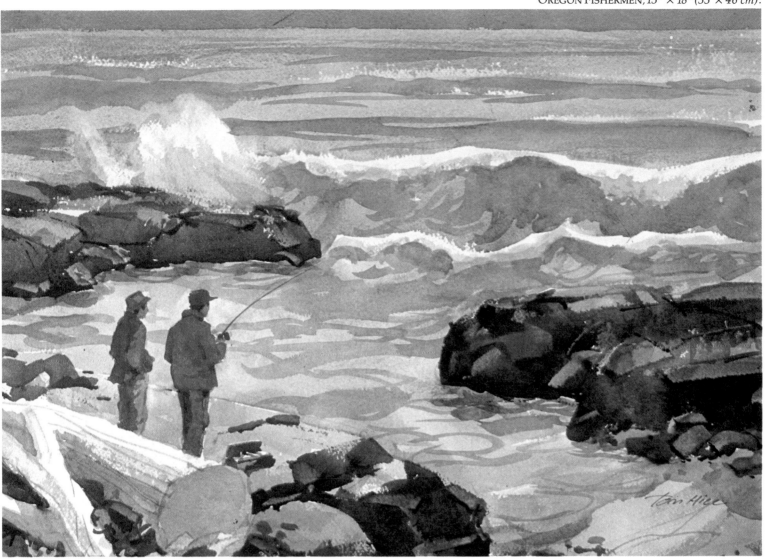

Step 5 (Detail). It's a temptation to add more detail—especially to the figures—but that would be out of keeping with the rest of the painting's technique and approach. Notice in this closeup that there are no eyes, lips, nostrils, etc., delineated. Just the attitude, silhouette, and gesture are enough to tell the story.

Step 5 (Above). I feel that the painting is carrying its own weight now. In other words, the problems are basically solved, and all that really remains are the finishing touches. I add a few touches to the figures, paint in an indication of their fishing gear, add details to the logs and rocks, and a touch or two to the little beach on the right-hand side. As a finish, I mix a middle-to-dark-value wash of manganese blue and a touch of alizarin crimson, and with my 1" (2.5 cm) flat brush, I paint the distant sky as a glaze over the previously painted wash.

PROBLEM NINE

Moving Stream

Here's water again! In this book we talk about many problems connected with water—showing water's reflections, water's action in ocean waves, and light or glare on water. Getting familiar with and understanding water's many faces and forms is good, for water is a common ingredient in landscape painting.

The term "moving stream" is broad in one sense, for a stream can be only a tiny beginning trickle up high on a mountainside, or it can be a large stream, almost a river, down in the valley. But in a broader sense, the problems in painting water are all similar, for water is water and its actions and characteristics remain the same.

Let's examine a stream's behavior in terms of how we can paint it. Imagine, if you will, that you're hiking with me along the side of the stream I'm using as the subject of this demonstration. We're up in the Green Mountains of Vermont. There's a path above us, but not down here at the water's edge, for there are too many large rocks and boulders for a path to be practical. Trees crowd around the stream's edge, making the lighting on the rocks and water somewhat flat. There are calm stretches of water in some places, and there are other stretches where boulders narrow the pathway so that the water runs faster and its surface is much more active. Here and there, rapids occur. They look like little waterfalls; the water zipping over these areas falls to a small pool below, aerating and producing whitish water and foam in the process.

How can we convert all this into painting procedures that will tell our story in an orderly, unchaotic fashion? Here are some thoughts for you to consider: (1) Study an actual stream, observing the calm, active, and falling actions I've been talking about. (2) How can you express them in the simplest, most direct way? (If a flat wash will work for a calm area, use it. If the water is more active, and a flat wash and an overlaying elaboration of a few brushstrokes to represent wavelets will work for your painting, then do it. If a few dragged brushstrokes, properly applied and not labored, represent the water falling over the rocks, then use that and no more.) (3) Because the chances of your finding the "perfect" composition ready and waiting for you are not good, you're bound to be in for some *editing* of the scene. Always edit, design, and compose in favor of your painting. After all, that painting will have to stand alone later, far from the stream you've painted, and relate your story and your feelings all by itself!

Brushes. My 1½" and 1" (4 and 2.5 cm) flats are the workers; the No. 8 round sable and a No. 6 rigger came in later to finish up!

Paper. This was painted on stretched 140-lb cold-pressed Arches watercolor paper.

Colors. As is the case in so many of these paintings, I use a simple palette, tending to favor the more transparent colors. My yellow is new gamboge; my red, alizarin crimson; and my blues, manganese, cobalt, and ultramarine. I also use burnt sienna.

Painting Tip. Try to handle the water and rocks in simple values—two or three will probably do it. Do a little "practice run" on spare paper in advance of any passage you're about to paint but are afraid you'll spoil.

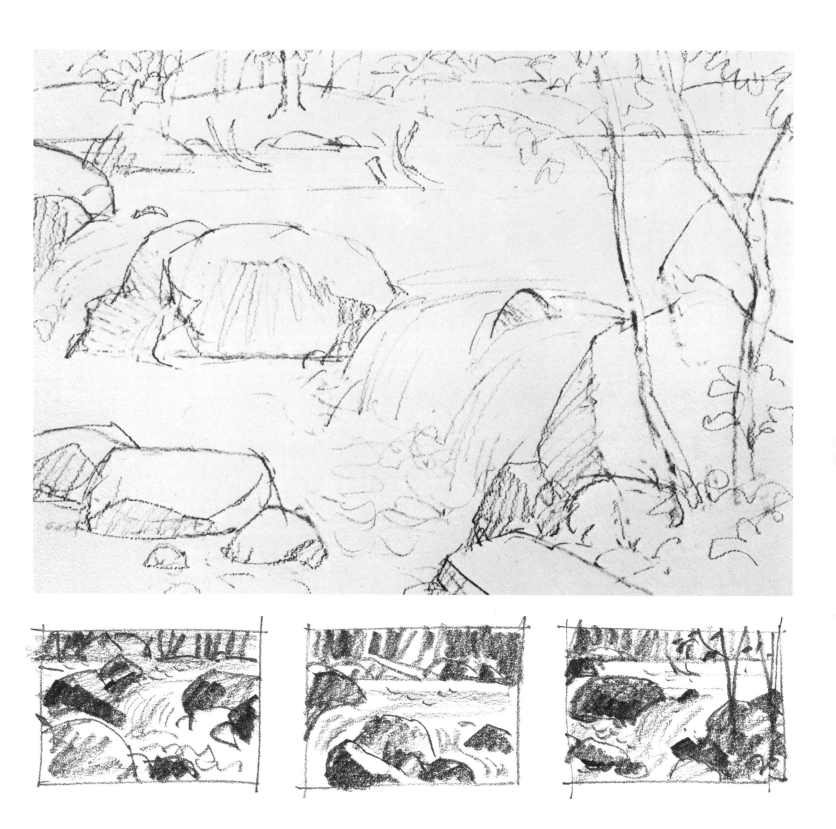

Step 1. The chaos and confusion of a rock and boulder-filled stream is hard to imagine unless you've seen one, and I need to do a lot of organizing of my reference material for this studio demonstration. I arrange and rearrange, and take out and add elements until I'm satisfied that my composition will work and actually be an improvement over what nature had placed in front of me. I pencil the final study onto my watercolor paper.

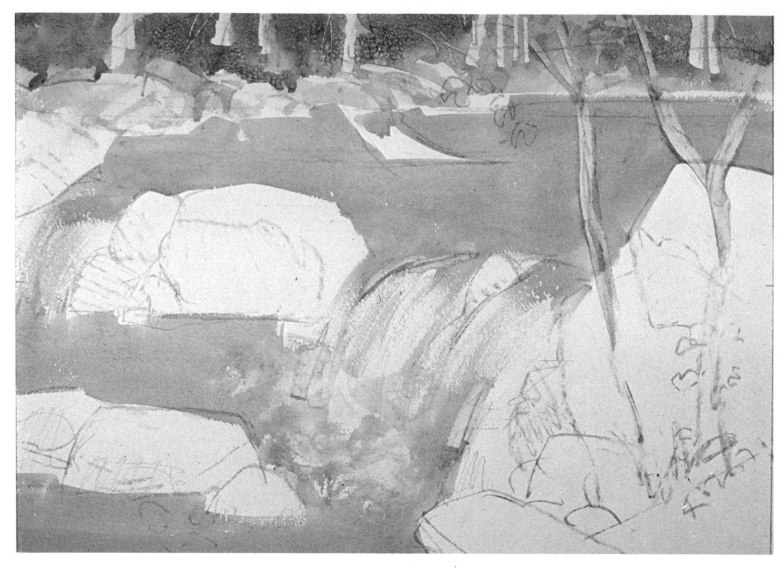

Step 2 (Above). Using my 1″ (2.5 cm) flat brush and a mixture of manganese blue and raw sienna, I paint in the lightest value in the water, cutting around the rock shapes and the driftwood. When I come to the area where the water is falling over and down the rocks, I use the same paint mixture, but a drier brush, to create a dragged-brush effect (not as dry as real drybrush), depicting the water's speedup and aeration. While this is still wet, I knife out the foreground sapling trunks that intersect the water area. Now, I paint the background above the stream, partially using a wet-in-wet technique, and charging color into color. For this I use varying amounts of new gamboge and raw sienna, manganese blue, alizarin crimson, and burnt sienna. I knife out tree trunks and rock shapes, using a little salt here and there to add texture.

Step 2 (Detail). Here's a closeup of the dragged-brush effect I used for the cascade.

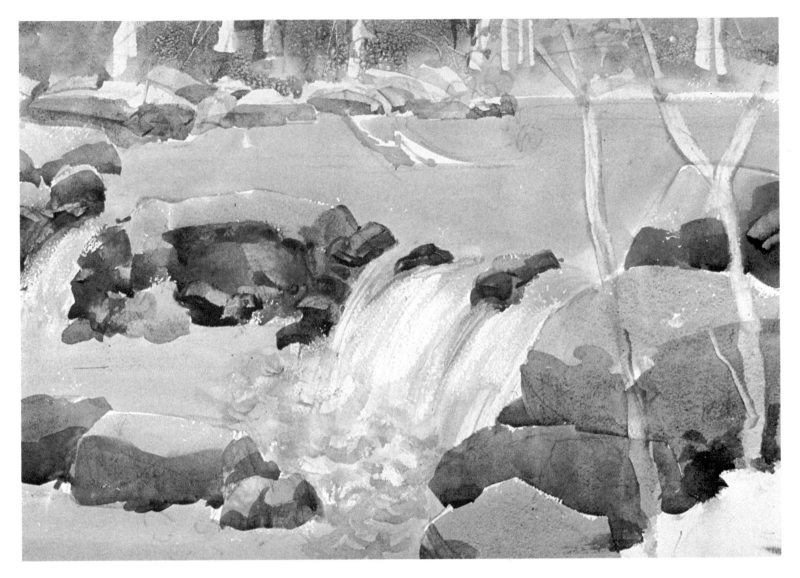

Step 3 (Above). I erase some of the pencil, then paint the lighter values of the rocks and boulders, using the 1" (2.5 cm) flat brush and various colors, often grayed slightly, such as manganese blue, burnt sienna, and alizarin crimson. There's a great variety of color in these rocks, and so I use many warms and cools to express it. The darker sides of the rocks are now painted, with areas knifed out for the trunks of the foreground saplings.

Step 3 (Detail). Notice that the painting treatment of the rocks and boulders isn't especially detailed, but consists basically of dark and light sides or facets of various grayed colors.

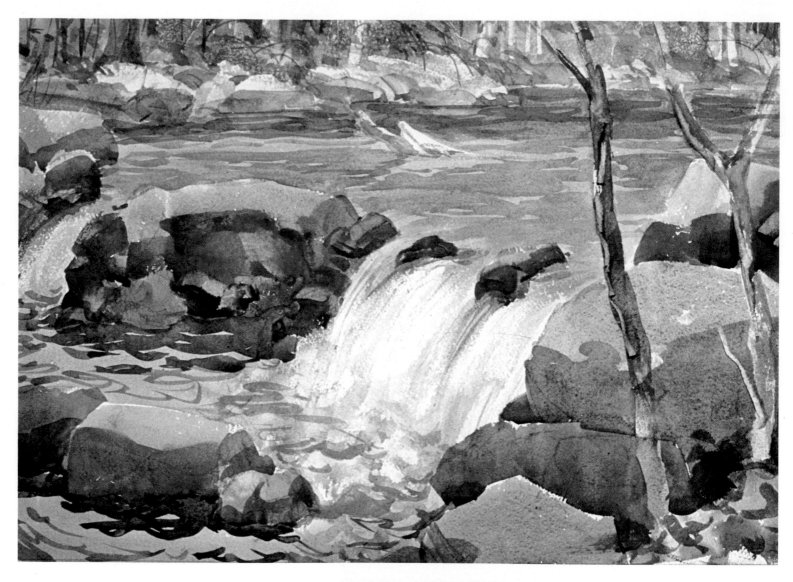

Step 4 (Above). Next, I paint the reflections—shown as active wavelets or ripples. I use my No. 8 round sable for this, with mixtures of manganese blue and bits of alizarin crimson and burnt sienna thrown in where the reflection is darker because of the dark rock above it. I add more detail to the background, and add various colors to the previously knifed out tree trunks and rocks. I add some smaller branches, twigs, and foliage with the No. 6 rigger.

Step 4 (Detail). This detail now shows the brushwork used in painting the little choppy wavelets and foam at the foot of the cascade.

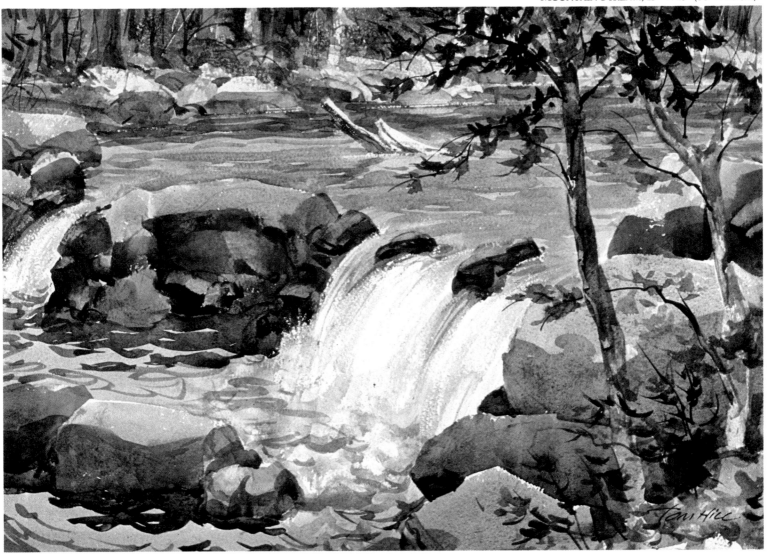

Step 5 (Above). The painting is about done, but still needs a few more finishing touches. I add the leaves, branches, and twigs to the foreground saplings, using both my No. 8 round red sable and my No. 6 rigger. I also add just a touch of texture and detail to some of the rocks and the water.

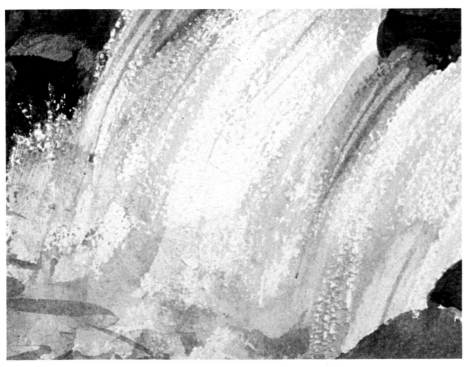

Step 5 (Detail). If you look carefully, you may notice that I've scratched out a few more whites in the cascade and its splash. I do this with the corner of a single-edge razor—and only do a little bit!

Light on Water

I'm sure you've seen, and maybe even been almost blinded by, the glare of sunlight reflecting off water. Let's imagine that you're driving alongside a large body of water. Suddenly the road takes a turn and you find yourself facing the sunlight's glare from the water's surface.

The chances are that this would happen in the morning or evening, when the angle of the sun's rays is low enough to reflect into your eyes; it's not that likely to occur around high noon when the sun is directly overhead. The water acts as a mirror, so the angle of your eye to the water must be the same as the angle which the sun's rays strike the water's surface, in order for the glare to occur this way (see Reflections in Water, Problem 11).

Have you ever seen a glare like this? I'm almost certain that you have, and I bet that if you stop to think about it, you'll recall the terrific impact and potency of the scene! It makes a fine subject for a painting; the overwhelming effect of light and the sort of singleness of focus it creates can evoke a powerful mood, both as you experience the actual event and later, when you interpret it in a painting.

Not long ago I was driving along the northern California coast, in an area called Tomales Bay—the bay between me and the afternoon sun. A distant fog bank beyond the headlands lent a rather dark value to the sky just above the horizon, even though the sky overhead was clear and sunny. Facing west, the sun's reflection off the bay was so dominant that I had to look hard, even shield my eyes from the glare, in order to make out the color and detail of anything near the pathway of its light on the water! The old pier pilings, the sea birds, even the wet tidal shore in front of my feet were all somewhat confined to being silhouettes and darker values.

Several points come to mind when considering a painting problem such as this: (1) If your painting viewpoint is in the direction of the glare, you're just about bound to paint it as your center of interest! (2) The white of the white paper is a far cry in intensity from the *real* light bouncing off the water, but it's all you have. Therefore, you must bring all the other parts of the painting down in both intensity and value, making the white paper seem brighter by contrast and increasing the feeling of light. (3) Being so strongly backlighted, many elements will appear to be silhouetted, and painting them that way will further enhance the sense of light bouncing off the water.

Brushes. Again, my 1½" and 1" (4 and 2.5 cm) flat brushes were the mainstays in getting the big areas and shapes started in this painting. I also employed my No. 12 round red sable as well as a No. 6 round sable and No. 6 rigger.

Paper. I used stretched, 140-lb cold-pressed Arches watercolor paper.

Colors. My yellow was new gamboge; my red, alizarin crimson; the blues: manganese, cobalt, phthalo, and ultramarine blue. I also added burnt sienna and raw sienna.

Painting Tip. I'm not much on using painting "tricks" per se, preferring solid, knowledgeable painting, but once in a while, a trick is useful. In this case I used the corner point of a single edge razor to pick out the tiny extra sparkles that glint as even *lighter* values in the sun's reflection on the water. Of course, this was done after everything else was solved properly and the paper was dry.

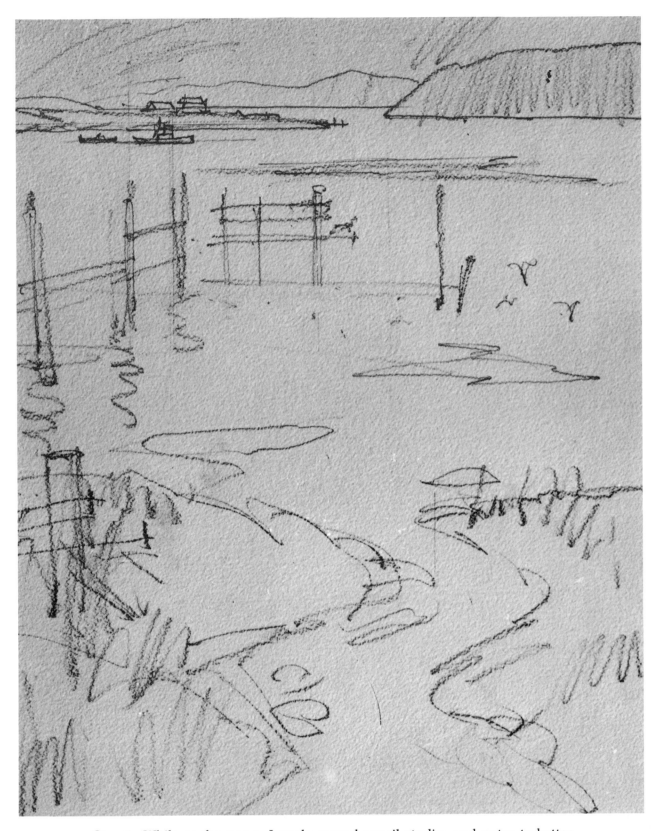

Step 1. While at the scene, I made several pencil studies and notes to better remember the setting and the feeling later when painting it in my studio. I also took several color slides to record the detail of the pilings, gulls, etc., and they're also useful in bringing back the memory. After my usual compositional thumbnail studies, I decide on a vertical composition, which works well with the path of light on the water, and pencil this onto my paper.

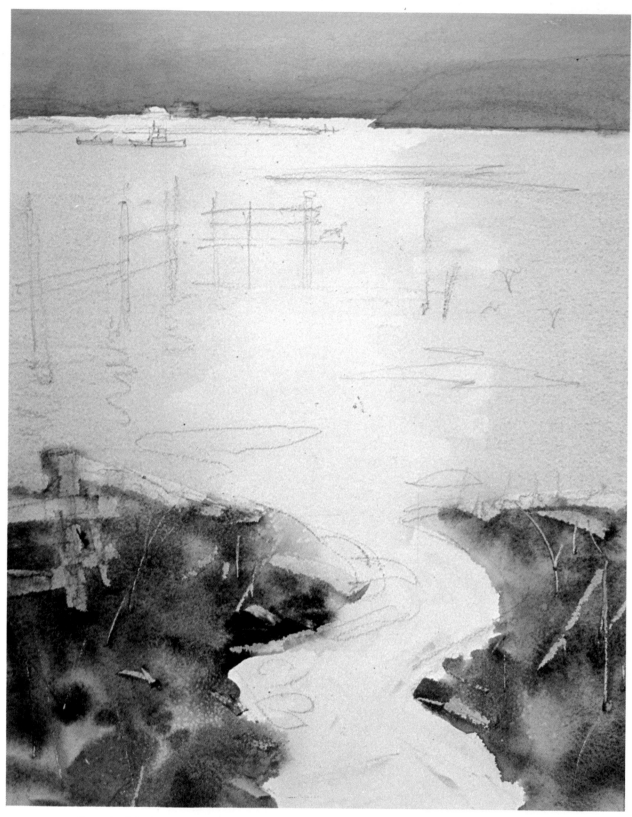

Step 2. Working with the paper dry, I paint the area above the horizon line a wash of phthalo blue (grayed with a tiny bit of burnt sienna), keeping it lightest at the top and center. As this is drying, I wet *all* of the paper below the horizon line using my 1½" (4 cm) brush and clear water. When it's evenly wet to damp (in other words, not running wet), I use my 1" (2.5 cm) flat brush and "pull" in a wash of slightly grayed manganese and cobalt blues, leaving either a wet-in-wet soft edge on the center light path, or a light, lifted drybrush effect—so that my center-light path is essentially white paper. Now I paint the foreground, almost "dropping" in burnt sienna, ultramarine blue, and alizarin crimson, together with bits of new gamboge onto the area, really mixing and mingling them right on the damp paper. Then I knife out a few lighter areas and strokes from this foreground, and add a little salt to some still-wet areas for texture.

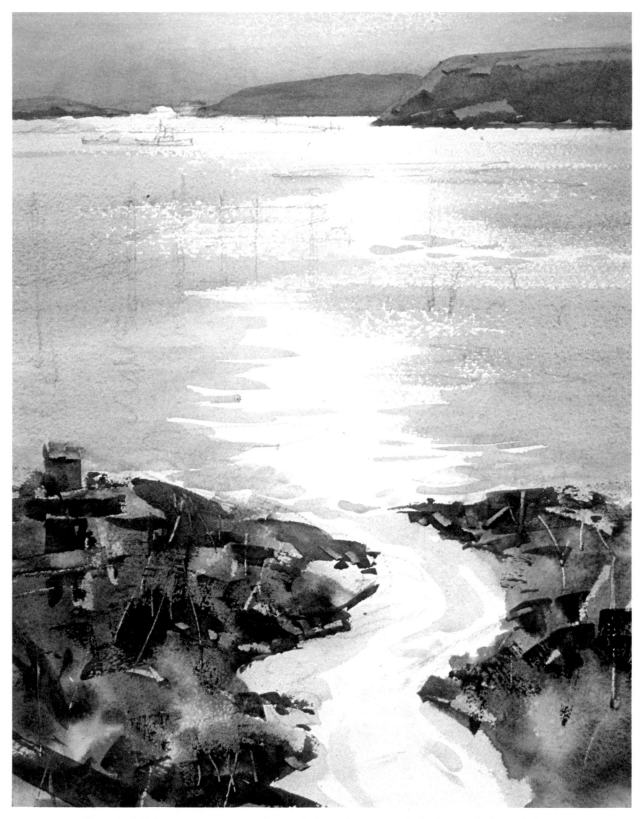

Step 3. With my paper now dry and the salt removed, I glaze cobalt and manganese blues over the water, charging in bits of alizarin crimson and raw sienna near the foreground, using my 1″ (2.5 cm) flat and some with my No. 12 round sable, to create both more drybrush edges and wavelet shapes where the water and sun's reflection meet. Now I add some rich darks made from combinations of ultramarine blue, alizarin crimson, and raw and burnt siennas, using the flat side of my 1″ (2.5 cm) brush as well as the tip edge, with the paint quite dry. The distant headlands are painted in two steps, the lighter and more distant one first, then, a moment later, the closer and darker one, from which I knife a few lighter planes.

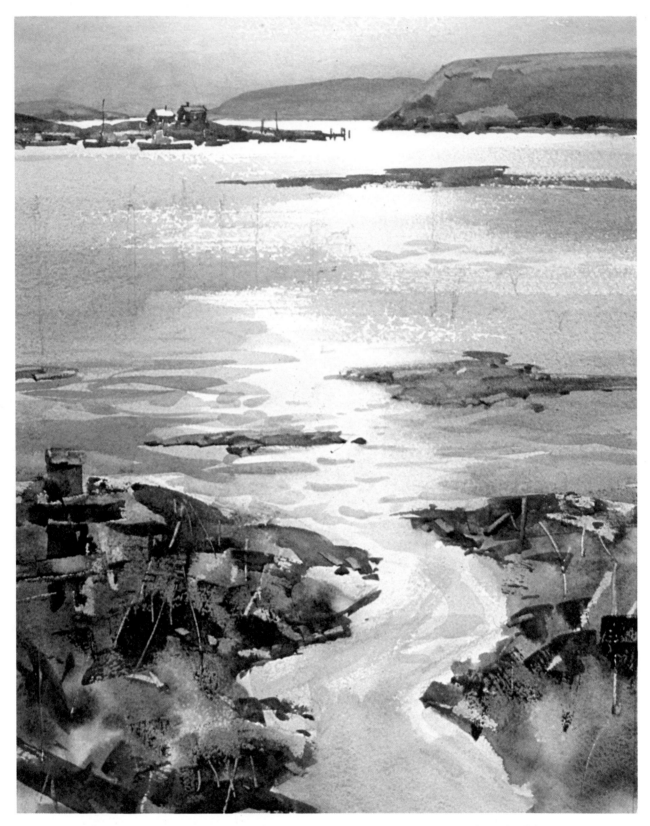

Step 4. The spit of land in the middle background is next, with its buildings, pilings, and boats—all are painted with the 1″ (2.5 cm) flat and a touch or two of the No. 6 round sable. After this, I paint in the closer sand spits with my 1″ (2.5 cm) flat, then with the No. 12 round sable I add darker wavelets in the nearby water, using more cobalt and manganese blues. At this point, I further develop the mouth of the little stream at the bottom of my picture by adding some directional lines in the water with my No. 12 round sable.

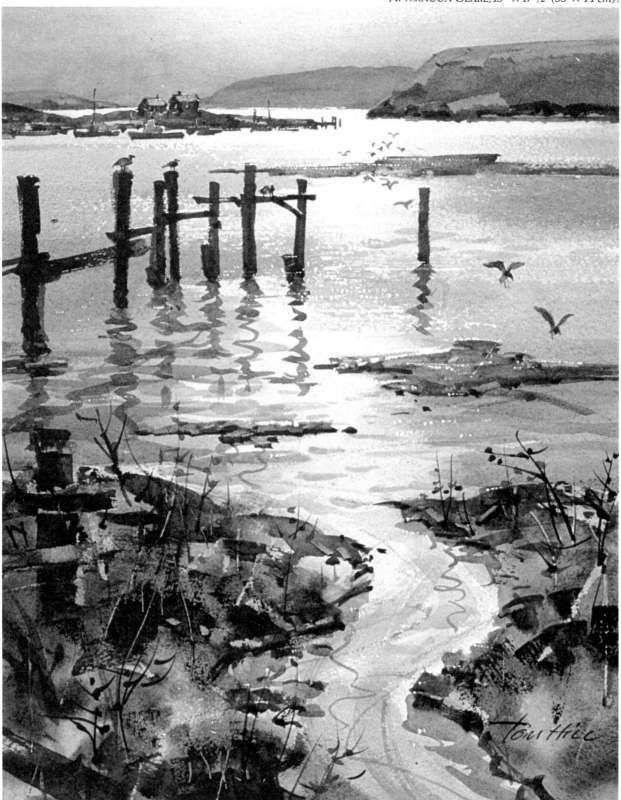

Step 5. I check the water areas to make sure they're correct, then paint the pilings with my 1" (2.5 cm) flat and my No. 6 round sable. The paint I use is a very dark value, mixed from ultramarine blue, alizarin crimson, and burnt sienna in varying proportions. The way these pilings are painted can make or break the feeling of perspective and can add to or confuse the compositional balance, so I'm careful to consider this as I paint them. Note that the pilings do *not* go in an even line, like so many telephone poles, but rather, vary in distance from each other as well as in diameter and height above the water. I use the No. 6 round sable and the rigger to finish off the painting, adding the sea birds, weed stems, and a wiggle or two of reflections in the little stream.

Reflections in Water

Reflections in water are intriguing subjects for artists, but rather confusing and often not well understood. Let's analyze them so we'll understand them a little better—then they won't be such a problem!

Water, nearly colorless by itself, nevertheless acquires color in a landscape setting because of several factors: there may be actual colored material in the water (such as algae, minerals, and sediment or sometimes, when the water isn't too deep, the bottom can show through a bit, adding its own color. Most of the effect of color, though, comes from the reflective properties of the water's surface. This surface reflects what's above and around the body of water, such as the sky, clouds, and nearby land.

Once, when I was very young, I saw a picture postcard that depicted a snowcapped mountain in the upper half of the picture, and a calm lake in the lower half. The mountain was perfectly reflected in the lake, and I was interested in it because I could look at the darn thing either rightside-up or upside-down and it would "read" either way! The card had a caption that read, "Morning at Mirror Lake."

The important word to remember is "mirror," for water acts in the same way that a mirror does—reflections in water are merely mirror images of what's above them! If all water was as calm as Mirror Lake was in the postcard, we'd have little to learn that we couldn't get from laying a mirror horizontally and observing what happened. However, a small breeze, not to mention a stronger wind, can easily ruffle the surface of a body of water, fracturing the surface and breaking up the reflection into a myriad of little mirrors, each reflecting what it's pointing toward. Ocean waves, moving water in streams, and tidal flows *still* are reflecting, but their reflections are even more distorted and difficult to analyze, simplify, and then use in a painting. Next time you want to use reflections in water in a painting, increase your understanding of it by observing the following points: (1) The image of the object you see reflected in the water strikes the water at an angle that's exactly the same as the angle your eye is looking into the water—of course, from the opposite direction (see Figure A on the facing page). (2) In "still" water, reflections appear equal and inverted (Figure B). (3) In "active" water, the same reflections can appear "broken" and deeper or longer (Figure C). (4) Although wavelets and ripples are continuously curved, try thinking of them as having several sides, like a series of mirrors. As each side is at a different angle, it will reflect a different thing than the one next to it. One might reflect the low sky toward the horizon, another the sky above, still another might reflect an object such as the nearby shore, a boat, tree, or whatever. Because the water is moving, all these reflections will be constantly changing, too (Figure D). (5) A piling or post in the water slanted away from you will appear to have a shorter reflection, while one slanted toward you will have a longer reflection (Figure E). (6) Sometimes the underside of an object will be reflected and seen, even though you can't see that part of it from above (Figure F). (7) Darker objects usually appear *lighter* in value in their reflection, whereas lighter ones appear slightly *darker* (Figure G).

Brushes. Again, my 1½" and 1" (4 and 2.5 cm) flat oxhair brushes did most of the work, with a No. 12 and smaller sable rounds and the No. 6 rigger adding finishing touches.

Paper. This painting was done on 300-lb cold-pressed Fabriano, a nice, cotton-fiber Italian watercolor paper.

Colors. My yellows were raw sienna and new gamboge; reds, scarlet lake and permanent rose; and blues, cobalt, ultramarine, and manganese. In addition, I used phthalo green and burnt sienna.

Painting Tip. Before you paint, look at actual water reflections and observe the seven points listed above.

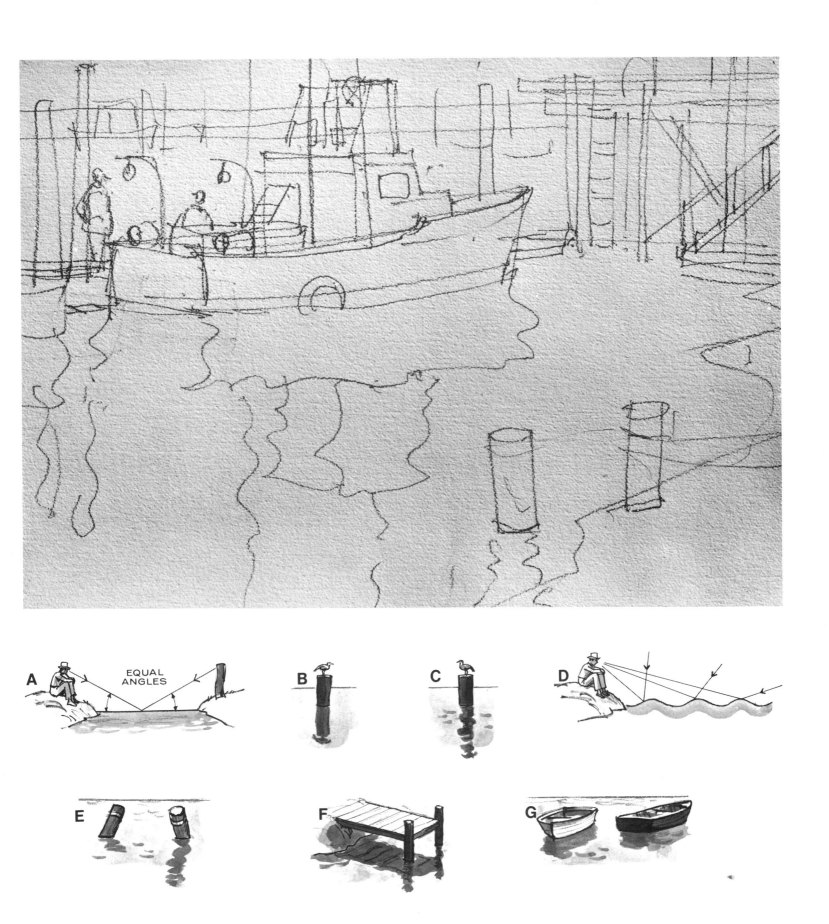

Step 1. I make careful studies of all parts of my composition, making sure I understand everything I'll need to know. Then I make a little thumbnail value composition. When I'm pleased with this, I transfer it directly to my stretched watercolor paper.

81

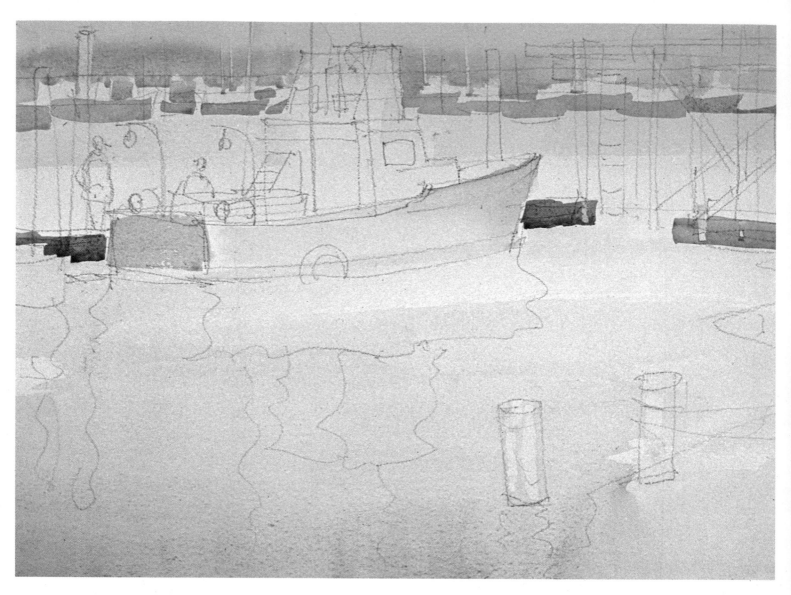

Step 2 (Above). Wetting the lower two thirds of my paper, I quickly wash in violet tints of manganese blue and permanent rose, using my 1½" (4 cm) brush. Raw sienna is added to the bottom to indicate the sand and mud showing through the shallow water there. Next, I paint the sky a tint of new gamboge, charging in a little ultramarine blue and cutting around the house and boat shapes. The distant boats are painted—just the hulls—with a grayed tint of violet. Now I paint the big boat's hull using my 1" (2.5 cm) brush, manganese blue and a tinge of permanent rose. At this point, I knife out a few objects such as masts and posts.

Step 2 (Detail). This shows the direct way I apply color with the larger flat brushes. You can see how really simple some of the color mixtures are—the dock, for example, is only water and burnt sienna.

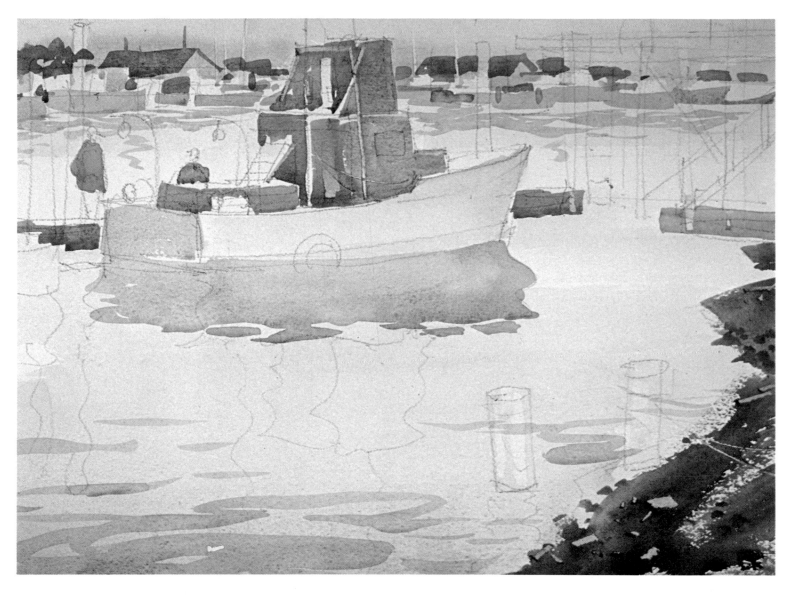

Step 3 (Detail). Here you can see how I simplified the broken reflections caused by the constantly undulating water.

Step 3 (Above). Next, I paint the distant reflections with tints—mostly rather diluted manganese blue and some permanent rose and raw sienna. I use a No. 12 round sable that still keeps a good point, and paint these reflections as casual "squiggles." The roof tops, tree shapes, and some darks are added with burnt sienna, new gamboge, and permanent rose. Now, I paint the mud flats in the lower right-hand foreground, using a loaded 1½" (4 cm) brush and quickly swiping in the partially mixed pigments. This allows each color to retain a little more of its identity and gives the area a casual vitality. After this, I paint the cabin of the boat with phthalo green and cobalt blue, knifing out some structural lights. The reflection of the hull is painted with a grayed manganese blue, slightly darker in value than the actual hull above it. I pay attention to simplifying the broken reflections along the edge. The hold cover is now painted with raw sienna, and the silhouettes of the jackets are indicated.

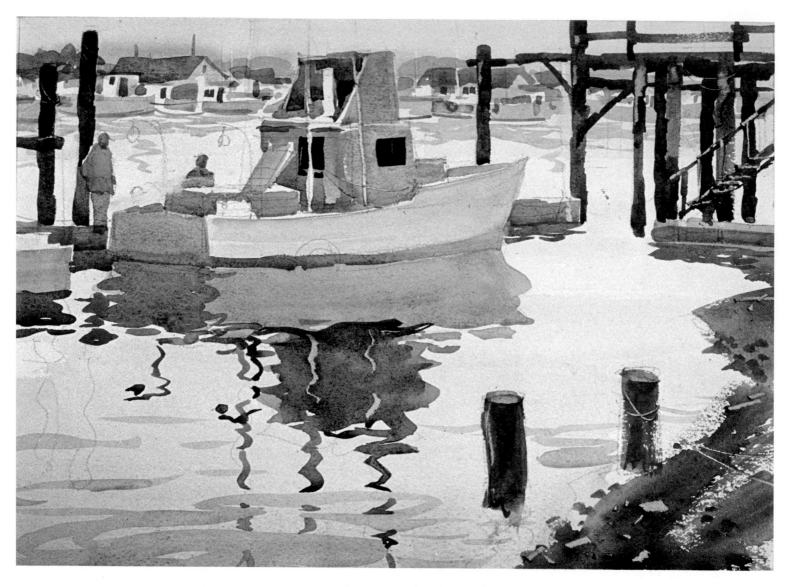

Step 4 (Above). I paint a few more darks into the distant background, then add the darks and details of the cabin of the main boat, using a mixture of ultramarine blue and burnt sienna. Next, the reflection of the cabin is painted with grayed phthalo and cobalt blues. It's made darker this time because it's silhouetted against the sky (as seen from the water's surface). I continue to work downward on the mast's reflections, after knifing out some lights where they show lighter against the darks. With my 1″ (2.5 cm) brush, I paint the pier and pilings in combinations of ultramarine blue, burnt sienna, some permanent rose, and manganese blue. Now I glaze a darker value of manganese over the reflection of the boat's stern and add the reflections of the dock and figure.

Step 4 (Detail). This shows my efforts to take the very complicated real-life reflection patterns and simplify them for the painting, striving all the time to capture the feeling of the smooth, undulating surface of the water.

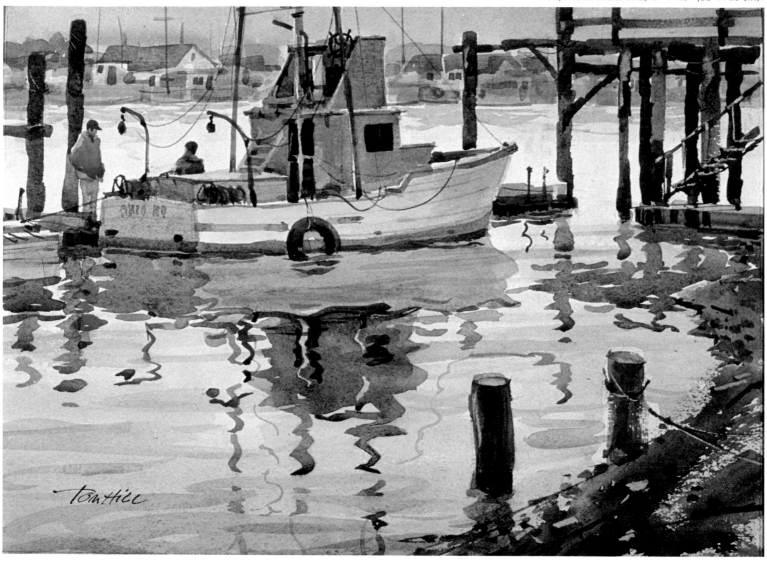

Step 5 (Above). At this point, I decide to unify the foreground water, lowering its value a little by glazing it with light washes of manganese blue and permanent rose. I work quickly, careful not to go back into the washes so I don't disturb the previously painted parts. Then I paint the reflections of the piers and pilings somewhat lighter than the real objects above them, using grayed ultramarine blue, burnt sienna, and some manganese blue and permanent rose. The details of the figures, rigging, and masts are added mostly with my No. 8 round sable and No. 6 rigger.

Step 5 (Detail). Please notice, although the reflections are wavy and broken, they still line up below the objects they're reflecting.

Glass in Windows

Since many landscapes have buildings, buildings have windows, and windows have glass, sooner or later the problem of how to handle the painting of glass in windows will come along. At that point, you'll have to do some looking, analyzing, and maybe a little experimenting in order to understand it. This chapter examines the problem.

Painting the effect of glass—in windows or elsewhere—is tough! It's confusing in many of the same ways that painting reflections in water is (see Problem 11). For, like water, glass reflects. Unlike most water, however, which is usually horizontal, glass is often in a vertical position, and is thus capable of catching and reflecting an even greater variety of things than water. And the fact that you can see *into* or through glass more often than you can see through a body of water, further compounds the problem.

Recently one morning I drove my car down to the mechanic for a minor repair. I was early and he was late, so I sat in my car waiting and looking at his closed garage door, which had a window in it. As I looked at the window I could vaguely see some of the garage interior and equipment within. But, at the same time, superimposed over this, I could see my vehicle, me in it, and the traffic and buildings behind me! All of this confusion in one small window at one time! I got out of my car and walked over to look at the window from a side angle of about 45°. Then I could no longer see my car, myself, or anything inside the garage—instead I could see some sky and different buildings down the street on the other side! The same rule for reflections in water applies to glass: the angle that your line of vision follows is duplicated in reverse by the angle of what's being reflected to your eye (see Figure "A," Problem 11, Reflections in Water). These angles are referred to as the "angle of incidence" and the "angle of reflection."

Dusty or dirty glass is harder to see through and acts less effectively as a mirror, sometimes seeming almost opaque. If it's darker inside than outside, the chances are that the glass will be doing some reflecting. If, however, there's a dark object *in* the reflection, then it's possible for the glass in the window to appear dark, and it may look sometimes as though there were no glass at *all* there—an effect to think about!

So, in order to successfully paint glass, I think we must "vote in favor of the painting"—in other words, add what will help it, and take out what won't help it. Usually this means simplifying the

Consider these points: (1) What is the simplest way the glass can be painted and still tell what you want? (2) What is being reflected—is all or only a part of it useful? (3) How much can be seen inside, and will adding any of it help the painting?

Brushes. I used only a few—mostly my 1½" and 1" (4 and 2.5 cm) flats—to do most of the big areas and washes. Details and smaller passages were done with my Nos. 8 and 6 round sables, and just a bit with the No. 6 rigger.

Paper. I used stretched 300-lb rough Arches watercolor paper.

Colors. My yellows were new gamboge and raw sienna; my reds, only permanent rose; and my blues, ultramarine, cobalt, and manganese. I also used burnt sienna.

Painting Tip. This is really a *pre*-painting tip: try looking at windows from different positions and conditions, observing carefully and taking notes or making sketches for reference when you paint.

Step 1. There are so many possible positions and conditions windows can be in, that it's difficult to decide which ones to use. However, I selected this arrangement because it shows several aspects of the problem: A window seen straight on and close enough to have to interpret the glass in it; another window, seen at an angle, which presents different problems; broken pieces of glass, so you can examine one possible way to paint glass in this condition; sunlight shining on part of the scene, and shade or shadow covering the rest. After I plan my composition and solve some of my perspective and value problems with a thumbnail sketch, I pencil the design onto my paper.

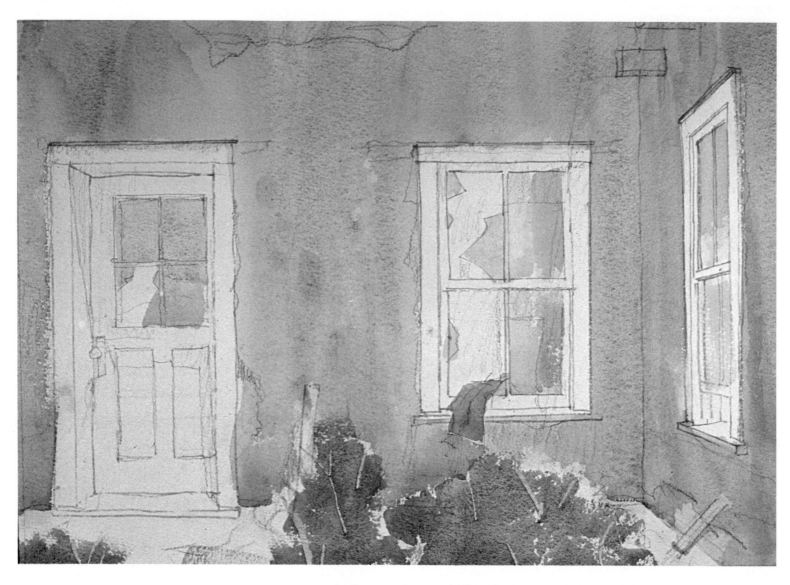

Step 2 (Above). Using my 1½″ (4 cm) flat brush, I wash in tints of burnt and raw sienna, permanent rose, and manganese blue onto the walls of the building, not mixing them together, but rather painting them somewhat individually on the paper and then letting them mingle at random. Next, I mix a simple grayed green of manganese blue and raw sienna and paint the shrubs in the foreground in a blocky manner with my 1″ (2.5 cm) brush, knifing out a few lights before this dries. Now, I paint the reflections of sky, ground, and right-hand wall, as seen in the window and door of the facing wall, and also add the reflection of *that* wall in the window on the right. I use manganese blue, raw sienna, and burnt sienna for this, painting it in *very* simply with my 1″ (2.5 cm) flat brush. I now paint the old cloth in the window with a middle value of permanent rose.

Step 2 (Detail). Here you can see the granulating or sedimentary tendencies of manganese blue, which, in this case, add interest and texture to the old adobe wall.

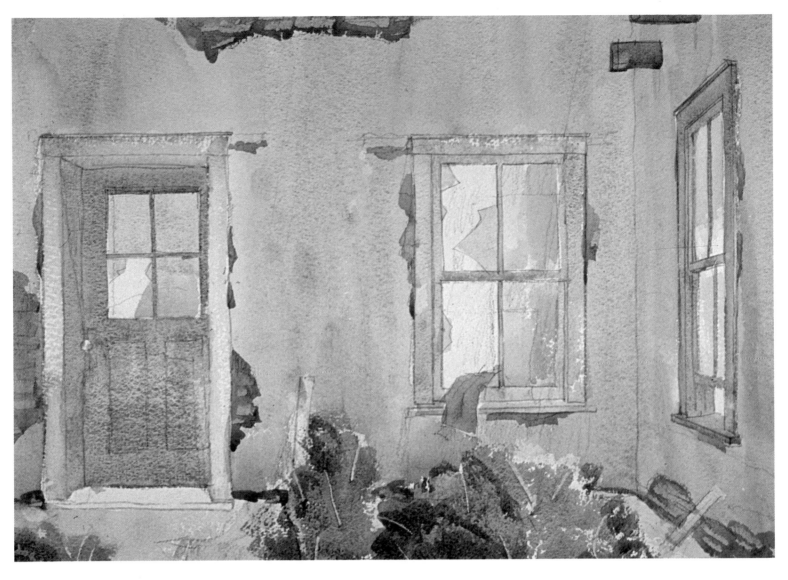

Step 3 (Above). A wash of manganese blue with a touch of cobalt blue is applied lightly and quickly to the window and door frames. I use a lighter value in the sunlight, and a darker one in the shade. I now add the shadows on the shrubbery using a darker version of the same manganese-raw sienna mixture, and then paint the inner wall of the adobe, where it shows through the broken stucco plaster. For this I use burnt sienna, with a bit of permanent rose and raw sienna added here and there to vary it. I knife out some of the lighter values from the wet wash. Then with the same color, I paint the ends of the two rafters at the upper right.

Step 3 (Detail). This closeup enables you to see better how the blue paint is applied to the windowframes. I work lightly and quickly enough to leave some "skippers" (white paper) showing where the brush only touched the tops of the rough paper's surface, thus giving an interesting rough and weathered look to the old painted wood.

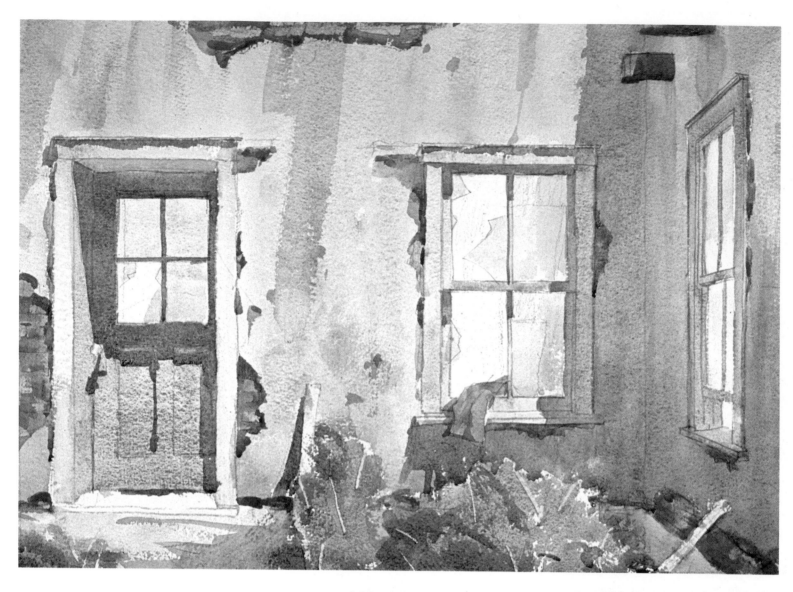

Step 4 (Above). Now I paint the cast shadows on the walls, mostly with washes of slightly grayed manganese blue and a little permanent rose. Where the shadow is cast from a distant object, I make it lighter because there's more of an opportunity for reflected light to get into it and lighten its value. Where the shadow is closer to the object casting it, I paint it darker in value and "crisper" in character, because the closer the shadow is to its source, the *less* reflected light is present. I paint the little shadow accents on the adobe that shows where the stucco has fallen off, add the shadows on the windows and door with a grayed manganese blue, and paint the shadows on the ground a grayed violet.

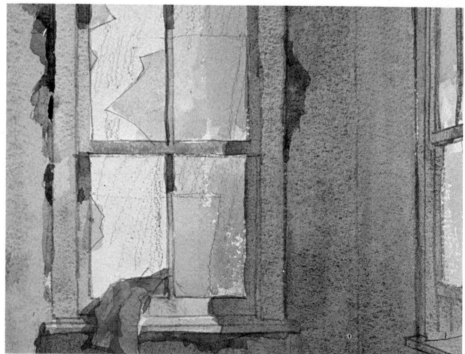

Step 4 (Detail). If you want to get the feeling of sunshine, you've got to paint *shadows*—that's what tells the "story," as this detail clearly shows.

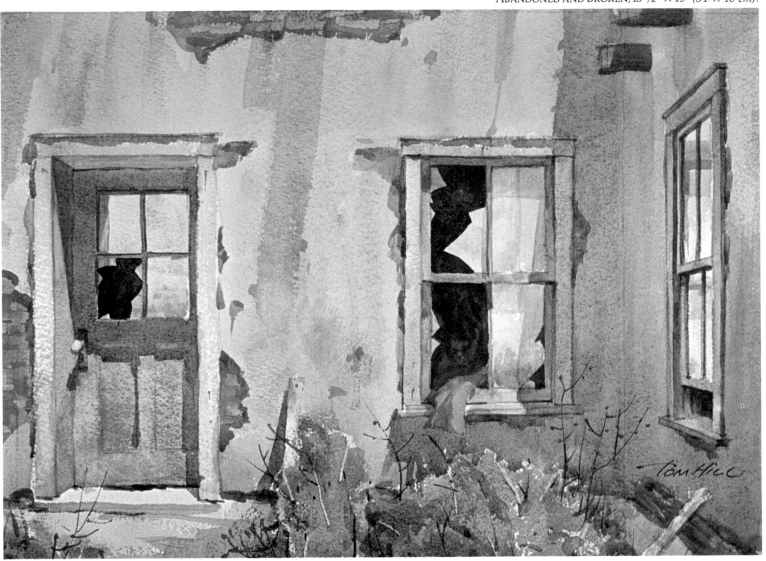

Step 5 (Above). I paint in the darks that show where the glass is broken, paying careful attention to the character of actual broken glass in my reference sketch. I use a mix of ultramarine blue, burnt sienna, and permanent rose, letting the warm colors dominate. To me, warm darks in this type of situation seem to recede or "go in" better than cool darks. I add the final details to my door and windows, mostly with my Nos. 6 and 8 round brushes. The No. 6 rigger helps me produce some good stickery weed stems in the foreground.

Step 5 (Detail). Note how the addition of darks along the frames and muntins of the right-hand window increases the mirror effect of the glass, which is reflecting a vague bit of the center window.

Weathered Wood

Artists have always been fascinated by textures, and being able to successfully portray an object's texture helps the success of your painting. Since the problem of painting weathered wood often comes up, let's examine one way it might be handled.

The first step, as always, is to know and understand the subject. When wood is unprotected and exposed to the weather, many changes take place. The softer grain erodes, leaving the harder grain raised. Heat and cold cause cracking and splitting. The sun's rays do their work too, changing the color—usually bleaching it (lightening its value) and turning the wood from an original warm color to a grayer, cooler one. Stains, like the rusty ones caused by nails, run down the surface, or creep along the direction of the grain.

You'd think that wood would weather more in a harsher climate, but I've seen weathered wood all the way from Alaska to South America, and it's all similar. People love to call this weathered wood "driftwood," though the wood itself may never have been near a *puddle*, much less the ocean!

Having this particular painting problem in my mind while on a recent trip to northern California, I was delighted to come across a marvelous example of weathered wood to use in this demonstration. It was the gate of an abandoned ranch, exposed to the sun, wind, and rain on a hill facing the Pacific Ocean. It was obvious that the weather had been at work on it for a long time: The wood grain was stained here and there from the nails, screws, and bolts that had gradually loosened in their fight to hold the now sagging gate together. The old buildings in the background were about to collapse too, roofs sagging, shingles blown away, windows broken and askew. It was a great subject for a watercolor with weathered wood.

When you're painting weathered wood, remember: (1) Look for color and value changes from the new wood; it's usually grayer in color, and lighter in value (though not always—sometimes it's darker). (2) Observe the character—splits, cracks, and knots missing from knotholes, a general loss of sharp edges, a more worn quality. (3) Note how old wood is often twisted and warped, with pieces or parts coming off or missing.

Brushes and Other Tools. Most of this painting was executed with my 1" (2.5 cm) flat sable, though I did use the 1½" (4 cm) flat oxhair a little. My No. 8 round sable and the No. 6 rigger were employed in the last stages. I used a mat knife for knifing out.

Paper. This was painted on an old sheet of Crisbrook (English handmade) 300-lb rough watercolor paper, though I'm not sure it's still available now. It's a little more absorbent than the comparable Arches paper and, I think, a little whiter. As usual, if I have the time, I stretch even 300-lb paper!

Colors. Again, you can see my preference for the more transparent colors. My yellows were raw sienna and new gamboge; my reds, alizarin crimson, permanent rose and scarlet lake; and the blues, manganese and cobalt. In addition I used burnt sienna and a little phthalo green.

Painting Tip. I used warm color against cool and light value against dark to help the gate and background work together and "read" more easily.

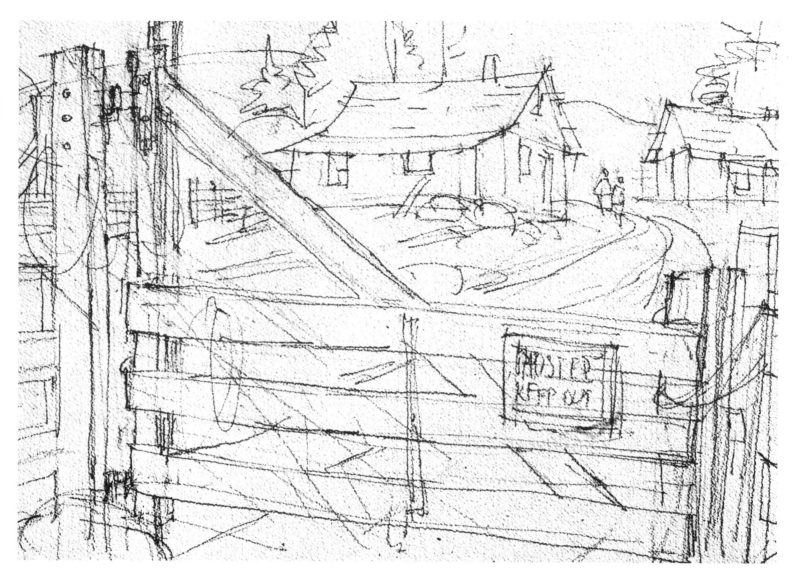

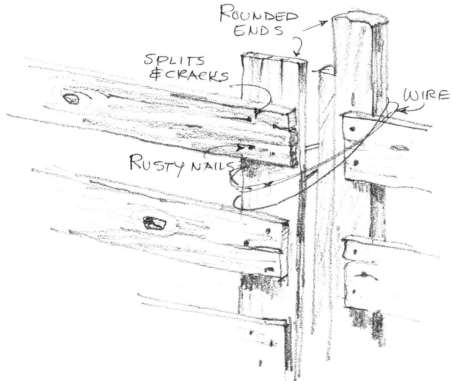

ROUNDED ENDS

SPLITS & CRACKS

WIRE

RUSTY NAILS

Step 1. I decide to enlarge my thumbnail sketch directly onto my stretched watercolor paper, using my eye and working freehand, rather than enlarging it by the grid method. As in the other demonstrations in this book, I've used darker pencil lines than usual so that they show up in the printing process, and you can see my drawing more clearly. Normally I don't do this, preferring lighter and fewer lines and I usually erase most of them about halfway through the painting process (when the paper's dry, of course). Pencil marks will erase from transparent watercolor fairly successfully, especially if they aren't too heavy or haven't been erased and redrawn a lot.

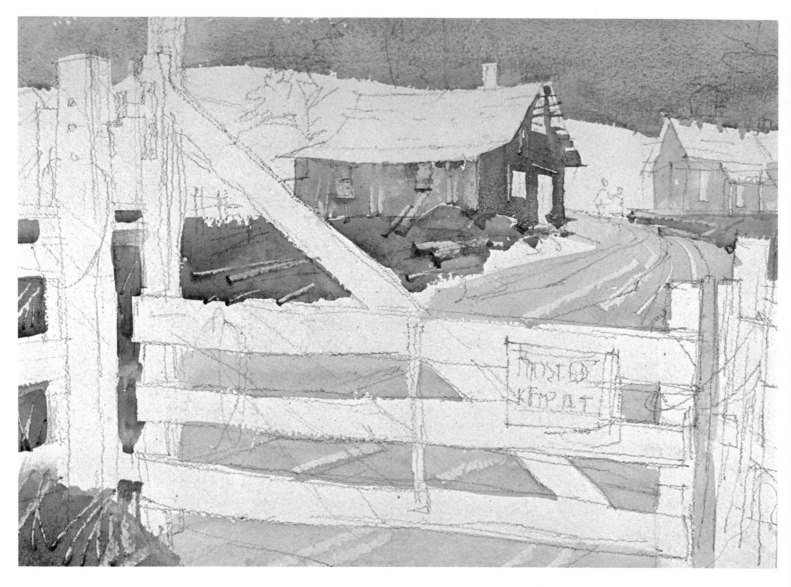

Step 2 (Above). With my 1½″ (4 cm) brush and a mixture of manganese blue and a tiny touch of phthalo green, I paint the sky area, cutting in around the mountain, fence, and buildings. With the 1″ (2.5 cm) flat brush, and a mixture of new gamboge and permanent rose, I paint the road, leaving the gate white paper. While this is wet, I knife out a few directional lights from the road. Next, I paint the walls of the buildings using new gamboge and scarlet lake on the sunlit side, and manganese and alizarin crimson on the shadow side. I paint around the windows, door, and ragged roof, and knife out a few lights. The grass and weeds on the left are a mixture of phthalo green, grayed with scarlet lake, and charged with bits of new gamboge and burnt sienna, and are also knifed out.

Step 2 (Detail). You can see here how I paint *around* the fence (negative space) rather than mask it out with tape or liquid frisket.

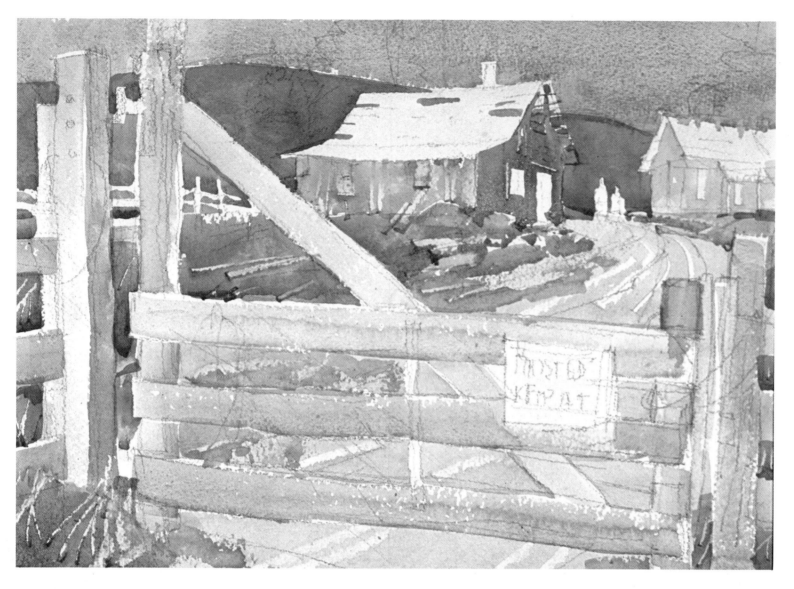

Step 3 (Above). The mountain's shape, a mixture of alizarin crimson and cobalt blue, is painted very simply around fences, houses, and potential figures. Now I use my 1" brush and lightly and quickly paint light washes of manganese blue and permanent rose on the gate, and new gamboge and scarlet lake on the fence. More greens, this time lighter and yellower ones, are added in back of the fence and gate to show weeds and grass growing by the road. I knife out parts of this while wet for additional weed texture.

Step 3 (Detail). Here you can see how spots of white paper or texture ("skippers") are left as the brush moves lightly over the rough paper. This is fine for a more weathered wood "feeling" and much easier to accomplish on a rough-surfaced paper than on the others.

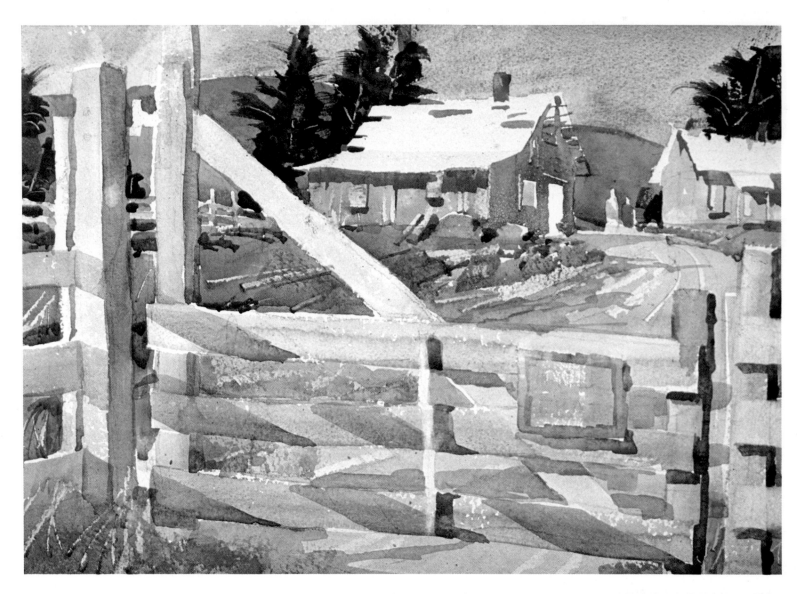

Step 4 (Above). After erasing some of the pencil, I paint in the dark trees using a mixture of phthalo green, alizarin crimson, and burnt sienna, paying attention to their individual silhouettes and where they show through the broken roof. I knife out a few lighter limbs. I add some darker greens to the grass areas. The cast shadows on the fence, gate, and road are painted mostly with a blue violet mixed from manganese blue and scarlet lake. I add the shadows on the walls of the building with burnt sienna. I'm still using a 1" (2.5 cm) brush—it helps keep everything simpler and looser! Warm shadows on the fence and little dark shadow accents on the gate are added, as is the "posted" sign.

Step 4 (Detail). My shadows show clearly here, cools blending into warms as the reflected light indicates.

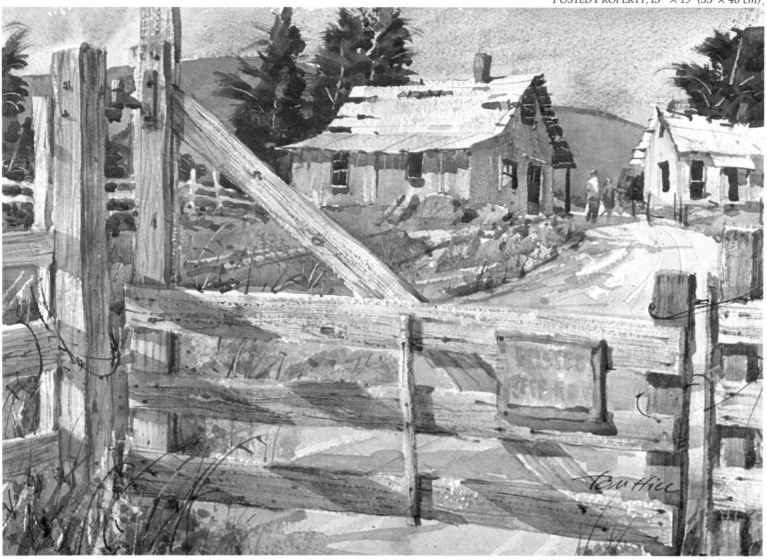

Step 5 (Above). I drag my nearly dry 1" (2.5 cm) brush, with darker values of grayed blues, violets, and burnt sienna, across the gate and fence boards, the color just "kissing" the little peaks of the rough paper's surface. Then using my No. 8 round and No. 6 rigger, I paint in cracks, knots, nails, and rusty streaks. This is done with warms and cools, some light and some darker. Details are added to the houses, and the two figures are painted, using smaller brushes. Feeling the need for more texture in the gate, fence, and nearby foliage, I add it with the rigger and do some scraping out with the mat knife. A final look, then I paint in the dark barbed wire using the rigger, some grayed burnt sienna, and a quick, sure hand.

Step 5 (Detail). This closeup shows the final technique. Though it's fairly elaborate, I think you can see that none of that detail is overdone or out of keeping with the rest of the rather free watercolor technique.

PROBLEM FOURTEEN

Rusty Metal

When unprotected iron or steel are subjected to the effects of moist air, rust occurs. To the chemist, rust is hydrated ferric oxide; to the artist, it's a lovely grayed red-orange color, often containing interesting textures.

Rusty buildings and roofs, rusted machinery, cars, and bridges, all offer interesting and colorful possibilities as subjects in paintings. The subject of the demonstration in this chapter is rusty shrimp boats in drydock near Biloxi, Mississippi. Watercolorists love to paint boats, and I'm no exception. The configuration and compound curves found in boats can cause drawing problems for many artists, but at the same time offers almost endless composition and design possibilities, especially when the boats are in groups and surrounded by all the paraphernalia concerned with caring for them.

In other chapters, we will talk about eroded plaster and weathered wood, and here we'll talk about rusty metal. The point I want to make is that, in every case, you must understand the effect desired and be able to paint it in the picture, and still have a *complete* painting, not just a rendering of one of these effects or textures. Too often, I've noticed, artists (especially beginners) become so enraptured and focused on a particular effect or texture, such as rust, that their paintings suffer in other areas like color, design, and composition. You always run this risk when any one such element dominates your painting too strongly.

As I mentioned in Problem 12, I believe in "voting in favor of the painting." This means that even the most fascinating detail or element must be only a part of the whole! In the following demonstration, I want my painting to say "old shrimp boats in for repair," and everything in the painting is made to work toward *that* end. The indication of rust on the hulls isn't an end in itself, but says "steel boats that have been around a while," just as the sunshine and puffy clouds help the painting say "it's a nice day," and the palms indicate that "it's a southern climate."

So, in painting the effect of rust (or any other effect, texture, or condition, for that matter) you might try asking yourself: (1) What is my painting "saying," what "feeling" do I want to convey? (2) Will adding the rust help—and will adding more rust help even more? (3) Will adding this effect or texture tend to confuse or perhaps destroy the form or shape of my subject? (4) How can I render this rust effect in the simplest way, so it won't detract too much from the other equally important parts of my painting?

Brushes. Again, I painted the bulk of this painting with my 1½" and 1" (4 and 2.5 cm) flat brushes, only employing my No. 8 round sable and No. 6 rigger at the end.

Paper. I used 140-lb cold-pressed Arches paper, stretched, as usual.

Colors. My palette here was similar to those already mentioned. For my yellows, I used new gamboge and raw sienna; my reds were scarlet lake and permanent rose; and my blues, ultramarine, manganese, and cobalt. Burnt sienna completed the selection.

Painting Tip. Sometimes, as on the sides of these boats, the actual source of the rust is at the top, and the rust stain has run down over the painted sides, coloring them grayed red-orange in a soft, gradually disappearing way. To get this effect, try using a little graded wash of burnt sienna, with more pigment near the rust source, and less as you get further away.

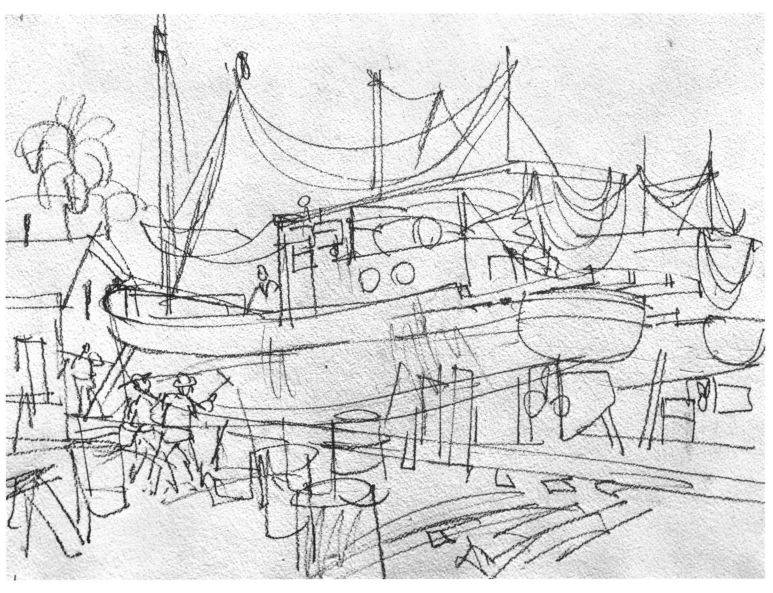

Step 1. I plan my composition, working from numerous drawings and photographs made on the spot. When I feel that my value and composition study is about right, I quickly and freely sketch it onto my stretched watercolor paper, using a 4B (soft) graphite pencil. As I don't bear down too hard with the pencil, its marks can be erased as I finish the painting.

99

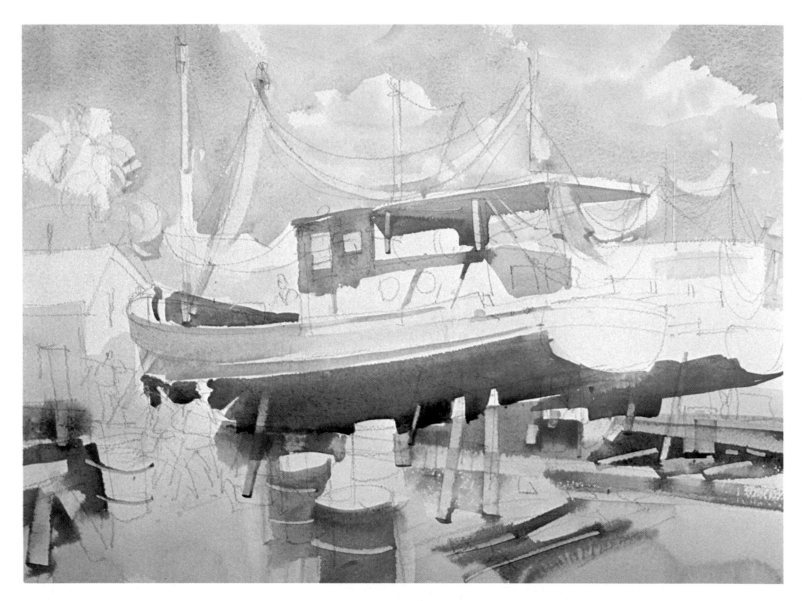

Step 2 (Above). First, I wet the sky area, and while it's wet, charge in a warm light gray for the shadow side of the clouds. I quickly paint the blue sky with manganese and cobalt blues, part of it wet-in-wet, and part crisp around the clouds, cutting around the cabin of the boat. While the wash is still wet, I knife out the masts and nets. Tints of scarlet lake, new gamboge, and raw sienna are painted wet-in-wet as abstract shapes in the foreground. While this is drying, I paint the hull burnt sienna with a bit of permanent rose, grading down darker with ultramarine, and cutting around the figures and barrels with my 1" (2.5 cm) brush. I paint the shadows under and on the boat's superstructure, using burnt and raw sienna, plus small amounts of scarlet lake and permanent rose. Similar and darker mixtures are used to paint the tracks, and some knifing out is done at this point. The barrels are painted in burnt sienna, allowing them to bleed a little, and some lights are knifed out.

Step 2 (Detail). You can clearly see the broad treatment and design of shapes here, both made easier by the use of larger brushes.

100

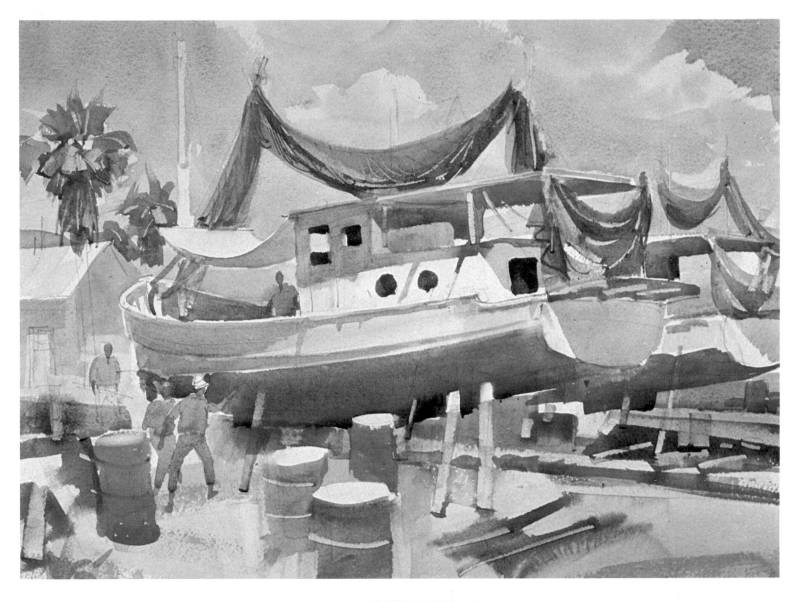

Step 3 (Above). At this point, I erase some of the pencil lines, then paint the nets and palms using my 1″ (2.5 cm) flat brush and mixtures of new gamboge and raw sienna, manganese and cobalt blues, plus bits of burnt sienna, knifing out textures in it before it dries. The cool shadow on the upper hull is next, and is painted with grayed manganese and cobalt blues, following the path of the shadow, which disappears as the hull comes into the sunlight. Now, I block in the figures in simple terms, in a style consistent with that of the rest of the painting, and add more barrels, the light value on the little building, and the darks (ultramarine blue and burnt sienna) of the portholes, doors, and windows.

Step 3 (Detail). Although this closeup shows that more detail is added, note that it's still handled in the broadest and simplest technique. The stress is on design and the relationship of the various parts of the painting to each other.

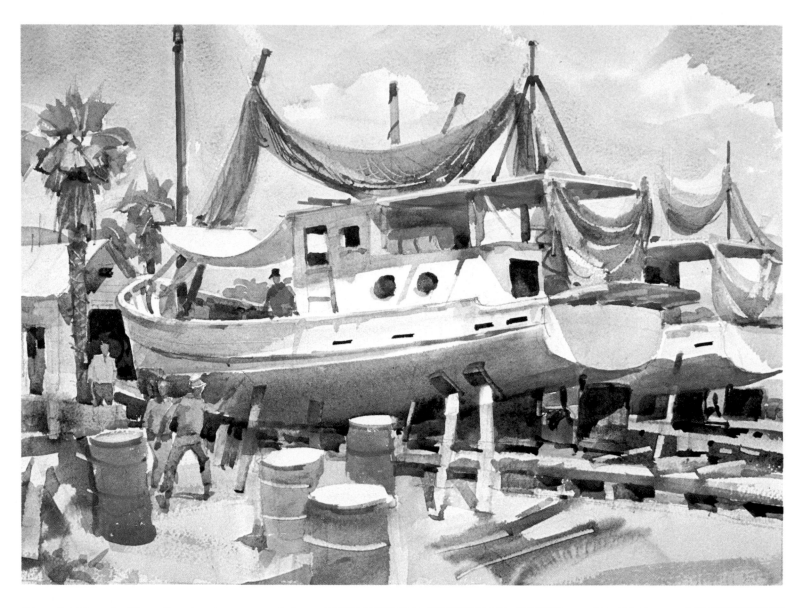

Step 4 (Above). Now I paint in some of the darks that are under the boats—the blocking and struts that hold it in place, the rudder and propeller, and more track detail—all handled in the same style as what was painted so far. Nearly all this is done with my 1" (2.5 cm) flat brush, plus some knifing out is done with my Dexter mat knife. I use its blade as a squeegee, pulling away from the cutting edge, and moving the wet paint aside. This way, not much change takes place in the paper's surface, as it would if I actually *scratched* the paper. I paint more cast shadows, add trunks to the palm trees, and put darks in the building.

Step 4 (Detail). So far, no rust has been painted, but here you can see the scuppers, the little dark slots on the boat's hull. This is where most of the rust will come from.

102

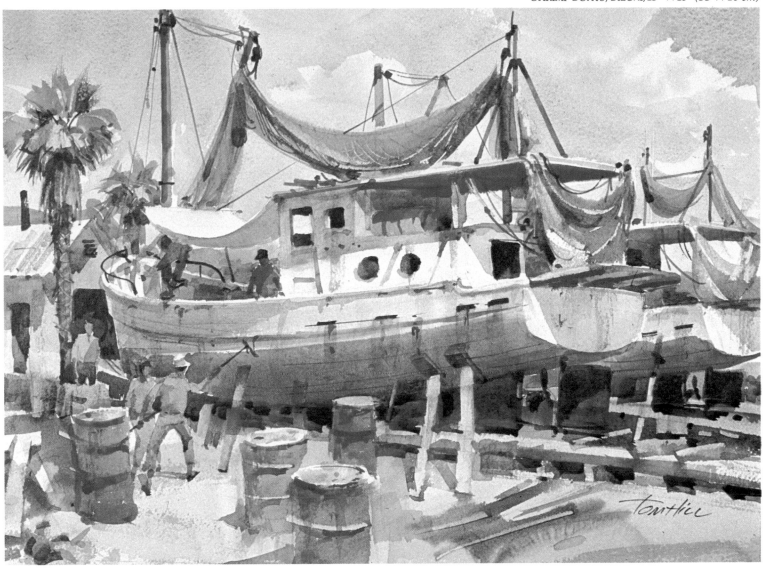

Step 5 (Above). Now I add the detail. Notice how a minimum of rigging will suggest a lot. The actual boats have much more detail than I've shown, but painting it won't really do anything but add to the busyness of an already "busy" composition! Finally, I paint the rust on the boat's hulls, pulling burnt sienna down from the scuppers in little graded washes, with my No. 8 round sable brush. I also add a few rust patches or spots, being careful to not paint too many so this doesn't get "jumpy." Then I paint the shadows on the barrels and patches of rust on them, too. Other details are added to the figures, saw horse, building, and the boats, mostly with the No. 8 round and No. 6 rigger.

Step 5 (Detail). As you can see, rust was about the *last* thing I painted in this picture—and it didn't take very much of it to be enough!

Stone Wall

Of course, there are many kinds of stone, just as there are many types of walls. But when I think of a stone wall, I think of the old fieldstone walls our ancestors built when they cleared their fields and just piled up the stones, without fitting them together, and without mortar. On the other hand, I've seen stone walls that were cut, fitted, and even *polished*! So, the way you paint a stone wall depends on *which* stone wall, and how important it is in your painting!

I decided to paint the stone wall of an old barn in eastern Pennsylvania. It was late winter and the morning sun was striking the barn's overhang, casting an interesting shadow over the wood and stone wall below. Patches of old snow and raw sienna-colored earth reflect light up under the overhang and into the shadows creating a very "high-key" situation—fun to look at, and a challenge to paint!

The stone wall *you* paint may be entirely different, but let's analyze the way I handled this one in order to better understand the painting process. What are the features—the "essence"—that make a wall look like *stone*, and not wood or glass? For one thing, the stones are of different sizes and different shapes. Although the stone mason probably used stones of the same kind, and from the same source, these stones still differ in color and texture. And even though he split, chipped, and cut them, they don't line up perfectly. There are cracks, but these are different from cracks in wood. They're shorter and not as straight. The wall has mortar in it, but sometimes the mortar is flush with the surface, blurring the cracks (joints)—while, at other times, it's more hidden, making the cracks between stones more pronounced. Here and there a stone protrudes over the one below it, casting a shadow—or the reverse situation happens and the stone above indents, leav-

ing a highlight or lighter value instead of a shadow on the stone below. Exposure to weather makes the outside stones a little different, both in color and texture, from those inside the barn. The stones in sunlight are sharply defined; those further back in the shadows are more blurred, and some of the joints or cracks are hardly noticeable there.

Some points to think about in painting this particular stone wall: (1) The stones are of different sizes, and although cut and fitted to a degree, don't line up perfectly. (2) There's a variety of color (warm and cool), value (light to dark), and texture (rough to smooth). (3) The cracks vary—they're not straight, and some are more visible than others. (4) Although the stone wall in this painting is important, it's not the *whole* picture, therefore must be integrated with the rest of the painting.

Brushes and Other Tools. As in so many of my watercolors, I use only a few brushes: my 1½" (4 cm) flat oxhair, a 1" (2.5 cm) flat sable, a No. 8 round red sable and my No. 6 rigger. Most of the painting is done with the first two. I also use my mat knife for scraping and knifing out, plus a little salt.

Paper. I used a half sheet of rough 300-lb Arches watercolor paper (even so, I stretched it!).

Colors. I always have more luck painting transparent watercolors if I use the more transparent colors. Here the yellows I used were new gamboge and raw sienna; the reds, alizarin crimson and scarlet lake; and the blues, cobalt, ultramarine, and manganese. In addition, I added some burnt sienna.

Painting Tip. There's a little glazing here, but mostly I mix the color, put it down, and leave it!

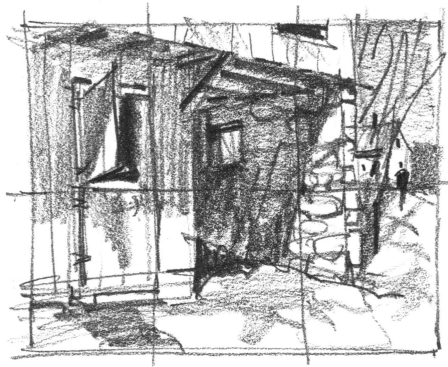

Step 1. I make a thumbnail composition and value study, in the same proportion as my stretched watercolor paper, to serve as a plan for the painting. I use the grid method to transfer and enlarge this thumbnail onto my watercolor paper. By dividing both the thumbnail and the watercolor paper into the same proportions, and by observing where each part falls on the grid, and reproducing it, it's relatively simple to transfer the design and composition to my paper. I also indicate in pencil about where my major shadows fall. This is always a help, for the sun keeps changing every moment, and you must decide where the shadows will be, then paint them that way even though a short time later they're quite different! The land slopes up, so most of the elements in my painting are above eye level. I'm careful that my perspective is correct and I show this angle by indicating the underside of the barn's overhang.

105

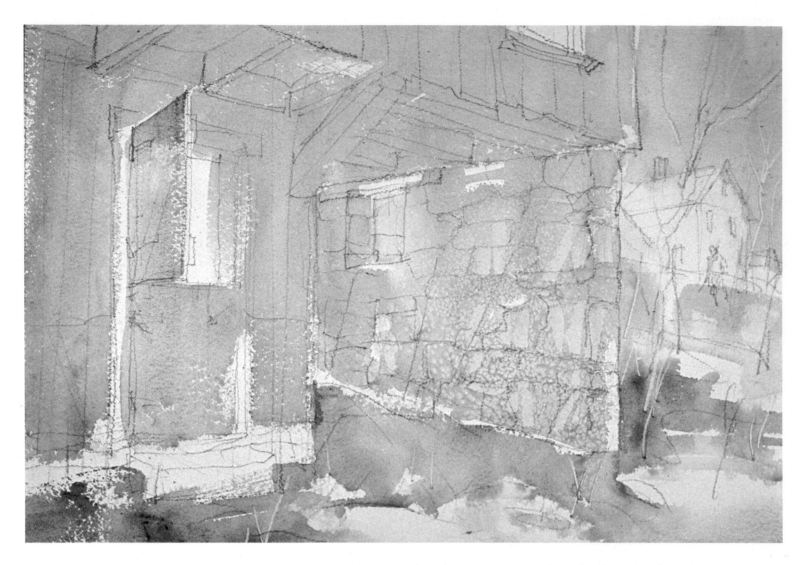

Step 2 (Above). After erasing some of the graphite, I *lightly* spray the entire paper with clear water from my atomizer. I paint the sky with ultramarine blue, adding some manganese blue to the snow areas. Using my 1½″ (4 cm) brush, I quickly wash an alizarin crimson tint over the wooden walls, and cobalt blue and alizarin crimson over the stone wall, charging new gamboge and raw sienna into parts of each area while still quite wet. I dash a bit of salt into the stone wall wash, then paint the "Dutch" door with a mixture of manganese blue and scarlet lake. The earth is painted with raw and burnt sienna around the patches of snow. While it's still wet, I knife out a few weed stems. When the paper dries, I brush off the salt granules.

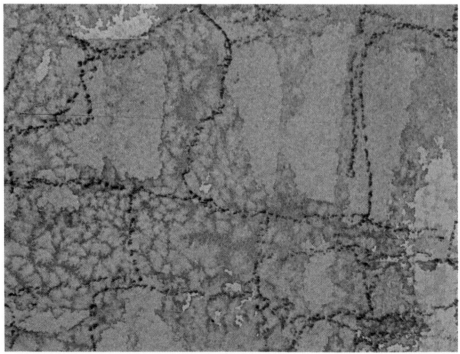

Step 2 (Detail). Here you can see how the salt adds an interesting texture to the stone-wall wash.

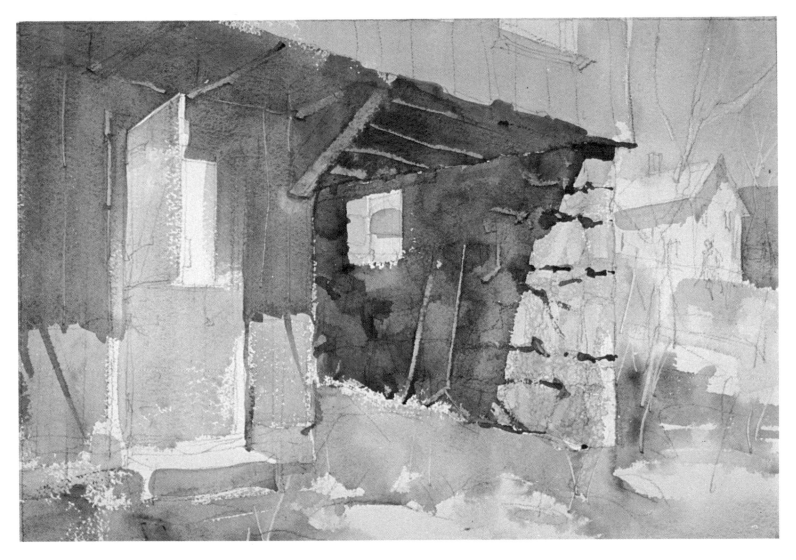

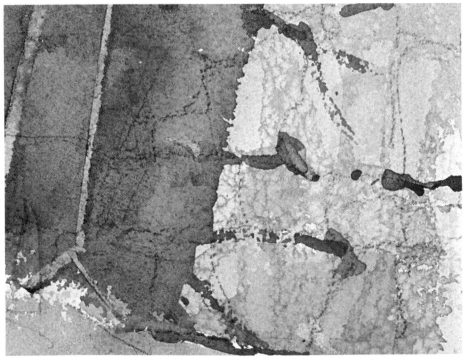

Step 3 (Above). Using my 1″ (2.5 cm) brush, I paint the diagonal shadow on the stone wall with alizarin crimson and cobalt blue, charging in raw and burnt siennas toward the back. With the same sienna mix, I use the tip of the brush to "drag" some of the shadow wash out of the edge of the diagonal and create some of the shadows cast by the cracks in the stone wall. Next I paint the ceiling and shadows of the overhang with a mixture of manganese blue and scarlet lake, charging in new gamboge while it's quite wet, to give the feeling of reflected light. At this point, I knife out the rafters and the brace, and the handles of the farm implements leaning against the stone wall. While all this is still wet, I paint the shadow on the wall with alizarin crimson and manganese blue, blending it with the shadow of the overhang.

Step 3 (Detail). This closeup clearly shows the granular quality of the manganese blue and how it settles, and the way I treated the cracks between stones.

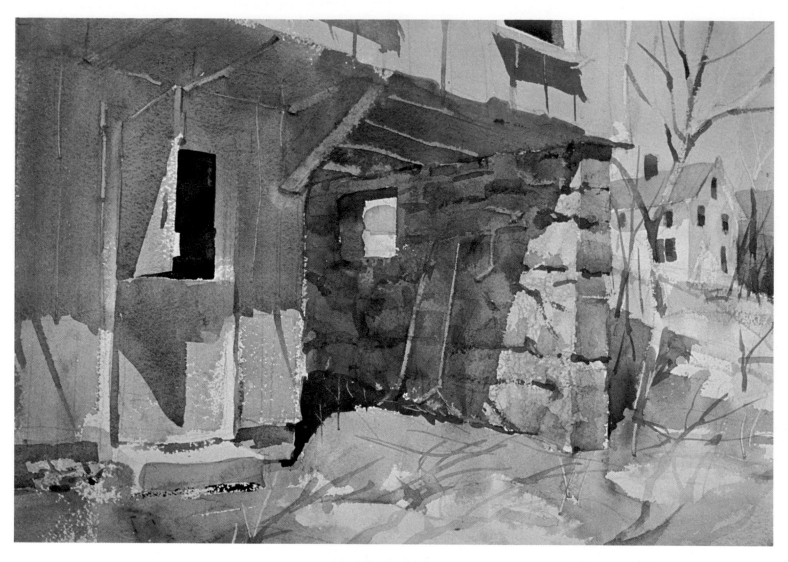

Step 4 (Above). Next I paint the shadows on the door and windowsills, using a grayed manganese blue and some alizarin crimson. The shadows on the ground are painted with grayed burnt sienna, and those on the snow in blue/violet. I use a rich mixture of burnt sienna, alizarin crimson, and ultramarine blue for the dark shadow behind the doorway of the barn. I enrich, and slightly darken the *end* of the stone wall with warm and cool glazes, adding a few tints to the rest of the stone wall and elaborating on the cracks just a little more. The house and trees in the background on the right are given more detail.

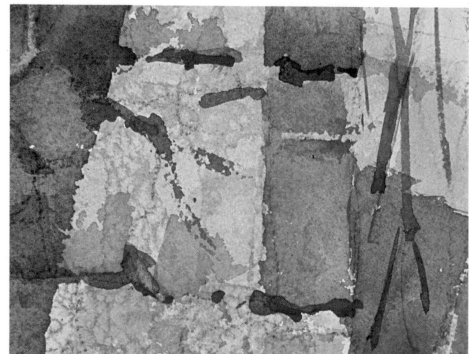

Step 4 (Detail). This closeup shows the glazes that darken the end of the wall and help show that it's getting slightly less sunshine than the side of the wall.

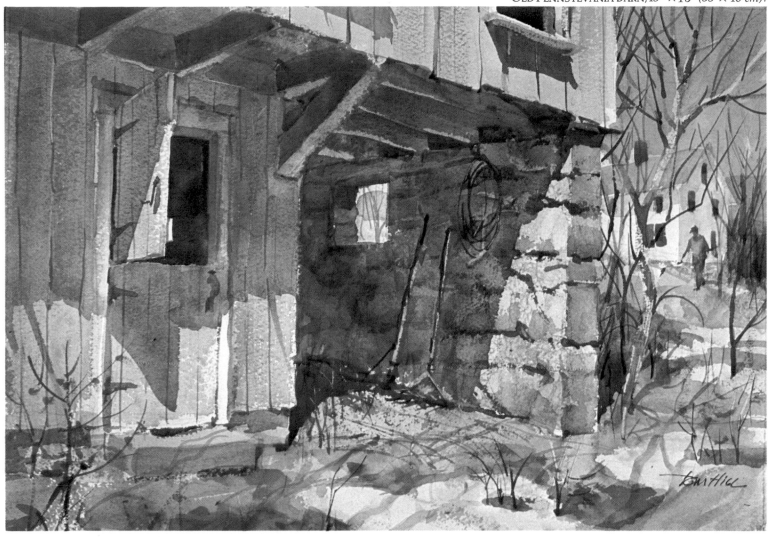

Step 5 (Above). Here's where I finally use my smaller brushes, though sparingly! I use a No. 8 round sable and a No. 6 rigger to add details to trees, weeds, wood cracks, door hardware, coiled wire, and so forth. You may have noticed that I'm not using any black on my palette. All these dark details, and some that aren't so dark, are mixed from complements! It's easy to slant the mixture from warm to cool, depending which complement dominates, and the results don't have that "dead" look. Try using warm darks for dark openings like windows, doors, or cracks—they'll appear to go "in" better than they would with cool darks.

Step 5 (Detail). It's easy to add details after you've solved the big basics in your painting of composition, color, value, and what you want the painting to "say." The trick *then* is to not to add too many!

109

Eroded Wall

Whether sun-dried mud in some far off native village or modern cement-lime stucco on a new building here, any such wall left to neglect and the weather will start to fall apart, or erode—and *that's* when we artists love to paint them, not when they're new!

Down in Mexico, plastered masonry walls are common—and so is their neglect! Stucco gives way in pieces and falls off, revealing the brick, stone, or rubble beneath it. Later it might be patched, maybe even painted—only to have it occur all over again as the paint weathers, fades, and peels. The stucco may also become weakened by rain leaking or seeping under a part of it, and more pieces will fall off.

Stains also develop where the rain washes over or through the masonry, and rust from downspouts and gutters may cause long "wet-in-wet" red-orange streaks running down the wall. All of this makes for fabulous textures, colors, and effects—and sometimes for confusion, too, when you try to interpret it in a painting!

For this demonstration I picked a wall and window in one of the old colonial towns of central Mexico. I added the figure of a nice local resident, heading home from the market with her purchases in hand (and on head!). She gives scale and life to my painting. The eroded wall, plus part of a window and the sidewalk and curb are her "stage." By adding the sunshine streaming down nearly vertically at high noon, I can use this downward light and the resulting long cast shadows not only for drama and to tell the viewer the time of day, but also to help explain the eroded character of the wall.

As in the previous problem, you must decide how to paint such a wall and have it look like plaster or stucco, and not wood, brick, or some other material. As with any other painting problem, if you *understand* your subject, you'll be able to paint it more easily.

Here are some points to consider: (1) Originally, the entire wall was smooth—and some smooth parts still remain. They help the eroded parts look even more eroded! (2) Where you decide to place these "erosions" (cracks, stains, fallen plaster, etc.) should be carefully considered. They must be a part of your painting's design, not just rendered for its own sake! (3) Even though you may be painting a very simple composition showing an eroded wall, try to incorporate some element that will give it scale—and life.

Brushes and Other Tools. My 1½" (4 cm) flat oxhair brush and my 1" (2.5 cm) flat sable did the bulk of the work. I also used a No. 8 round sable and a No. 6 rigger for final details, together with some salt and knifing out.

Paper. I used a half sheet of stretched, rough, 300-lb Arches watercolor paper. Its surface is just rough enough to greatly aid in the dragged and drybrush technique I planned to use.

Colors. My yellows were new gamboge and raw sienna; my reds, alizarin crimson and scarlet lake; and the blues, manganese and cobalt. As usual, I added some burnt sienna.

Painting Tip. Avoid over-rendering the details—they should be no more "finished" than the rest of the painting.

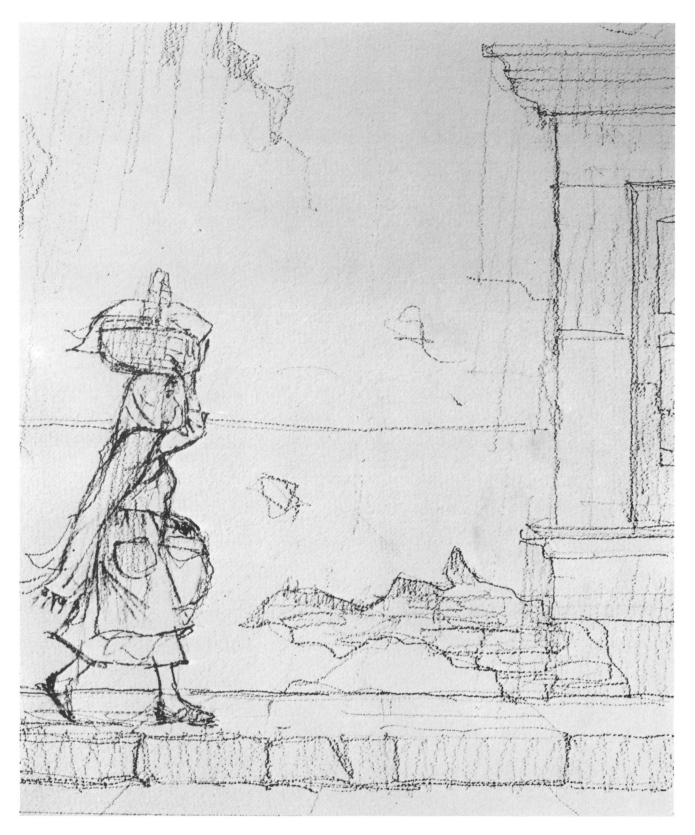

Step 1. A vertical composition seems natural for this subject. Looking at the wall straight on, and running it out of the top and sides of the picture gives me a chance to make my subject *seem* even bigger than the size of my paper would normally allow. This arrangement is actually a one-point perspective—verticals stay vertical, and horizontals are at right angles to my line of vision. Referring to my "thumbnail" plan, I carefully sketch the composition onto my paper. The figure, based on a previously drawn study, is facing into the picture and is balanced by the window on the right.

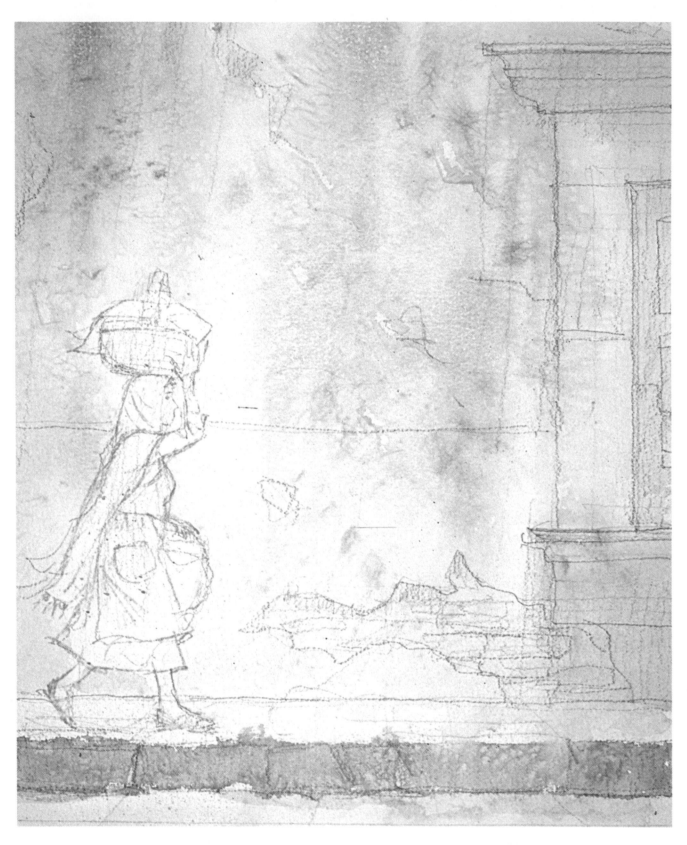

Step 2. With clear water and my 1½″ (4 cm) brush, I wet the paper from the top down to the sidewalk, except the figure, which I leave dry. Next, I apply separate washes of manganese blue and scarlet lake, letting each one run down, spreading and mingling on the tilted paper. Then while everything is still wet, I charge touches of burnt sienna into some areas, knife out several highlights for future cracks, and sprinkle salt into other parts of the wet washes. While this is drying, I wet the area of the curb, and while it's damp paint it in 1″ (2.5 cm) strokes, mingling raw sienna, permanent rose, and manganese blue. After everything is completely dry, I brush off the salt and erase a lot of the pencil drawing.

112

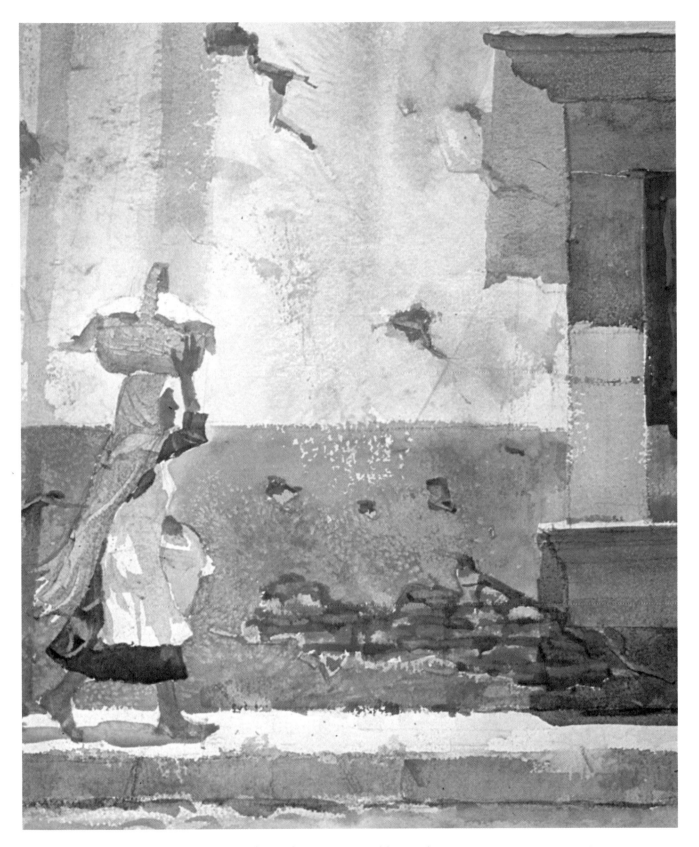

Step 3. With various values of a manganese blue and permanent rose mixture, I paint the stone frame, lintel, and sill of the window, charging in some yellow/orange on the underside to show reflected light. With the same mixture, I later paint the shadows cast by the window, the figure, and the long shadows down the wall (diluted a bit). Next I wash in the painted "wainscot" effect of the lower wall with a mixture of alizarin crimson and new gamboge, cutting around the figure, and the patches of exposed bricks and rubble. These are later painted with raw and burnt sienna, and their shadows with a darker value of the same color. The figure is painted with manganese and ultramarine blues, burnt sienna, raw sienna, and a touch of green. The shutter is painted in two values of burnt sienna, and is knifed out for some reflected light detail.

113

Step 4 (Detail). Here you can see the delicate, transparent glazes I ran over the original wet-in-wet washes of Step 2 to add to the effect of subtle bulges and hollows in the wall. It also shows the knifed out reflected light in some of the detail in the dark burnt sienna shutter in the window.

Step 4 (Detail). More eroded wall effects are seen in this closeup, as well as my treatment of detail on the figure. If you look carefully, you can see the texture of the salt and of the "dragged" brush, and the tiny plaster cracks I made with the No. 6 rigger.

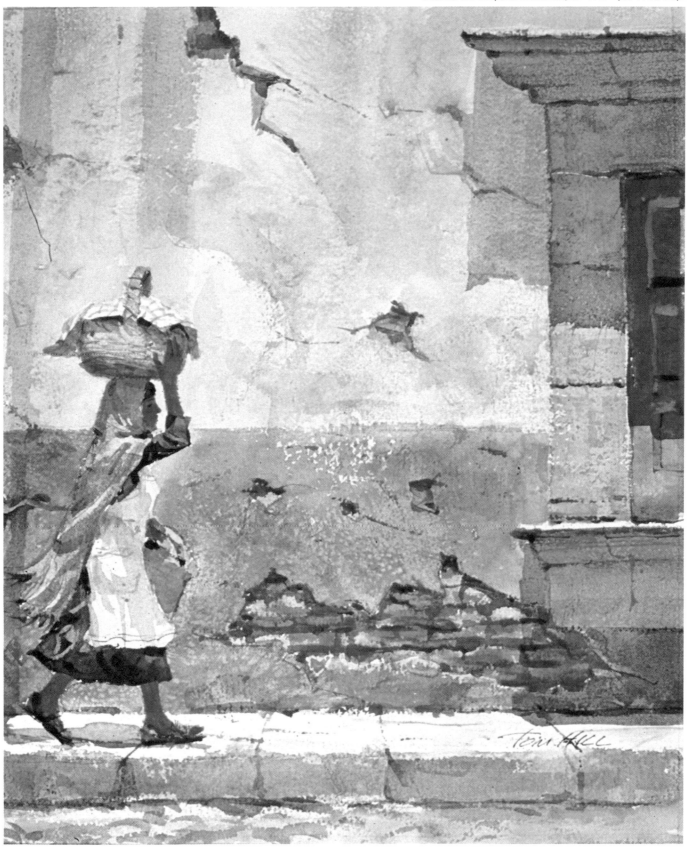

Step 4. Now I pull the painting together; that is, "fine tune" it! In addition to the 1" brush, I employ my No. 8 round and No. 6 rigger to further elaborate shadows and details. Cracks and architectural shapes in the window are now delineated, and details, tiny cast shadows, and highlights in the eroded wall are carried further. Now, with my 1" (2.5 cm) flat brush, I lightly wash some delicate glazes on parts of the wall to help show the more subtle irregularities in it. With the same brush, I "drag" nearly dry paint—in various warm and cool mixtures—over parts of the wall, window, sidewalk, and street, to add even more rough textures.

115

Long Shadows

Throughout this book we've been involved in painting shadows of one sort or another because, in representational painting, this is one of the principal ways to describe the light. If you want to show sunlight, for example, you paint the shadows! So, as a painter, it's important to understand all you can about light and shadow.

This demonstration involves long or slanting shadows—those that most often appear in early morning or late afternoon situations. The way the shadows occur and fall in a painting can tell a lot about the time of day, the weather, and mood of the scene.

In many of the paintings I've seen, the shadows are more or less correct in value and are passable in perspective, but often the artist apparently hasn't understood some of the subtle things that can happen to them, or has not been too concerned with the aspect of their hues. When sunlight is interrupted by some object there's a shadow *on* the object as well as one cast *by* it. (Some of this will be covered in the next problem, "Shadows on White Objects"). The color that you see in the shadow is determined by the local color that's already there, plus the additional color reflected into the shadow by nearby objects in their surroundings, the sky overhead, and so forth.

My painting is a street scene in Guanajuato, a beautiful colonial city in central Mexico. This made a good subject because the quality of light there is good and the buildings are interesting in both color and architecture. In the scene, late afternoon light streams in, spilling diagonally and shallowly across the face of the buildings, creating very long cast shadows. This provides a good opportunity to use the patterns that these shadows make for an interesting design and an arresting composition.

The following points might be useful to keep in mind when you're painting a similar subject: (1) After you've determined the local color, look for whatever else might be reflecting some light—or dark—color into it. Take these colors into account when you paint the shadow, and then try for the simplest way of stating it. (2) Cast shadows are darker in value and have "crisper" edges when they're close to what is casting them than when they're farther away. Their edges get sort of "out-of-focus" as they move away from their source, and since more reflective light influences them then, they also get lighter in value. (3) Be aware of perspective when painting shadows—it's there as well as everywhere else! (4) The longer and more oblique the cast shadow, the more distorted it looks when compared to the object casting it.

Brushes. I used my 1½" and 1" (4 and 2.5 cm) flats for a great deal of this painting. A No. 6 and a No. 8 round sable as well as a No. 6 rigger aided in the smaller details.

Paper. I used 140-lb cold-pressed Arches watercolor paper—stretched.

Colors. I can't think of a better place for transparent colors than in shadows! My palette reflects this thought. For my yellow, I use new gamboge; for my reds, scarlet lake and permanent rose; and for my blues, manganese, cobalt, and ultramarine. My earth colors are raw and burnt sienna.

Painting Tip. If you're unable to paint on location and must use some colored prints or slides for reference, paint your shadow colors and values the way I described above. Don't go by the shadows in the photos. All too often they'll be too dark in value, (even black!), and the film will also be insensitive to the many colors that are present in actual shadows.

Step 1. The subject matter of this painting is very familiar to me for I've lived and painted in many of these towns in central Mexico. Many of the buildings are gems of colonial architecture, some dating back to the 1500s, but it's hard to tell the newer ones from the older ones, for they're still built about the same way. I have good reference material and a good thumbnail plan, which I now pencil onto my stretched watercolor paper.

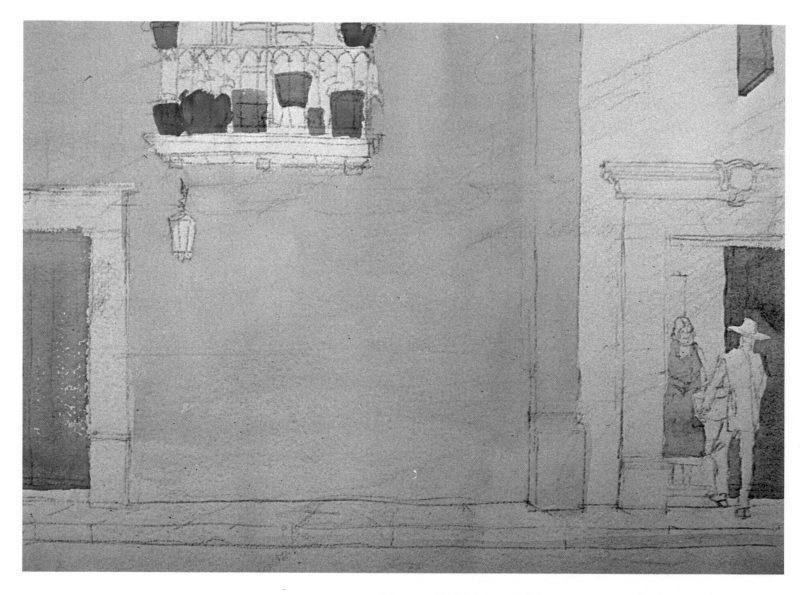

Step 2 (Above). First I wet the paper completely and, using my 1½″ (4 cm) flat brush, I paint in areas of scarlet lake, manganese blue, and raw sienna—as light values. I hold my board at about 45°, letting the pigments mingle and run, staining here, and settling as granulated washes there. When this is dry, I glaze the central building with scarlet lake, making some parts lighter and some parts darker in keeping with the faded character of the actual wall. Next, I paint the door on the left a middle value mixture of scarlet lake and burnt sienna, and the door to the right a grayed manganese blue. The sign above is blocked in with raw sienna. Finally, I paint the flowerpots on the balcony, blocking them in simply with raw and burnt sienna, manganese blue, and scarlet lake.

Step 2 (Detail). This closeup shows the lucidity of the transparent scarlet lake glaze I just painted over the first washes, as well as the sedimentary nature of the manganese blue already there.

118

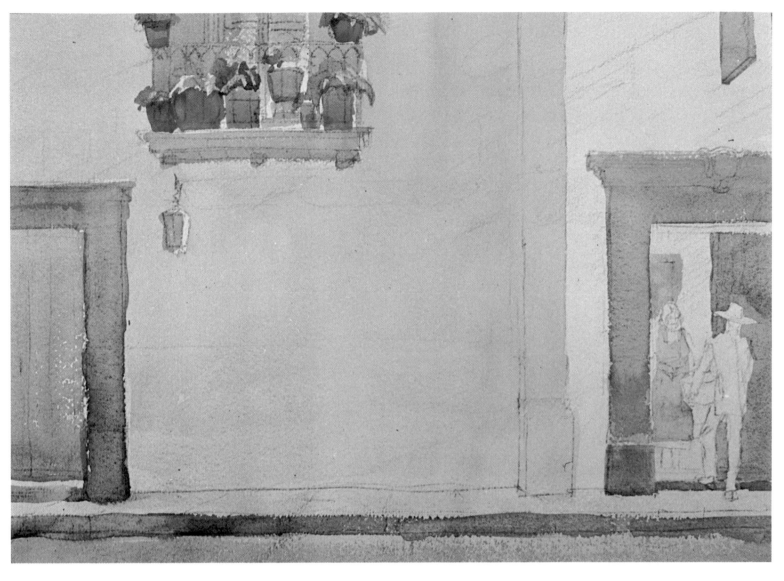

Step 3 (Above). Using the 1″ (2.5 cm) flat brush, I paint the door frames. The one to the left and the window above it are a mixture of permanent rose and manganese blue, while the right-hand door is raw sienna, tinged with some manganese blue. Now, I add some green to the foliage of the flowers in the pots on the balcony, and then paint the curb with varying strokes of raw sienna, cobalt blue, and scarlet lake.

Step 3 (Detail): This closeup shows the directness and simplicity in my treatment of the door frame.

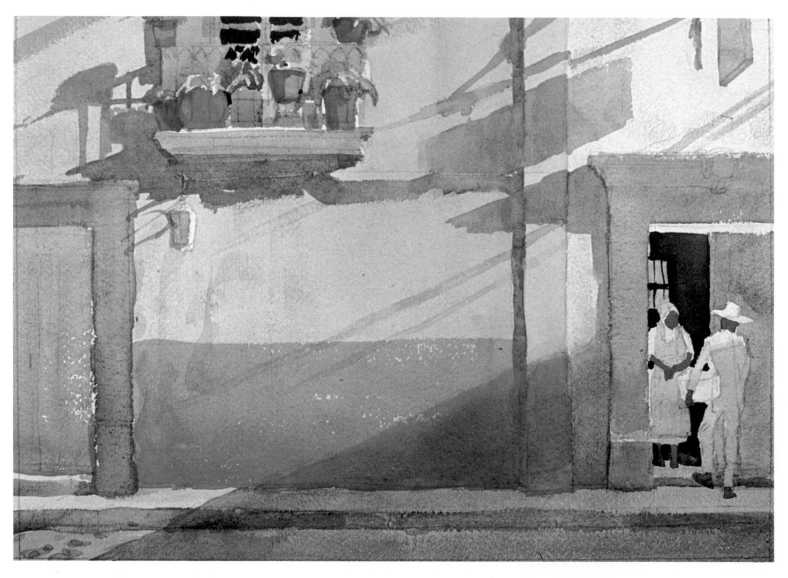

Step 4 (Above). Next, I add the painted panel at the base of the pink wall, painting it a mixture of scarlet lake with some burnt sienna, using my 1" (2.5 cm) brush. After carefully considering the pattern of the cast shadows, both from the standpoint of what can realistically happen and what effect they might have on the impact and design of my painting, I paint in the cast shadows, using darker-value versions of their local colors, and adding some cobalt blue and bits of manganese blue to account for the blue skylight reflecting into them. Note how the shadows are crisp close to their source and fuzzier when farther from it. Now, I add heads and arms to the figures using darkened burnt sienna, and use a rich mixture of ultramarine blue, burnt sienna, and permanent rose for the darks in the door and window.

Step 4 (Detail). This closeup shows the figures in more detail. Note how I'm keeping them in the same degree of finish as the rest of the painting, since I'm mainly striving for gesture and shape.

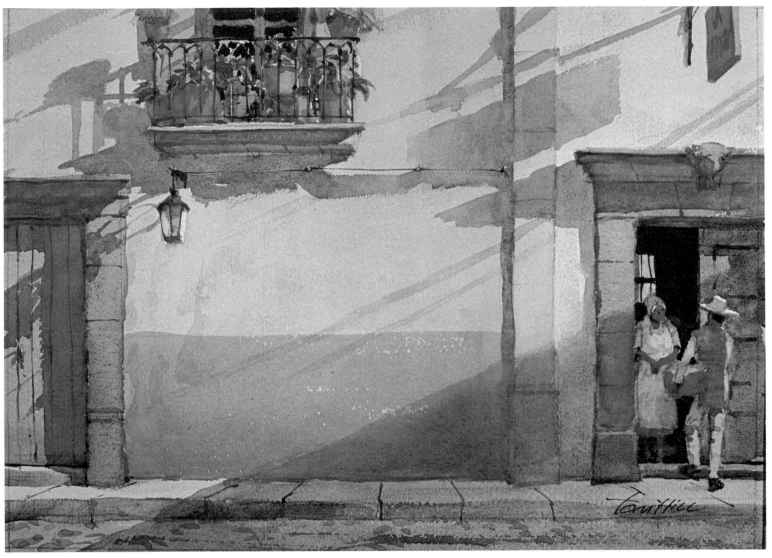

Step 5 (Above). Now's the time for adding the finishing detail. I paint the shadows on the door frames with my 1" (2.5 cm) flat brush, and most everything else with the Nos. 8 and 6 rounds and the No. 6 rigger. This includes the details of the flowerpots and wrought iron of the balcony, figures, doors, lantern and its wire, cracks in the sidewalk, and so forth.

Step 5 (Detail). This closeup shows good examples of crisp and out-of-focus shadow edges. You can also see that cast shadows are usually darker where they're close to what's casting them, and lighter farther away.

Shadows on White Objects

In painting the shadows on a white object, the painting can easily become a "white elephant" if the artist doesn't understand what's happening! As I said earlier, shadows on any object or subject are very useful in explaining many things in a painting: Time of day; type of day; color, scale, and physical nature of the object they're cast on, and so on. But understanding, and then painting, the right color of shadows on a *white* object seems to be a particular problem for lots of painters. Let's examine the problem more closely.

Contrary to the colors I've seen some artists paint them, shadows on white are *not* necessarily neutral gray, nor are they "always blue" as one painter informed me. Let's assume our "object" to be a white house in a sunlit situation. Though many people think sunlight is yellow in color, it's actually white light, and it's neutral. If everything surrounding this white house were also white—or neutral gray or black—then the shadows would be neutral gray. Such a setting is not very likely, however, for we live in a very colorful world. The fact is that shadows, especially those on a white object, offer the opportunity to observe the color of the light that's being reflected into them. Reflected light is always present (it's what enables us to see when we're not in direct light), but it's overpowered by and somewhat invisible in direct sunlight.

On a sunny day, the big dome of a blue sky—reflecting from the opposite direction of the sunlight—can have a lot of influence on shadows exposed to it, tinting them blue. The reflections from white clouds would tend to lighten the *value* of the shadow, without changing its *hue*, whereas a nearby red barn, if it's at the right angle, could cast a definite red or pink tint into the shadow. Green grass, trees, brightly colored clothes on a clothesline—any or all of these things could be reflecting their colors into the shadows, thus affecting the final color of the shadow. It's true that this phenomenon is harder to see in some cases than in others, and is more complicated and hidden when the object receiving the reflection is another color and not white. But this situation is going on all the time and, if you understand it, you can paint it with more authority and confidence! I've know many good artists who, after becoming aware of what reflected light does with color, could then *see* the subtle differences better, thus improving their use of color and producing better paintings!

So, when you're confronted with the problem of painting color in shadows on a white object (or any other color object, really) remember to: (1) Notice the environment around it. What object might influence the shadow by reflecting its particular hue? Can you use this color to help your painting? (2) Even if the color influence isn't too apparent, and may even look neutral to you, at least consider analyzing its color in terms of temperature—whether it's a warm or cool gray—and paint it accordingly. (3) Don't be afraid to simplify what you see, and to act as an editor in the sense that you amplify or intensify the color a bit, if it will improve your painting.

Brushes and Other Tools. As usual, I stuck to just a few brushes, painting mostly with my 1" (2.5 cm) flat brush. I did use a No. 8 and a No. 6 round sable and my No. 6 rigger a bit.

Paper. I used 140-lb cold-pressed Arches watercolor paper, which I first stretched.

Colors. I used a simple, transparent palette. The yellows were new gamboge and raw sienna; the red was just permanent rose this time; my blues were mostly cobalt and manganese, plus a little ultramarine blue to help me mix the few darks I used. I also used burnt sienna.

Painting Tip. If you're working on location, first draw the shadows in lightly—I guarantee that they'll move!

Step 1. At the turn of the century and earlier, some unbelievably ornate and skillfully made houses were constructed in California. A few survive, some in remarkably good condition. This is one of the ones I saw in northern California. At the time I wasn't able to actually paint it on location, but I did make sketches and take some photographs that served as the basis for painting this demonstration. Rather than portray the entire building, I elected to zero in on a part of the front, which enabled me to show in greater detail something of what happens to shadows on a white object. Referring to my reference material, I carefully pencil in my subject, using a one-point perspective (looking straight at my subject, which faces me at right angles to my line of vision). The palm tree and distant hill give just a hint of background and sense of distance to an otherwise flat picture.

Step 2. This is a very high-key, sunny situation and, since I don't want to use dirty washes, I keep all my color mixtures very simple—often using just one color! Using my 1½" (4 cm) flat brush, I wash in light tints of manganese and cobalt blues. They're not mixed together on my palette. Instead I allow them to mingle on the paper, charging them with a bit of permanent rose. All of this is done in a very light value. A tint of raw sienna is placed under the porch and on the distant hill, and added wet-in-wet to the foreground. I then add cobalt and ultramarine blues, burnt sienna, and permanent rose to the foreground, charging it into the wet wash, then knifing out a few lights. I paint the palm fronds with greens made from new gamboge and raw sienna with manganese and cobalt blues added, and darkened with bits of burnt sienna and ultramarine blue. I also knife out the lights, and pay attention mainly to the tree's gesture and silhouette.

Step 3. The shadows on parts of the house (away from the sunlight's direction) and the *cast* shadows thus produced, are next. They're very intricate, so I plan them, both in my mind and with a little pencil indication on the paper. Some of them are both warm and cool within the same area, and will meet wet-in-wet. Notice that cast shadows are often darker in value than the shadows on the objects themselves because there's usually less chance for reflected light to get into them. Reflected light from the warm colors on the ground below is noticeable mostly on the underside of horizontal projections such as the porch, roof, window-header trim, eave, facias, and the like, so I use raw sienna, new gamboge, and bits of permanent rose in these areas. Where the shadow is more exposed to the blue sky, such as below from the eaves and on the face of the house, I use blues (manganese and cobalt) plus a little permanent rose and a bit of raw sienna, which help gray the blues just a whisper.

Step 4 (Detail). This shows the warm colors from the ground below reflecting up into those parts of the window that face it, while the cast shadow, which is more on the face of the house, is being tinted blue by the sky.

Step 4 (Detail). The porch and bay window project, offering opportunities for both warm and cool reflections to bounce back and forth on it. The "barn red" paint on porch floor and steps has faded and now projects lovely pinks upward on the front door and face of the house.

Step 4. Now I add the darks, mostly mixtures of ultramarine blue, burnt sienna, and permanent rose. They're painted in the windows, and foreground shrubs and weeds with my 1" (2.5 cm) brush. Details on the windows, doors, porch, and shutters are also added, some with my 1" (2.5 cm) brush, and others with my Nos. 8 and 6 round sables plus a few touches added with my No. 6 rigger. The main idea here is to not get too carried away with the detailing! It's so easy to do this, especially when it's so much fun! However, "less is more" and I don't want my painting to take on the character of an architectural rendering, but rather just want it to say "old house, sunny day."

127

PROBLEM NINETEEN

Snow on the Ground

The problem here is to paint a transparent watercolor with snow on the ground as a prominent feature of the painting. Since I'm working transparently, the white paper must be my whitest white. This means that, from the beginning, I must plan to save some white paper for my lightest values. This approach is diametrically opposed to that of pure opaque painting, where the whites or lighter values can be added last.

Since my problem is to paint snow already on the ground and not falling or starting to fall, I decided to paint a situation for this demonstration that would depict a sunny winter morning after a storm. The newly fallen snow is largely undisturbed—just a few ski tracks and footprints mar its surface. The amount of new snow isn't so great as to obliterate everything, and it hasn't even stuck much to the thin, bare tree branches. Yet there's a feeling of soft contours and curves, with an occasional little drift or pile up where the storm winds have moved the new snow about a bit, further emphasizing its curved, rounded feeling.

The same problems that occur in painting shadows on a white object (Problem 18) also occur when painting snow, only there are even more white objects when nearly everything's covered with snow! As you may recall, nearby objects reflect their colors and values into shadows. Since this is most noticeable in shadows occurring on white or light-value objects, the shadows on the white snow will be influenced in their hue by what's being reflected into them. In this case, the reflection is predominantly of the blue sky overhead, which influences the shadow color toward the cool side, adding mostly blues and blue-violets. Of course the angle of the sun and the angle at which we view the scene can make a difference, as can the nearby colored

objects, such as the cabin and the forest, which might reflect their colors on the snow, too.

Since we don't add white paint in transparent watercolor, we must plan to make the original white paper *look* like snow. So, to make your lightest values look really light—in this case, to make the snow seem intensely white—you must put dark and middle values and hues against the whites for contrast. In planning a painting like this, try to keep in mind that only a small part of your painting—even with a lot of snow depicted—will remain pure white paper.

Brushes. Because this isn't a large painting, my 1" (4 cm) flat was sufficient for the large areas, while a No. 8 round and No. 6 rigger handled details.

Colors. I used a limited palette here of only seven colors, and I stayed with the more transparent ones, which seems fitting for white snow! Not all "transparent" colors are equally transparent, though. For example, scarlet lake and alizarin crimson are as transparent as colored glass, but other reds, like cadmium red or vermilion, are almost opaque, especially at full intensity. My palette was: yellow—new gamboge; red—permanent rose (a red toward violet); and blue—cobalt, manganese, and ultramarine. I also used some burnt sienna and a small amount of phthalo green.

Paper. This is 140-lb stretched Arches watercolor paper, with a cold-pressed surface.

Painting Tip. Strive for both crisp and diffused areas in the shadows as they fall across the snow. They're crisp near what's causing the shadow, but get more diffused farther away, where more reflected light gets in.

Step 1. The subject matter of this painting—the figures, cabin, trees, and background—is based on a trip I took some years ago to the Laurentian mountains in Canada. The weather was almost perfect for the week I was at this ski area, and I have vivid memories of it all, supplemented by a notebook, sketches, and some colored slides. As usual, I plan my painting by making a "thumbnail" sketch, which helps with my composition and values. This is enlarged by eye onto the stretched watercolor paper, using a soft graphite pencil (4B or 6B). The lines are especially dark here so you can see them. I usually use less pencil, but wanted this drawing to show in reproduction.

Step 2 (Above). I want to keep the feeling of freshly fallen snow which, except for a few ski tracks and footprints, is largely undisturbed and retains a soft, curved character. So I apply washes of cobalt and manganese blues, charged wet-in-wet with different values and with a touch of permanent rose here and there, and manipulate my 1″ (2.5 cm) brush to emphasize this character. I paint around the icicles and the trunk of the large tree, but knife out a few lights in the still-damp wash for future trees in the background.

Step 2 (Detail). This detail shows shadow patterns from the cabin and the skier's tracks, and the reflections in them of the blue sky overhead.

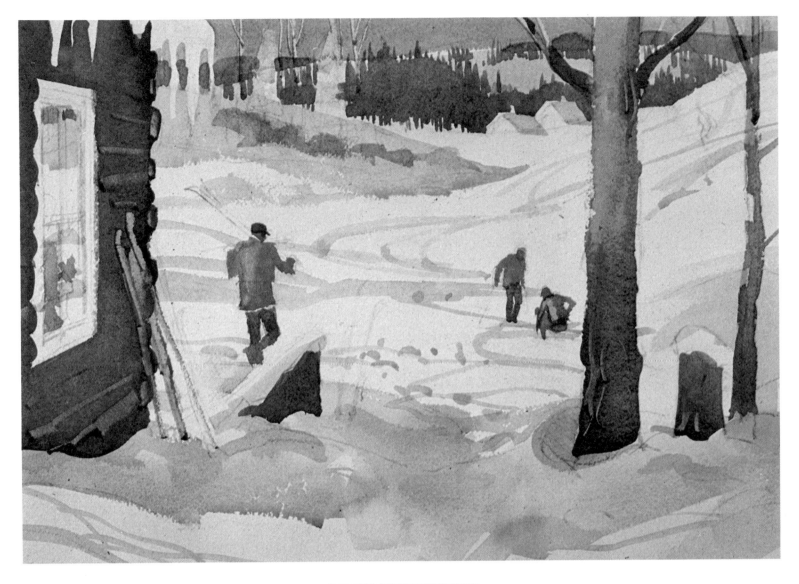

Step 3 (Detail). Here you can see how I maintain a warm and cool side on the lower tree trunk, simply by the way I put color into it while still wet.

Step 3 (Above). While my paper is dry, I erase some of the pencil drawing. Then I paint the shadows on the distant buildings with a grayed manganese blue and, after it's dry, add the forest behind the houses with permanent rose, loosely charged with a little phthalo green. This forest area is handled as a shape rather than as individual trees. Next, I paint the distant mountains a dark value of ultramarine blue. The side of the cabin is painted next, using a mixture of burnt sienna and permanent rose, out of which I knife some lighter values to indicate the caulking between the logs, and to show where the skis are leaning against the wall. The foreground trees are painted new gamboge plus permanent rose grayed with manganese, and a darker value of this same mixture is carried down toward the bottom of the tree trunk. Next I knife out a few areas to show the texture of the bark, then paint the figure shapes very simply, with no concern for any real detail, only for their silhouette and gesture.

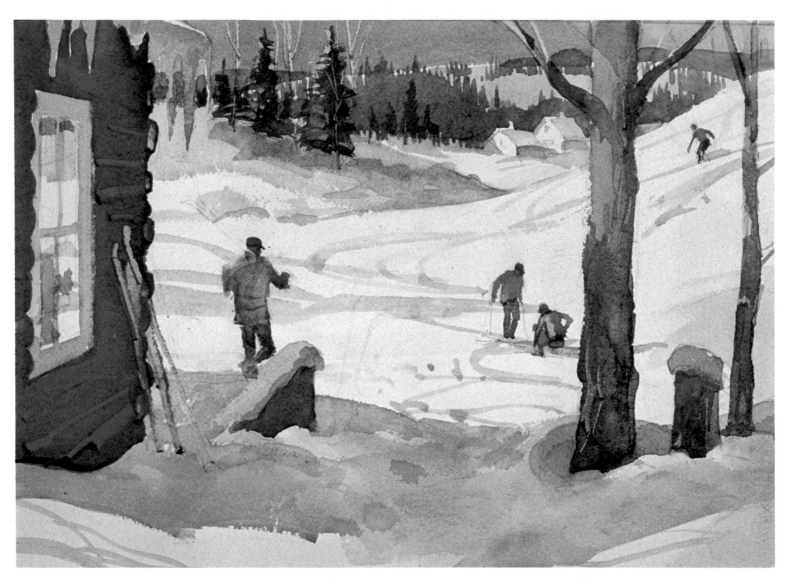

Step 4 (Above). The shadows cast onto the distant houses are added next, as well as the dark evergreens, which are placed against the lighter, previously painted forest. Now I add an additional skier in the right-hand middleground and paint the shadow on the porch and porch wall. The clump or "cap" of snow is now painted atop the stump, and the icicles are given a blue-violet wash, which I vary in value to indicate translucency. Next, I indicate the white-painted cabin windowframe with a grayed blue mixed from cobalt blue and a touch of burnt sienna.

Step 4 (Detail). Note how the shadow on the "cap" of snow on top of the stump is dark enough in value to read against the lighter area in back of it, yet the color mixture is still clean and not too gray, so it doesn't appear dirty or muddy. I used cobalt blue with a hint of burnt sienna to gray it.

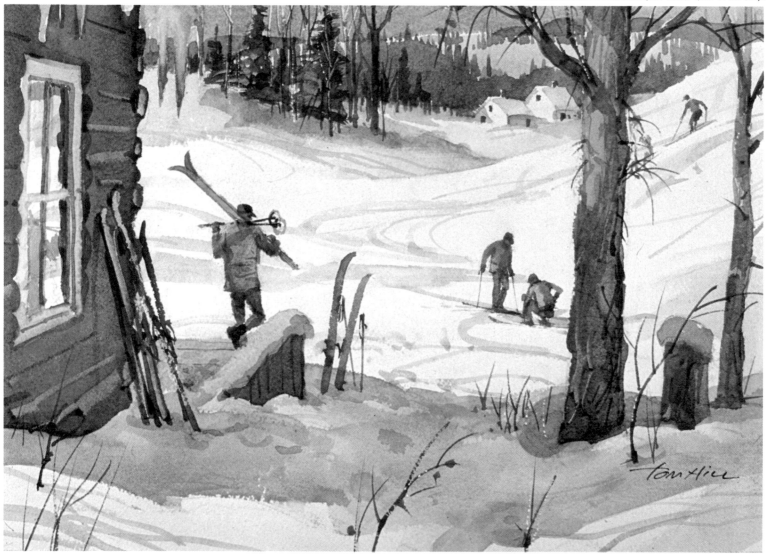

Step 5 (Detail). Here you can examine more closely the lines and brushwork I use in painting the twigs and bark—mostly the No. 6 rigger. Remember: a little of this goes a long way!

Step 5 (Above). Now, after everything else is solved, I can add the details. I add the darks to the areas around the windowframe, including the reflections in the glass, using a dark mixed from ultramarine blue and burnt sienna. Next I paint the figures—only a touch or two of my brush is needed to complete their bodies, poles, skis, mittens, and so forth. Now I paint the skis and poles in the snow and leaning against the cabin, mostly using my No. 8 round sable, with just a touch of the rigger for some of the smaller lines. After this, I paint the smaller branches, the twigs on the trees, and the stems and twigs that are long enough to stick up out of the snow. Again the No. 8 round and the No. 6 rigger are used. I decide to lighten a few of the middleground and background snow shadows. This I do by softening the pigment with clear water and a small bristle brush and gently blotting up some of the pigment until it looks like the correct value.

Ice on a Frozen Pond

People who have never visited or lived in an area where there are real winters would have difficulty painting this problem—even more than those of us who are familiar with the ice, snow, and gray skies of winter. Having lived some years in both the Midwest and New England, I have no trouble remembering the feeling of the scene that I'm using in the following demonstration: A winter morning that dawns cold and overcast. No new snow has fallen, but cold temperatures for many days have formed ice on the farmer's pond. A little warming and some wind probably promoted cracking and spreading of the thinner parts of the ice, revealing the dark, green water under it. Great stuff for a moody and atmospheric watercolor! How to interpret it best? First you must understand what's happening in order to paint it convincingly.

This is a low-light situation. The light is diffused because of the overcast sky, so there's no direct sunshine and accompanying crisp, cast shadows and bounced light. Shadows are more diffused and colors (hues) less intense and more grayed or neutralized because with less light, there's less reflection of color (see Problem 2, Dusk).

Here are some thoughts I have for helping to understand this problem: (1) The light level is lower and colors less intense on this overcast day, but this doesn't mean that we have to paint muddy grays— far from it! The colors are there and you can paint these subdued hues in a clear, transparent way— and still have the grayed, low intensity feeling. The trick is to gray or neutralize the color as simply as possible, using the fewest colors. If a tube color "as is" will do it, fine! If you can gray it by adding only one other color, the result will be a lot clearer and cleaner than if you mix three or four colors together. You might get the correct *value* with a complex mixture, but it will probably be muddier than the simpler one. As an example, let's say you want to produce a soft, grayed blue. There are a number of

ways you could gray the blue. Adding black would gray the blue, but it would also tend to deaden it. You could mix an orange from yellow and red and use the resulting complement to gray the blue. Depending on which colors you used, this could be okay, or look rather muddy. Cadmium orange is somewhat opaque and tends to muddy the mixture, as well as turn it slightly toward green. A simple and effective way would be to use a bit of burnt sienna—an orange-red that's *already* grayed—and a transparent color as well! (2) "Water always seeks its own level," the old expression goes—and so it does. The ice is flat and horizontal, and must be painted to look that way. Be aware of the perspective inherent in everything, even though there are no obvious lines or divisions to show it. (3) Though the ice may be split and fractured, with edges and cracks running in different and diverse directions, it's still level and, if smooth and not covered with new snow, will act the same as a mirror, reflecting what's above or beyond it.

Brushes. As usual, I used my 1½" and 1" (4 and 2.5 cm) flats for most of the painting, with round sables and a rigger for finishing.

Paper. This is 200-lb, cold-pressed Crisbrook, stretched.

Colors. My yellow was new gamboge; my red, permanent rose; and my blues, manganese, cobalt, phthalo, and ultramarine. I also added earth colors—raw and burnt sienna.

Painting Tip. Since there's no direct sunlight on the scene, you won't have sharp contrasts between light and dark. But you can *still* leave some pure white paper and at the same time have everything else balanced and in key, as you'll see in the following demonstration.

Step 1. This painting is based on scenes I saw while driving through Missouri late in the winter, but it's also typical of many other areas in winter. Because I was on a schedule that wouldn't allow stopping very long, I made notes and sketches and took a few color snapshots to remind me of the feeling of the area when I painted it later. When I have the painting planned and designed to my liking by doing compositional and value studies, I pencil it on my paper.

135

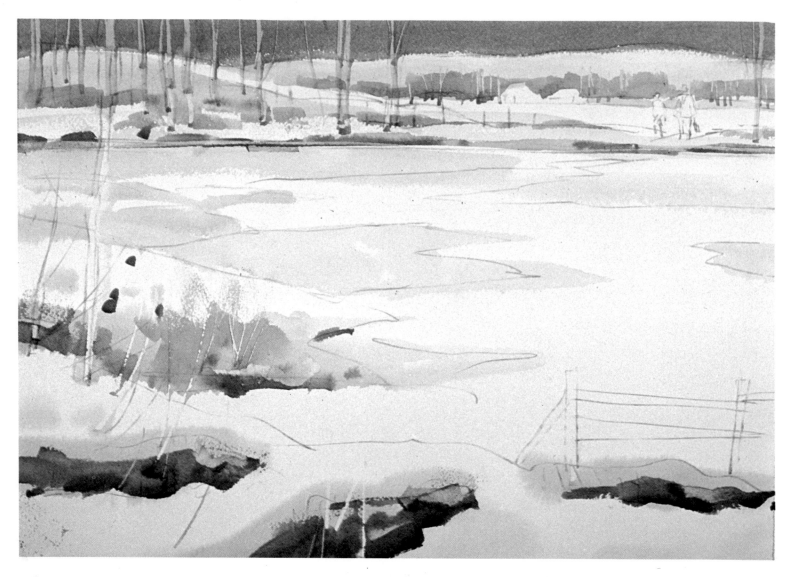

Step 2 (Above). I start by wetting the lower half of the paper with clear water, and then wait until the glisten has left the paper's surface but it's still fairly wet. Using my 1″ (2.5 cm) flat brush, and a mix of ultramarine blue with a tiny bit of burnt sienna, I paint the soft shadows on the piled-up snow in the foreground. Because the paper is still wet, but not *too* wet, the color doesn't run much but does produce a soft, diffused edge on the brushstrokes. Into parts of this I charge raw and burnt sienna and bits of ultramarine blue. The ice on the pond is painted with a tint of phthalo blue and, with the same color, I paint a tint under and in back of what will be trees across the pond. The sky and distant forest are next. Some raw sienna is added to show thickets and shrubbery, then the tree trunks are knifed out of the wet wash.

Step 2 (Detail). This closeup reveals the simple handling of the washes and shapes.

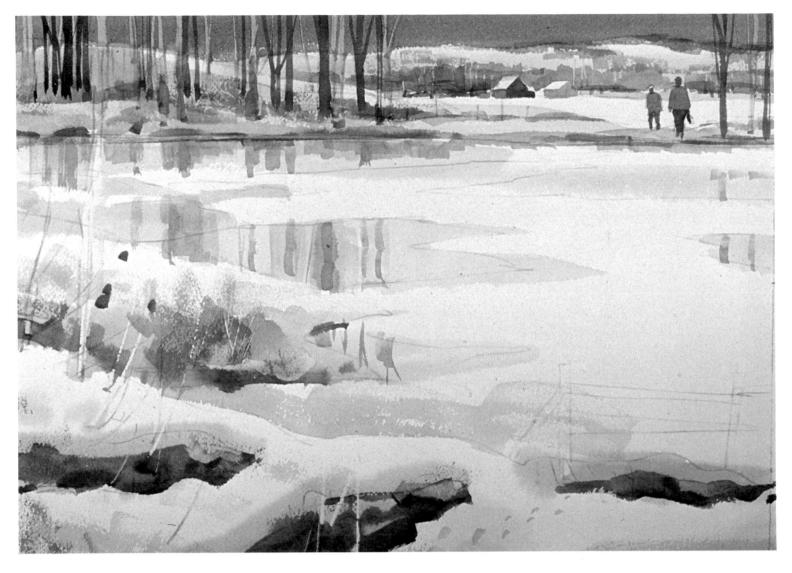

Step 3 (Above). After erasing some of the pencil, I paint the shapes of the distant buildings, leaving their rooftops white, then the tree trunks across the pond and the two blocked-in figures, using my No. 8 round sable brush. With my 1" (2.5 cm) flat brush and a mix of grayed blue-violet (cobalt blue, with bits of permanent rose and burnt sienna), I further define the shapes of the piled-up snow in the foreground, painting on dry paper with simple, direct strokes. Using about the same color, I paint the reflections of the tree trunks on the sheets of ice.

Step 3 (Detail). Here you can see an early stage in the painting of the reflections. I'll modify them in the next step.

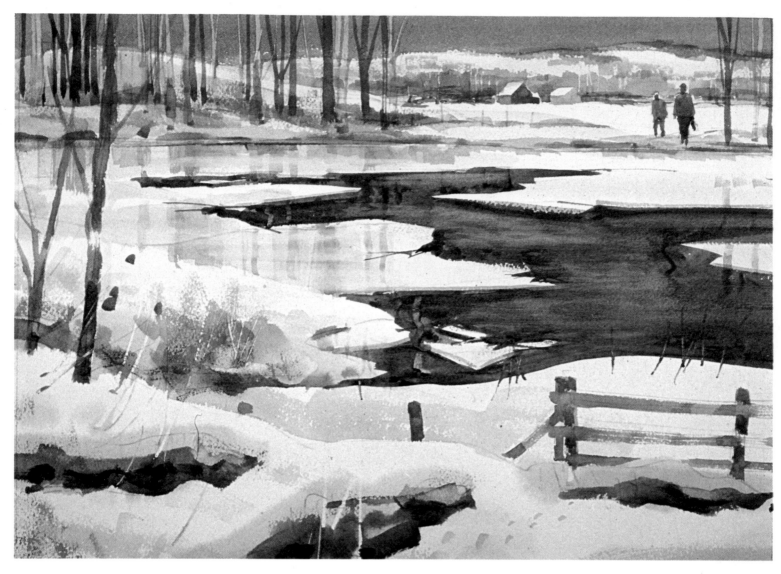

Step 4 (Above). I paint part of the foreground trees with my No. 8 round sable brush, then I mix ultramarine blue and raw sienna and block in the dark water, paying careful attention to my reference for the character of the water as well as the ice shapes it defines. As this is drying, I add a few vague reflections of the tree trunks to the water, then paint in the piece of fence showing above the snow, using my 1" (2.5 cm) brush, and warm and cool grays. Now, I finish the effect of the reflections on the ice by softening some parts with clear water and mopping them up gently with tissue. This gives a flatness to the ice, and adds a horizontal surface, in contrast to the vertical reflections.

Step 4 (Detail). The mopped-up technique shows clearly here.

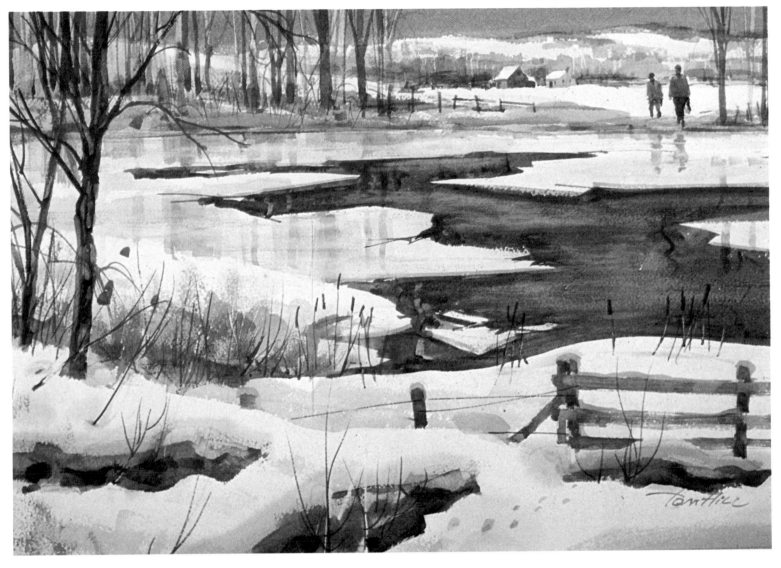

Step 5 (Above). The painting is actually finished in the previous step. All I do now is add a few details and adjust a few little relationships. I paint in the fence across the pond, the branches and twigs on the trees, and the snow piled up on the foreground fence. I use both my No. 8 round sable and No. 6 rigger for all of this.

Step 5 (Detail). The treatment of the cattails and the little twigs is easy to study in this detail.

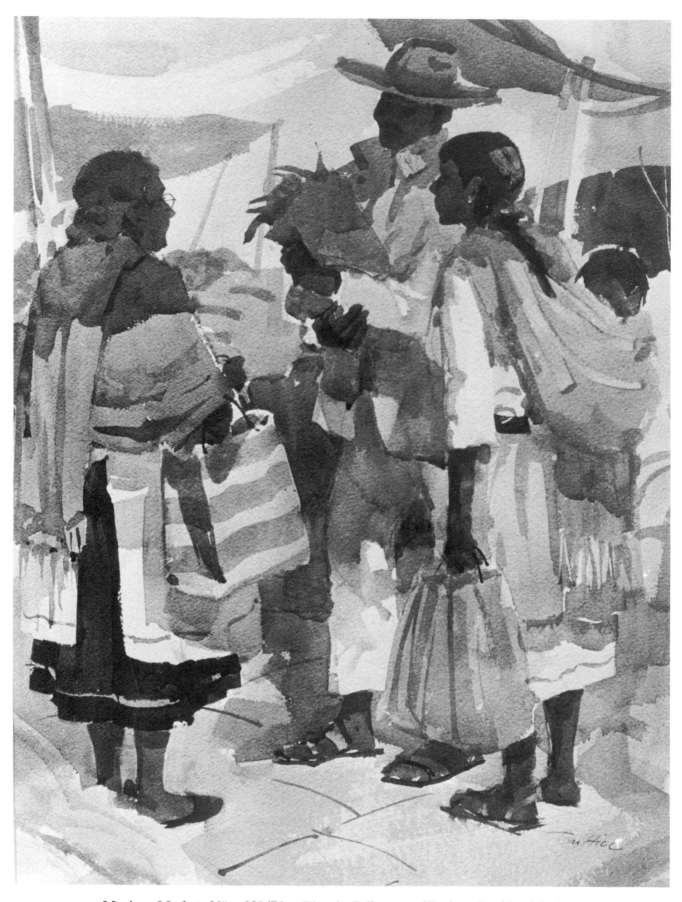

Mexican Market, 30″ × 22″ (76 × 56 cm), Collection of Barbara Luebke. Mexican markets fascinate me. The local folks have such a good time while doing their marketing. This is in a village near Toluca.

Suggested Reading

Betts, Edward. *Master Class in Watercolor.* New York: Watson-Guptill, 1975.

Blake, Wendon. *Creative Color: A Practical Guide for Oil Painters.* New York.: Watson-Guptill, 1972.

Brandt, Rex. *Watercolor Landscape.* New York: Van Nostrand Reinhold, 1963.

Hill, Tom. *Color for the Watercolor Painter.* New York: Watson-Guptill, 1975.

Itten, Johannes. *The Elements of Color.* New York: Van Nostrand Reinhold, 1970.

Mayer, Ralph. *The Artist's Handbook of Materials and Techniques.* New York: Viking Press, 1970. London: Faber and Faber, Ltd., 1964.

O'Hara, Eliot. *Watercolor Fares Forth.* New York: Minton, Balch, and Co., 1938.

Pike, John. *Watercolor.* New York: Watson-Guptill, 1978.

——. *John Pike Paints Watercolors.* New York: Watson-Guptill, 1978.

Schmalz, Carl. *Watercolor Lessons from Eliot O'Hara.* New York. Watson-Guptill, 1974.

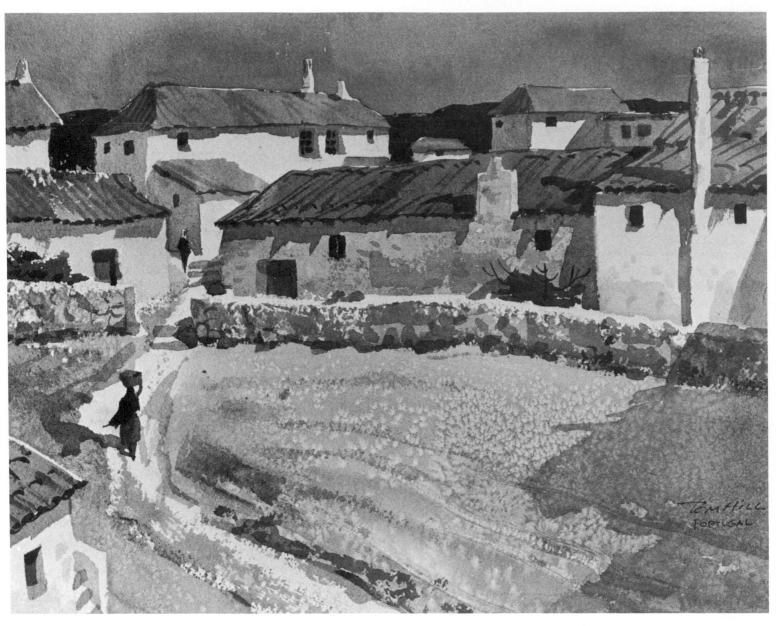

Familiaçao, Portugal, 11″ × 15″ (28 × 38 cm), Collection of the artist. This tiny village in Portugal was neatly maintained and the villagers cordial. The brilliant sunshine was very white, since it reflected off the whitewashed walls.

Index

Edited by Bonnie Silverstein
Designed by Jay Anning
Set in 11-point Palatino